Photofascism

Visual Cultures and German Contexts

Visual Cultures and German Contexts publishes innovative research into visual culture in Germany, Switzerland and Austria, as well as in diasporic linguistic and cultural communities outside of these geographic, historical, and political borders.

The series invites scholarship by academics, curators, architects, artists, and designers across all media forms and time periods. It engages with traditional methods in visual culture analysis as well as inventive interdisciplinary approaches. It seeks to encourage a dialogue amongst scholars in traditional disciplines with those pursuing innovative interdisciplinary and intermedial research. Of particular interest are provocative perspectives on archival materials, original scholarship on emerging and established creative visual fields, investigations into time-based forms of aesthetic expression, and new readings of history through the lens of visual culture. The series offers a muchneeded venue for expanding how we engage with the field of Visual Culture in general.

Proposals for monographs, edited volumes, and outstanding research studies are welcome, by established as well as emerging writers from a wide range of comparative, theoretical and methodological perspectives.

Titles in the Series:

Art and Resistance in Germany, edited by Deborah Ascher Barnstone
and Elizabeth Otto
*Bauhaus Bodies: Gender, Sexuality, and Body Culture in Modernism's Legendary Art
School*, edited by Elizabeth Otto and Patrick Rössler
Berlin Contemporary: Architecture and Politics after 1990, by Julia Walker
Photofascism: Photography, Film, and Exhibition Culture in 1930s Germany and Italy,
by Vanessa Rocco
Single People and Mass Housing in Germany, 1850–1930: (No)Home Away from Home,
by Erin Eckhold Sassin

Photofascism

Photography, Film, and Exhibition Culture in 1930s Germany and Italy

Vanessa Rocco

BLOOMSBURY VISUAL ARTS
LONDON • NEW YORK • OXFORD • NEW DELHI • SYDNEY

BLOOMSBURY VISUAL ARTS
Bloomsbury Publishing Plc
50 Bedford Square, London, WC1B 3DP, UK
1385 Broadway, New York, NY 10018, USA
29 Earlsfort Terrace, Dublin 2, Ireland

BLOOMSBURY, BLOOMSBURY VISUAL ARTS and the Diana logo are trademarks of Bloomsbury Publishing Plc

First published in hardback in Great Britain 2020
This paperback edition first published 2022

Cover design: Tjaša Krivec
Cover images: Top: *The Deutschland* exhibition: Hall of Honor with Hitler front of photo montage, 1936.
Courtesy Dittrick Medical History Center, Case Western Reserve University | Bottom: Cover of the *Mostra della
Rivoluzione Fascista: Guida Storica*, 1933. Collection Archives, Harry A.B. & Gertrude C. Shapiro Library, Southern
New Hampshire University, Manchester NH. © Archivio Centrale dello Stato, (ACS), Fondo MRF (Aut. 1593/2019).

All images from the Archivio Centrale dello Stato, Rome (ACS), are reproduced by concession of the Italian
Ministry of Culture and Activities (Authorization # 1593/2019).

A catalogue record for this book is available from the British Library.

Library of Congress Cataloging-in-Publication Data
Names: Rocco, Vanessa, author.
Title: Photofascism: photography, film, and exhibition culture in 1930s
Germany and Italy / Vanessa Rocco.
Description: London; New York: Bloomsbury Visual Arts, 2020. | Series:
Visual cultures and German contexts | Includes bibliographical references and index.
Identifiers: LCCN 2020035606 (print) | LCCN 2020035607 (ebook) | ISBN
9781501347061 (hardback) | ISBN 9781501347078 (epub) | ISBN 9781501347085 (pdf)
Subjects: LCSH: Photography–Exhibitions–Political aspects–Germany. |
Photography–Exhibitions–Political aspects–Italy. | Fascism and
photography–Germany. | Fascism and photography–Italy. | Fascism and
motion pictures–Germany. | Fascism and motion pictures–Italy.
Classification: LCC TR6.A1 R63 2020 (print) | LCC TR6.A1 (ebook) | DDC 770.74/43–dc23
LC record available at https://lccn.loc.gov/2020035606
LC ebook record available at https://lccn.loc.gov/2020035607

ISBN: HB: 978-1-5013-4706-1
PB: 978-1-3502-8424-1
ePDF: 978-1-5013-4708-5
eBook: 978-1-5013-4707-8

Series: Visual Cultures and German Contexts

Typeset by Deanta Global Publishing Services, Chennai, India
Printed and bound in Great Britain

To find out more about our authors and books visit www.bloomsbury.com and
sign up for our newsletters.

Contents

Illustrations

Acknowledgments

Right at the start, I would like to thank the staff at Bloomsbury Visual Arts, as well as the editors of the Visual Cultures and German Contexts series, Deborah Asher Barnstone and Thomas O. Haakenson. This project simply would not have seen the light of day without them. The foundation of this book project goes all the way back to 2004 when I completed my dissertation ("Before Film und Foto: Pictorialism to Modernism in Germany Photography Exhibitions 1909-1929") at the CUNY Graduate Center. Although the bulk of the writing has been done in the last six years, when a project goes on for this long it means there are many people to thank.

I would like to thank my dissertation committee who believed in the importance of the project before many people were writing about exhibition histories: Drs. Rose-Carol Washton Long—my adviser—and Rosemarie Bletter were my lead readers. Photography historian Dr. Geoffrey Batchen and Distinguished Professor of History Dr. Richard Wolin added extremely important critiques and context. After many years as a curator at the International Center of Photography (ICP), I returned to the dissertation as a book project, and my colleagues at ICP were extremely supportive of my research, particularly then-director of Exhibitions and Chief Curator Brian Wallis. Christopher Phillips served as my consistent mentor at ICP, both curatorially and with scholarly advice, given that he is one of the pioneers of exhibition culture research. The exhibitions that I installed at ICP introduced me to other key scholars in the fields of photography as well as exhibition studies, namely Drs. Elizabeth Otto, Jordana Mendelson, and Andrés Zervigón, to whom I returned repeatedly for advice over the years.

Participating in the book project *Public Photographic Spaces: Exhibitions of Propaganda from Pressa to the Family of Man*, edited by Jorge Ribalta—as well as sourcing installation shots for his attendant exhibition *Universal Archive*—helped me immensely in clarifying the importance of linking Germany and Italy in the use of propaganda in the 1930s, and many thanks go to him for engaging me in that groundbreaking project. At that juncture in 2008–9, Pratt Institute—where I was a visiting assistant professor—funded important travel to research in the Bauhaus Archiv in Berlin, as well as my travel to Barcelona to photograph the reconstructions at *Universal Archive*. My current home institution, Southern

New Hampshire University (SNHU) in Manchester, generously gave me three successive summer grants, which funded research at the Archivio Centrale dello Stato in Rome, as well as rights, reproduction, and travel costs. In addition, my Inter-Teaching Partnership Grant to teach the course "Propaganda and the Visual Arts," with history professor John McCannon, allowed my students to opine on the practical functioning of this visual propaganda, and I'm grateful for their contributions. A grant from the Getty Research Institute Library in 2016 helped me finalize key exhibition images from the Nazi period.

Many people working in international archives, with permissions, went above and beyond to help me obtain images for this book, often times on an expedited schedule. I especially thank Todd Leibowitz at ARS, Meredith Self at Columbia University Library, Tracey Schuster at the Getty Research Institute, Anna DePascale at the Archivio Centrale dello Stato, and Julia Riedel at the Deutsche Kimenathek. Warm thanks to the late Bodo von Dewitz of the Museum Ludwig and also to Ute Eskildsen of the Folkwang Museum, Essen, for early support, especially Dr. von Dewitz for providing me with *Die Kamera* original literature and photographs from the archives at the Museum Ludwig formerly known as the AGFA Fotohistorama in Cologne. Antonella Russo saved the day with a key last-minute image and assistance!

Many others I need to thank include my research assistant Kelley Hayes, who was indispensable, particularly in transcribing the Appendix. Effusive thanks to Dr. Daniel Magilow who did a pivotal read of this manuscript in its early stages and nudged me on the Gramsci connections. And gratitude goes to my former Pratt students, especially Greg Lindquist, my first MA student with whom I've enjoyed an ongoing dialogue through many years, and who continues to send me crucial new literature in the area of exhibition studies. My students Bobby Walsh and Rebecca Walton took part in my Pratt seminar "Public Photo Spaces" and wrote highly original papers, both of which contributed to this book. I thank Guggenheim curator Dr. Vivien Greene, with whom I've conversed on the subject of Italian exhibitions since I was practically a child, cutting my teeth as a Guggenheim intern. In addition, I thank Karole Vail, director of the Peggy Guggenheim Museum for ongoing support and interest.

I also thank additional colleagues at SNHU, especially my fellow art historians Drs. Deborah Varat and Colin Root, and our very supportive dean Dr. Steve Johnson. A loud "shout-out" to our Archivist Chris Cooper, who never hesitated to offer his assistance and wise counsel. As I've entered a new phase of my research into human responses to propaganda, I must thank my partner in this

at SNHU, Dr. Vincent Corbo, and our student researchers: Julia Brau, Sabrina DiSorbo, Julia LaBelle, John Marendes, and Rachel Willoughby.

Although now living out in the "countryside" of New Hampshire, I'd like to finish with various New York friends who sustain my connection to the art and creative worlds there, including Cynthia Fredette, Catherine Davis, and Anthony De Curtis. My husband Alan Chin has been my anchor for over twenty-five years. My children Nora and Zack inspire me every day with their wit and creativity. Many thanks to all my parents—Dr. Thomas and Ellen Rocco, my stepfather Joe McKnight, my darling late mother Agnes Nora Walsh McKnight. Stephie, I could not have done this without you! Also thanks to my siblings Joshua Cowan, Julie Lusthaus, and their families. I dedicate this book to my sister Joanna Christine Rocco, whose sharp mind and beauty were taken from us far too soon.

Abbreviations

Key Exhibitions

Iphad: *Internationale Photographische Ausstellung*, Dresden, 1909

Kipho: *Kino und Photographische Ausstellung*, Berlin, 1925

DPA: *Deutsche Photographische Ausstellung*, Frankfurt, 1926

Fifo: *Film und Foto Exhibition*, Stuttgart, 1929

BWU: *Ausstellungsstand* der Baugewerkschaften (Exhibition of the Building Workers Unions)*, Berlin, 1931

MRF, or the *Mostra*: *Mostra della Rivoluzione Fascista (Exhibition of the Fascist Revolution)* mounted in Rome in 1932, 1937, and 1942

* This is how the Bauhaus Archiv captions the BWU. Patrick Rössler's more recent translation can be seen in Chapter 1, note 3.

Introduction

Designing, Displaying, and Facilitating Fascism

Exhibitions are the most efficacious vehicles for the knowledge, the diffusion, and the theorization of the concepts that dominate the modern sensibility.

—Giuseppe Pagano, *Casabella-Costruzioni* (1940–1).

Photography + Fascism—Photofascism for short throughout this book—in interwar Europe developed into a highly toxic and combustible formula. Particularly in concert with aggressive display techniques, the European Fascists were utterly convinced of their ability to use the medium of photography to "engineer" the consent of their publics. Unfortunately, as is known in hindsight, they succeeded.

Other dictatorial regimes in the 1930s—including the Soviet Union under Joseph Stalin and later in the decade in Spain under Francisco Franco—harnessed this powerful combination of photography and exhibitions for their own odious purposes. But this book, for the first time, will focus on the particularly consequential dialectic between Germany and Italy, and within each of those countries, vis-à-vis display culture throughout the 1930s.[1] Why so consequential? (1) Because mass media, which depended on the photographic medium, was a distinct enabler to the foundational Fascist Benito Mussolini, a pioneering twentieth-century dictator. (2) Because Mussolini functioned as a prototype for Adolf Hitler, who subsequently instigated the apocalyptic Second World War. This prototype was useful in the area which Robert O. Paxton has called the "contradiction" of Fascism: regressive ideas, progressive techniques.[2] (3) Because there was significant cross-fertilization in influences back and forth between the nations as artists and organizers/curators became more and more proficient at mounting large-scale exhibitions that went beyond persuasion, entering the realm of coercion—albeit a form of willing coercion.[3]

The third point was particularly true in the period during which it was not at all a foregone conclusion that Hitler would succeed in consolidating power. And thus, the early to mid-1930s[4] provides a potent case study for every generation, and it is as urgent as ever in the current political moment to deeply understand the central role of visual culture in what happened to Europe. In sum, this study will demonstrate precisely how dictatorial regimes use photographic mass media, methodically and in combination with display, to persuade the public— or more accurately to engineer consent for certain policies—with often times highly destructive, even catastrophic, results.

Equating the term *Fascism*[5] as it applies to the photography of both nations—rather than specifying Italian Fascism and German National Socialism—is complex, but there is precedence for doing so in both historical and recent scholarship, including in the aforementioned *Anatomy of Fascism* (2004). As far back as 1922, the right-wing intellectual Moeller van den Bruck recommended Mussolini's "ultranationalist" movement to Germans as a bulwark against Bolshevism.[6] Mussolini and Hitler both seized dictatorial power in the same manner, a fusion of quasi-legal and intimidating violence. But as Christian Goeschel has documented in his recent article "A Parallel History?" in the *Journal of Modern History*, work on "comparative Fascism" emerged in the 1960s, "when many historians saw Nazism as a manifestation of Fascism."[7] Goeschel speaks to the similarities of their "parallel histories," bemoans the lack of historical work in the area—although what he truly seems to be seeking is a larger Euro-discussion, not a simple duality—and goes on to create "the rise of Fascism in Italy *and* Germany" as one of the three pillars in his highly compelling argument, with the terms used interchangeably throughout.[8] This book will do likewise through the term *Photofascism*.

Methods and Sources

The analysis throughout *Photofascism* fuses newer and older methodologies and disciplines—including theories of reception, formal analysis, exhibition studies, and photo-historiography. It is ensconced in a sociocultural history of interwar European culture, pursuing a sustained use of Antonio Gramsci's theory of cultural hegemony to explain the correlations between Fascist political regimes and their attendant visual regimes.[9] Gramsci was uniquely positioned to understand the inner workings as well as the consequences of hegemonic power, having been jailed by the Italian Fascists in 1926 and having languished in their

prison cells for over a decade until his death. Terry Eagleton uses Gramsci to define hegemony in a particularly useful way in *Ideology: An Introduction*, which encompasses both consent and coercion: "Gramsci normally uses the word hegemony to mean the ways in which a governing power wins consent to its rule from those it subjugates, though . . . he occasionally uses the term to cover both consent and coercion together."[10] That conflation is productive for this book, as it will show this dynamic of photographic propaganda going beyond mere consent or even persuasion. It is the aggressive engineering of consent, leading eventually to willing coercion.[11] Historian Geoff Eley also formulates this intersection productively by naming it the "Extraction of Consent" and by actively discussing "the place of coercion *in* consent."[12]

The people consent in some manner to this subjugation, and this book proposes that exhibited photographic propaganda is essential to precipitating that acquiescence in a particularly aggressive way. To elaborate, Eagleton takes from Gramsci's *Prison Notebooks* the idea that the hegemonic class must understand the priorities of those they seek to dominate: "Any hegemonic class, he [Gramsci] writes in *The Prison Notebooks*, must take account of the interests and tendencies of those over whom it exerts power, and must be prepared to compromise in this respect."[13] If that happens, the individuals in the society will feel as though they are making their own independent decisions, within a kind of "self-government" that does not conflict with the State, and the hegemonic system will feel invisible.[14]

How does propaganda create the conditions for these feelings? It was partly accomplished then, as it is now, through simplicity and repetition. But the more complex transaction takes place through differentiation of message: for example, stability for the middle classes versus anti-elitism and empowerment for the lower and working classes. Throughout *Photofascism*, within this underlying structure of a hegemonic order (Fascism) winning consent from its publics—partly and very effectively through visual culture—formal analyses are undertaken of both photographs and how they were exhibited, as well as how they were received. Mussolini and his bureaucrats believed that exhibitions were a "uniquely powerful tool for swaying mass opinion" and could exert control without obviously "naked coercion."[15] Granted, this application of hegemony can be slippery, as Gramsci expressed support for hegemonic systems—on his socialist side of the power equation—but *Photofascism* proposes that he had a unique insight into this system of power because he witnessed the Fascists using it effectively, including against him.[16]

Cross-national studies of display have produced several of the most illuminating books in the art historical field over the last decade, including Karen Fiss's *Grand Illusion*, which detailed the manner in which the Nazis used cultural production to lull and/or coerce the French into believing in a relationship of equals,[17] and Romy Golan's *Muralnomad*, which explored the discomfort of European artists with the environment of the mid-twentieth century and how those sentiments led to strangely anachronistic forms such as the mural. Both of these books were published in 2009 and both used exhibition practices as the basis for their respective theses;[18] it is to such bodies of literature that this book aspires to add, but with more of a focus on photography. The "exhibition" is now considered a medium in its own right, as this author has previously argued in the 2013 essay "Exhibiting Exhibitions" in the publication *Made in Italy* edited by Grace Less-Maffei and Kjetil Fallen: "that objects on display are there as a result of being exhibited and therefore 'mediated.'"[19] This "new medium" argument was furthered in the title of a subsequent symposium that took place at Harvard University in March 2013 entitled *Exhibition as Medium*,[20] which included papers on artists as designers of exhibitions, exhibition spaces as works of art in and of themselves, and postwar critiques of conventional display spaces. More recently, the ambitious exhibition and catalog *Post Zang Tumb Tuum: Art Life Politics: Italia, 1918-43*, produced by Germano Celant for the Prada Foundation, revolves its thesis around reconstructed exhibition spaces, cementing the use of sites as highly productive for analysis in curatorial settings as well as scholarly production.

As far as photographic studies are concerned, it is no longer productive to separate photography out from these kinds of interdisciplinary sociopolitical matrices. As Jorge Ribalta explains in his introduction to *Public Photo Spaces*, "a new cartography for the study of photography" in historiographic studies is the intersection between art, the social sciences, and politics.[21]

From Interwar to War

The chapters will move back and forth, chronologically and between the two nations, as many of the cultural figures who will be described did at the time. Blockbuster-level exhibitions are emphasized as they best-crystallize design innovations and cultural priorities of the regimes. Although Mussolini's regime

predates Hitler's by over a decade, the story will begin in Germany, because of the explosion of innovative display techniques developed there in the late 1920s by an international cadre of artists (especially Soviet and German, as well as Italians such as the sometimes-Futurist Mario Sironi). Ironically, due to innovations in attention-grabbing techniques, many of the radical design concepts of left-leaning artists working in Germany would be appropriated and then perverted by the Italian Fascists and the Nazis. The first chapter will chart this intense and thwarted period of progressive experimentation, focusing on the astonishing and overlooked *Ausstellungsstand der Baugewerkschaften* (*Exhibition of the Building Workers Unions* (BWU) in Berlin in 1931.[22] The latter was a kind of climax of experimentation before the abyss of the reactionary period, particularly in its attempt to directly engage and educate its audience through didactic touch-feel stations, filled with combinations of supporting statistics and anonymous documentary photography.

Chapter 2 will then move chronologically to the phantasmagoria of the *Mostra della Rivoluzione Fascista* (MRF, or the *Mostra*) mounted in Rome in 1932 by Mussolini's acolytes. The hegemonic influence of this exhibition—a masterful combination of photo-based ephemera, sculptural elements, and architectural exhibition design—on the Italian populace must not be underestimated. People were encouraged to submit their personal pro-Fascist artifacts, and therefore they felt empowered and enfranchised. On site, they were encouraged to literally worship the "fact-based" photographs. The Fascists also instituted mutually beneficial relationships with tourist agencies and the like to bring in massive numbers of people. The result: a two-year installation with attendance figures upward of four million, one-tenth of Italy's entire population. To put such statistics in recent cultural context, those are *American Idol*–level rating numbers, and thus the rare historical occasion of an exhibition becoming "water-cooler" fodder.

This Italian exhibition also demonstrates the trafficking of visual propaganda between the two nations during the key years of 1928–33. MRF artists such as Mario Sironi had honed his techniques while designing the Italian pavilions of influential—and still socialist-leaning—German exhibitions such as *Die Internationale Press Ausstellung* (or *Pressa*) in Cologne in 1928. Conversely, Nazi elites such as Joseph Goebbels and Hermann Goering visited the MRF during a crucial moment of transition, in the late spring of 1933 after Hitler's power grab and while Goebbels was creating his long-term strategies for the Nazi cultural apparatus. Indeed, one of the first tasks Goebbels undertook once he was appointed Minister of Propaganda in March was likely to organize

a photography exhibition: *Die Kamera* (Berlin, November 1933). Due to its massive size and expedited opening, preparations would have necessarily begun immediately.

Consequently, *Die Kamera* is the subject of the third chapter. This exhibition opened just ten months after Hitler acceded to the chancellorship on January 30. An exhibition with thousands of objects takes at least that long to organize, and there is evidence that they were working on it through the night of the opening; Goebbels clearly comprehended the importance of solidifying Nazi-approved photographic images in the minds of the public as quickly as possible. As remarked upon by director Albert Wischek of the Berlin Nonprofit Exhibition, Trade Fair and Tourism Corporation at the press preview of *Die Kamera*, "It is no accident that this subject (photography) was chosen for this first joint undertaking with the German Labour Front," in concert with the "energetic assistance" of the Ministry of Public Enlightenment and Propaganda.[23] Wischek was himself a big fan of the MRF, stating several years later, in hegemonic fashion, that the Italian show "totally transformed the exhibition as an instrument of political conquest."[24] Wilhelm Niemann's design of the atrium through which every visitor to *Die Kamera* passed included multiple gargantuan blowups of outdoor Nazi spectacles, intended to both inspire and intimidate the viewer before moving on to a monotonous array of booths containing state-sanctioned images.

The Venice Film Festivals in the early to mid-1930s are the focus of Chapter 4. The related Biennale exhibitions, starting even earlier, were low-hanging fruit for the Fascists in demonstrating their power over the culture industry. They actively advertised through multiple "platforms," taking an event once associated with elitism and making the masses feel more enfranchised to come see it, and be a part of it. Mussolini expanded the film and music offerings, initially as part of the Biennales, as well as the applied arts sections, so it would not solely appeal to "high art" sensibilities. The festivals are an ideal example of the aforementioned fitting of Fascist messages into desirable packages that created platforms of veiled coercion: that is, films are for *everyone*. And per Mussolini's 1936 Billboard slogan: "cinema is the strongest weapon."[25] By the 1930s there was a well-established genealogy of film and photography being exhibited together, and film festivals are therefore a useful pendant to exhibitions as complex collective tools of coercion. Full 1930s schedules of German and Italian films are included in the Appendix to demonstrate the sheer numbers of films shown, along with analyses of the types of messages being received by contemporaneous audiences through Italian critical reception of both programs.

Chapter 5 will be the most tightly integrated chapter, examining exhibitions in both countries from 1936 to 1937. German exhibitions such as *Deutschland* (1936) and *Gebt mir vier Jahre Zeit!* (*Give Me Four Years' Time*, 1937) were by this time less about encompassing the viewer into the mass ornamentation of Nazi spectacle and more about pure Führer worship. This chapter will also rely on the voluminous documentation of the 1937 iteration of the Italian MRF exhibition to both fill out the contents and show how important avant-garde designers were to the visual success of the 1932 original. The spin-off lacked the calculated brilliance of such rooms from 1932 as Terragni's Sala (Room) O and Sironi's Sala P and instead became a march of tedious didactics.

The conclusion is also an epilogue: by the 1942 iteration of the MRF, all of the design originality of 1932 had been squeezed out even further, and newly disturbing anti-Semitic displays were included, reflecting Italy's total capitulation to Nazi-like racist ideology—also reflected in their adoption of racial legislation beginning in 1938.[26] That dissolution of the interwar Italian populace into a racist wartime ideology that many were initially resisting underscores *Photofascism*'s current relevance. In an age filled with a bombardment of political propaganda on various platforms, there is little evidence that we are schooling the digital natives generation in how to gain critical distance from visual culture in order to analyze it. Contemporary analyses of the twentieth-century phenomenon of mass-media propaganda are urgently needed to plug this gap, particularly as much of visual propaganda today still remains photographic at its core. And exhibitions are the ideal vehicle for this historical analysis. As introduced in the epigraph, architect Giuseppe Pagano firmly stated at the dawn of the 1940s that "Exhibitions are the most efficacious vehicles for the knowledge, the diffusion, and the theorization of the concepts that dominate the modern sensibility."

Prologue: Exhibitions and the German and Italian Avant-gardes in 1928–9

The Italian Fascist regime had, since its rise to power in 1922, been infatuated with the interrelationship between the malleability of history and certain tools of persuasion. It began to think of itself, and therefore present itself, in an obsessively historicized manner beginning in the late 1920s. This was partly due to the ten-year anniversary in 1929 of the founding of the *combattimento di fasci*.[27] Hence the late twenties ushered in a more aggressive participation in

international exhibitions, including the *International Press Exhibition* in Cologne (1928) and the *Italian Press and Book Exhibition* in Barcelona (1929).

"Each exhibition realized is a revolution" was a mantra of the Fascist and Futurist (but only in his early years) artist Mario Sironi, who collaborated with designer Giovanni Muzio on the Italian pavilions of both shows and who understood that Mussolini's style of politics and the production of large exhibitions were "inseparable."[28] If, as Peter Wollen has posited, the purpose of spectacle is to distract from the truths that regimes wish to conceal, then Mussolini's regime fit perfectly:[29] it was born with a narrative of spectacle intended to distract—and redirect—which created the conditions for consent. Although he came to power through a backdoor negotiation with King Emanuele III, the tale of his rise was reconfigured as one of violent insurrection through the so-called March on Rome in October 1922—which was, in fact, nothing more than a celebratory parade before Mussolini and the King, which will be examined further in Chapter 2. Such a spectacle was needed to distract from the more bureaucratic and less virile political machinations that transpired. Likewise, exhibitions with inclusive mass appeal were increasingly designed to distract from the totalitarian political realities of exclusion.

Sironi's abilities to choreograph these distractions certainly increased over time, as the Cologne and Barcelona exhibitions were fairly dry presentations, and were presented as histories of the publishing press in Italy, dating back to the Renaissance, but with an emphasis on recent production. In the 1928 Cologne show, there was a direct appeal to both celebrating the cult of Mussolini's personality and a wafting sense of ancient Roman nostalgia.[30] The centrally placed Adolf Wildt bust of Mussolini (Figure 0.1 on right) gives a sense of how the objects in Fascist exhibitions revolved around the cult of Il Duce, sometimes directly through busts or profiles, sometimes indirectly, or even metaphorically, in the form of maps or the iconography of ancient Roman architecture. The Italian pavilion was in the International Hall, along with several other pavilions. The repeated glass box entrances were designed in the international style, but the Sironi and Muzio-designed rooms inside were more eclectic, combining contemporary Fascist kitsch with stained-glass windows and heavy display vitrines. These primarily contained copies of the Mussolini-founded Fascist newspaper *Il Popolo d'Italia*, for which Sironi designed many issues.

The most sophisticated moment of this otherwise directionless interior emerged in the form of a vertical frieze separating two of the other ephemera-filled rooms (Figure 0.1 on left). Il Duce still anchored the center, but at least here there was a stylistic cohort to some of the revolutionary design techniques that would make El Lissitzky's massive, horizontal, and oft-reproduced photojournalistic frieze in

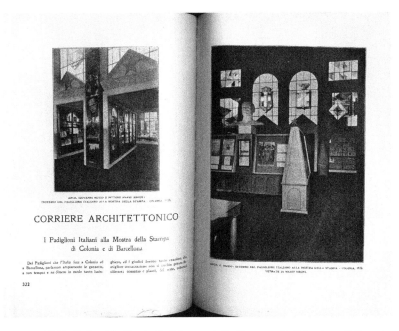

Figure 0.1 "I Padiglioni Italiani alla Mostra della Stampa di Colonia e di Barcelona" from *Architettura e Arti Decorative* (1930): 322–3.

the Soviet pavilion of the same Cologne exhibition such a sensation. This was especially true of other components of Lissitky's design, particularly the unfurling of images in a vertical, celluloid-like sequence on conveyor belts (Figure 0.2; part of the famous frieze is visible on the far back wall).

Indeed, international critical reception has shown that most of the other pavilions were considered staid and boring in comparison to Lissitzky's: "Amongst all the Pavilions of the various nations, the Russian one has the most visitors. . . . Compared with it, the other Pavilions seem colourless."[31] The excitement generated by Lissitzky's design was linked to the cinematic (the jump cut, the montaged sequence), which dovetailed with ruptured modern viewing. These types of techniques were still in the embryonic stage in the Italian pavilion where Sironi had direct access to the Lissitzky installation, but would be seen in full force at the *Mostra* (MRF) a few years later.

The Barcelona fair, in fact, functioned as a visual segue between Cologne and the later *Mostra*. Present were some of the myriad fusions between two-dimensionality and three-dimensional sculpture that would become hallmarks of the *Mostra*. The bust and the maps continued to posit Mussolini as the *conquistatore*; yet there was also a more interesting moment of display than seen at Cologne in the *Il Popolo d'Italia* glass case. Here the viewer confronted

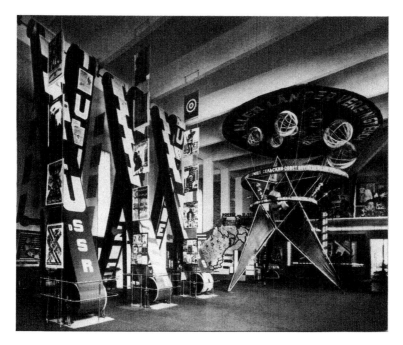

Figure 0.2 El Lissitzky, The Entrance Hall, from the *Pressa* exhibition, Cologne, 1928. © 2020 Artists Rights Society (ARS), New York.

newspaper spreads, juxtaposed with printing drums and a raft of newspapers lying in front, all crowned by large-scale typeface. These examples, or motifs, of how the objects on display actually functioned in the material world would seem to be didactic in an engaging way, but this was, unfortunately, offset by representing a newspaper that so clearly editorialized from a single, Fascist point of view.

Sironi was credited within his milieu as the most capable designer for dynamizing endless pages of newsprint. As art historian Emily Braun has explored, Fascist critic P. M. Bardi and others considered Sironi's illustrations to embody "the very mood of insurrection."[32] The more visually arresting combination of object itself plus display mechanism that Sironi developed here would continue to modernize at the *Mostra*. He was beginning to understand that Fascist display modes needed to look more contemporary, to achieve the veneer of progressiveness. Focusing too heavily on past glories would reveal one of the truths to conceal: that the regime was, in fact, rigidly regressive. This would lead to more reliance on three-dimensional photographic constructions and less reliance on traditional sculpture going forward.

Meanwhile, in Germany László Moholy-Nagy provided some of the foundation for the 1931 BWU exhibition (Chapter 1) through the "New Vision" organization of many aspects of a previous exhibition: the blockbuster *Film und Foto*, mounted in Stuttgart in 1929, regarded as one of the most important in photographic history, and on which some important recent scholarship has been done by Olivier Lugon.[33] Lugon makes it clear that Moholy's organizational function, previously vaguely defined, was largely limited to Room 1. In this Room, he installed a wide variety of experimental images, including photograms, montages, and strangely angled pictures that came collectively to be called the New Vision. The New Vision aimed to jar the viewer of modern photography out of their habitual complacency by using unexpected materials and highly dynamic contemporary subject matter. It seems that Moholy's first use of the term "New Vision" may have been in the wall text of *Fifo*.[34] There have been persuasive arguments, including very recent ones by Andrés Zervigón, that being sponsored by the Werkbund hampered the level of design innovation. However, one could argue that the Moholy's use of the typophoto design template in his rooms—similar to his book layouts in *Painting Photography Film* (1927)—at least in comparison with the gilt-framed salon-style hangs still being used in many photography exhibitions was fairly radical (Figure 0.3, upper left). John Heartfield's room was likewise pushing boundaries, also explored by Zervigón.[35]

Fifo traveled in Europe through 1930, to Zurich, Berlin, Danzig, Vienna, and Agram (now Zagreb, Croatia). In 1931 part of the exhibition was renamed *Das Lichtbild* and supplemented with the work of additional photographers, including Bill Brandt, Walker Evans, Lotte Jacobi, Hein Gorny, and August Sander. Max Burchartz and Kurt Wilhelm-Kästner contributed to the organization of *Das Lichtbild*, which traveled to Munich, Essen, Dessau, and Breslau. The two perhaps realized that their efforts in a *Fotografie der Gegenwart* (*Contemporary Photography*) exhibition had been utterly overshadowed two years earlier. Christopher Phillips, in his 1989 exhibition catalog *The New Vision*, pinpointed 1931 as the year in which the energy of the "new photography" began to wane, due to increasing opposition from both the Fascist right and the Communist worker-photographer movement.[36] Maybe so, but the BWU shows that the fusion of both the New Vision and its own version of worker-photography could still create highly charged spatial experiences.

Exhibition spaces served as a site of primary importance in early twentieth-century avant-garde experiments. Russian Constructivist El Lissitzky summarized this point succinctly in the opening epigraph of the next chapter, which affirms that the artists of the era were determined to create a more

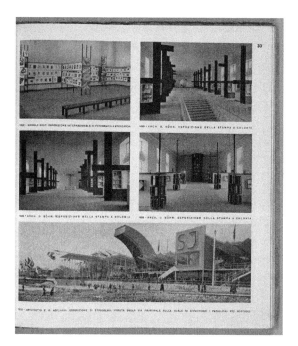

Figure 0.3 *Casabella-Costruzioni*, special double issue, no. 159–60 (March–April 1941): 33. Courtesy Avery Architectural & Fine Arts Library, Columbia University, New York.

engaged populace. Radically experimental exhibition spaces—often photo-based—were considered a mass medium unto themselves in the European interwar period, and as such the most radical emphasized mass messages, and de-emphasized individual experiences in front of individual prints. One of the starkest ways one can see this emphasis on collectivity play out is through the BWU, on which former Bauhaus designer Herbert Bayer and former Bauhaus master László Moholy-Nagy collaborated on the photo displays, while Bauhaus founder Walter Gropius designed the architectural structures. The next chapter aims to place this seldom discussed exhibition more prominently in the study of photography in the public sphere, particularly within historiographic analyses that create an intersection between art, the social sciences, and politics. As a growing area of research, it is necessary for exhibition studies to counter the art historical tendency to return repeatedly to the same canonical exhibitions, thus suppressing highly illuminating transitional moments. Such moments are all the more crucial to comprehend during political upheavals like those of the early 1930s, a crossroads at which BWU stands.

Notes

1 Benjamin Martin's important recent book *The Nazi-Fascist New Order for European Culture* (Cambridge, MA: Harvard University Press, 2016) confronts the cultural dialectic between the two nations. But, as reviewer Ian Beacock noted in his article "How the Nazis Made Art Fascist," in the *New Republic* (May 23, 2017), the visual arts are "curiously absent," although that overlooks his impressive analyses of filmic integration. Martin's other emphases include classical music and literature. https://newrepublic.com/article/142821/nazis-made-art-Fascist.

2 Robert O. Paxton, *The Anatomy of Fascism* (New York: Vintage Books, 2004), 12. His analysis led him to conclude that Italy and Germany were the most closely linked in realizing twentieth-century Fascism.

3 This reception dialectic between audience and the State has been described more recently by Nicholas O'Shaughnessy as the "engineering of consent," in *Marketing the Third Reich: Persuasion, Packaging, and Propaganda* (New York and London: Routledge, 2018), 1, and in the 1930s by Gramsci as cultural hegemony. Both formulations will be much discussed throughout this book.

4 For the sake of precision I want to define "mid" as being through 1936, that is, the period before the Spanish Civil War. For some who may question why not Spain or Russia in this book, it should be remembered that Spain's dictatorship came about later in the 1930s and therefore was not as essentially enabling to Hitler as Mussolini, and Stalin's Soviet Union was not founded as a Fascist regime; although it clearly became autocratic, the complexities of conflating Communism and Fascism are too immense for this book to encompass.

5 I will capitalize *Fascism* and all attendant uses, whether adjectival or not, to avoid headaches, in keeping with *The Chicago Manual of Style*, 16th ed. (Chicago: Chicago University Press, 2010).

6 Christian Goeschel, "A Parallel History? Rethinking the Relationship between Italy and Germany, ca. 1860-1945," *The Journal of Modern History* 88 (September 2016): 610–32.

7 Goeschel, "A Parallel History?" 614.

8 Goeschel, "A Parallel History?" See 622 for just one of many examples.

9 Many thanks to Dan Magilow for encouraging me to return to Gramsci in a deep and substantive way.

10 Terry Eagleton, *Ideology: An Introduction* (London and New York: Verso, 1991), 112. Eagleton creates—obviously in a predating sense—a riveting parallel to current millennial politics when he explains Western democracies as successfully hegemonic partly because they foster the "illusion of self-government on the part of the populace." And later: "the people are supposed to believe that they govern themselves, a belief which no slave of antiquity or medieval serf was expected to entertain."

11 Gramsci describes how the State does have consent but it also "educates this consent." Antonio Gramsci, *Selections from the Prison Notebooks*, eds. Quentin Hoare and Geoffrey Nowell Smith (New York: International Publishers, 1971/ reprinted 2014), 259. There is a more comprehensive translation by Joseph Buttigieg, *Antonio Gramsci, Prison Notebooks* (New York: Columbia University Press, 2011). However, given the thematic organization of Hoare versus chronological organization of Buttigieg and that Hoare's translations are still acknowledged by Buttigieg as reliable, I am using the earlier publication.

12 Geoff Eley, *Nazism as Fascism* (New York: Routledge, 2013), 43.

13 Eagleton, *Ideology*, 122. There is no specific cite from Eagleton of Gramsci on this reciprocity idea.

14 Gramsci, *Prison Notebooks*, 268.

15 Karen Fiss, Robert H. Kargon, Morris Low, and Arthur P. Molella, *World's Fairs on the Eve of War: Science, Technology, and Modernity, 1937-1942* (Pittsburgh: University of Pittsburgh Press, 2015), 111–13.

16 See Martina Caruso on Gramsci's 1926 argument for "national" hegemony, in *Italian Humanist Photography from Fascism to the Cold War* (New York: Bloomsbury, 2016), 88–9.

17 Fiss also collaborated with a working group (Robert H. Kargon, Morris Low, and Arthur P. Molella) on the book *World's Fairs on the Eve of War: Science, Technology, and Modernity, 1937-1942*, see above. However, as the subject was more about "national projections" (see page 2) of these nations on an international stage, it differs significantly from my goal of illuminating the persuasion of national publics. The chapter entitled "Mussolini's Appian Way to Modernity," however, is extremely useful on the subject of Mussolini's attitudes toward his domestic audience.

18 Karen Fiss, *Grand Illusion: The Third Reich, the Paris Exposition, and the Cultural Seduction of France* (Chicago: University of Chicago Press, 2009), and Romy Golan, *Muralnomad: The Paradox of Wall Painting, Europe 1927-37* (New Haven: Yale, 2009). Although not cross-national, I also want to acknowledge the groundbreaking work of Jordana Mendelson in this area, including my first exposure to the term "exhibition culture" in her book *Documenting Spain: Artists, Exhibition Culture, and the Modern Nation, 1929-1939* (University Park: Pennsylvania State University Press, 2005).

19 Vanessa Rocco, "Exhibiting Exhibitions" from Kjetil Fallin and Grace Lees Maffei (eds.), *Made in Italy: Rethinking a Century of Italian Design* (New York and London: Bloomsbury, 2013), 180.

20 This symposium became the basis for a special issue of *October* 50 (Fall 2014): "Artists Design Exhibitions," ed. Kevin Lotery and Claire Grace.

21 Jorge Ribalta presents this intersection for the study of photography in "Note on this Publication," in Jorge Ribalta (ed.), *Public Photographic Spaces: Exhibitions*

of Propaganda from Pressa to The Family of Man (1928–55) (Barcelona: MACBA, 2008), 9.

22 The use of this word "progressive" has become more polarizing in scholarship, partly due to the Fascist misuse of "progress," but I do mean it in the current political sense, which is re-circulating in contemporary parlance: reform-minded and forward-thinking.

23 *Die Kamera*, Press Release (1933), reprinted in Ribalta, ed. *Public Photographic Spaces*, 267.

24 Michael Tymkiw, *Nazi Exhibition Design and Modernism* (Minneapolis: University of Minnesota Press, 2018), 156. Tymkiw's analysis of Wischek's writings will be further discussed in Chapter 5.

25 Martin, *The Nazi-Fascist New Order*, 47.

26 In July of that year, Mussolini even spoke of the Italians needing to become more "odious" vis-à-vis their more ruthless partners in Germany, discussed further in Chapter 5.

27 The name given to the Fascist cells in 1919. In fact, the *Mostra* in 1932 was originally planned for 1929 for that reason, but was delayed. The first several paragraphs of this section, as well as portions of Chapter 4, are based on my book chapter "Exhibiting Exhibitions," 179–92.

28 Jeffrey T. Schnapp recounts that Sironi declared this in 1933 to his nemesis Farinacci in his essay "'Ogni mostra realizzata è una rivoluzione,' ovvero le esposizioni sironiane e l'immaginario Fascista," in *Mario Sironi 1885-1961* (Milan: Electa, 1993), 48. Sironi then went on to flip the equation, acknowledging that the reverse was also true: "Each revolution realized *is* an exhibition."

29 Peter Wollen, "Introduction," in Lynne Cooke and Peter Wollen (eds.), *Visual Display: Culture beyond Appearances* (New York: New Press, 1998), 10.

30 This combination whiffs of paligenetic Fascism, from the Greek "born again." It's a "paradoxical connection between . . . backward-looking ideology and forward-gazing modernity." Fiss et al. explore how this as a way of reliving glories of the past into the future, so society appears modern even when it contains all the aspects of Jeffrey Herf's "reactionary modernism": anti-intellectualism, anti-urbanism, and hero-worship. *World's Fairs*, 109–14.

31 Sophie Lissitzky-Küppers, *El Lissitzky: Life Letters Texts* (Greenwich: New York Graphic Society, 1968), 85, which reproduced numerous reviews from 1929 including from *Nouvelles litteraries*. *Paris-Midi* also stated that the Soviet Pavilion "wields the strongest power of attraction for the public," and according to the *Yorkshire Evening News*, "Pride of place must go to the outstanding Russian exhibit." Lissitzky-Küppers, *Life Letters Texts*.

32 Emily Braun, *Mario Sironi and Italian Modernism: Art and Politics under Fascism* (Cambridge: Cambridge University Press, 2000), 142.

33 Namely Olivier Lugon, "Neues Sehen, Neue Geschichte: László Moholy-Nagy,
 Sigfried Giedion und die Ausstellung *Film und Foto*," in Werner Oechslin und
 Gregor Harbusch (eds.), *Sigfried Giedion und Bildnsenierungen der Moderne Die
 Fotografie* (Zurich: gta Verlag, 2010), 88–105.

34 *New Vision* was the title of the 1930 English translation of László Moholy-Nagy's
 1929 Bauhaus book *Von Material zu Architecktur* (*From Material to Architecture*)
 (Munich: A. Verlag, 1929). Prior to this translation, in May 1929, Moholy-Nagy
 used the term "neue Sichten," or "new sight," in the didactic text accompanying the
 introductory room of *Film und Foto*. See "Werkbund-Ausstellung 'Film und Foto,'
 Stuttgart 1929," *Photographische Industrie* 27 (August 28, 1929): 911.

35 Andrés Zervigón, "The Peripatetic Viewer at John Heartfield's Film und Foto
 Exhibition Room," Conference paper presented at *Exhibition as Medium*, Harvard
 University, March 8–9, 2013.

36 Christopher Phillips, "Resurrecting Vision: The New Photography in Europe
 between the Wars," in Maria Morris Hambourg and Christopher Phillips (eds.),
 The New Vision: Photography between the World Wars (New York: Metropolitan
 Museum of Art, 1989), 93. However, 1931 was also the year that a component of
 Fifo traveled to Tokyo, leaving a lasting impression on photographers there, so the
 New Vision's influence continued to spread, even as it waned in Germany. See the
 discussion of *Fifo* in Japan, and the translation of *Malerei, Photographie, Film*, into
 Japanese in 1930, in Anne Tucker, *The History of Japanese Photography* (Houston:
 The Museum of Fine Arts, 2003), 145–6.

Last Stop before Photofascism

Activist Photo Spaces and the *Exhibition of the Building Workers Unions*, Berlin, 1931[1]

If on previous occasions, the viewer marching past the picture-wall was lulled [. . .] into a certain passivity, now our design should make the man active. This should be the purpose of the [exhibition] room.

—El Lissitzky (undated typescript)

The BWU exhibition was an example of precisely the opposite of what is offered in the rest of this book: it exemplified the possibility of exhibitions that educated the populace about complex economic ecosystems—in a dynamic way—rather than manufacturing compliance about a reductive set of principles. Particularly through the use of haptic devices and viewer control systems, BWU represents more of an authentic bottom-up model than a veiled top-down, and therefore subverts the surveillance-like "exhibitionary complex" evident in the rest of the displays in this book.[2]

Indeed, this overlooked exhibition should become more of a touchstone of thwarted experimental techniques, on par with Lissitzky's *Pressa*.[3] BWU as a case study reveals the complex circumstances embedded in a transitional moment of exhibitionary practice, one that paralleled one of the most incendiary political transformations of the twentieth century. It was a transformation whereby the year 1931 turned out to be pivotal.

The Political at BWU

The journal *Soziale Bauwirtshaft* (*Social Construction*), published by the VsB (the Association of Social Construction Companies), provided an introduction

to the *Bauausstellung*, the sprawling *Building* exhibition encompassing the BWU and various other displays, by giving some dry, basic facts. The text then provided an enormously detailed and surprisingly engaging guide to the one-room BWU display within. The fact that the BWU room was highlighted above others in the article was not surprising, given the mutual job of the journal and the show to espouse the position of the trade unions, a group assumed to be aligned with the political left. The VsB had many berths devoted to its enterprises at the BWU, and co-existed with those of several other building union organizations, including the *Baugewerksbund* (Building Workers Association), the Roofers Association, and *Dewog* (finance union enterprises). The societal urgency expressed in this publication for a strong free trade union movement was palpable. Indeed, the organized labor movement would become, especially in 1932 and early 1933, the final political bulwark against the vicious assaults of the National Socialists.

Eighteen months before Hitler assumed the German chancellorship, the organizers of the *Bauausstellung* were still convinced of the self-evidence of collective—rather than autocratic—prescriptions for the economic malaise racking Germany. Otto Rode included a manifesto-style list that equated the workers' enterprise with that of "economic democracy." Through the mounting of the larger exhibition, this was realized as a kind of spatial manifesto. His list advocated the myriad ways that trade unions held a special place in the economy:

> 1) The lost war in the consciences of the workers elevated responsibility for the state and economy [. . .]. 2) The workers desire [. . .] economic democracy through responsible participation in the production process and fair distribution of labor. 3) The working man should [be] in the future not only the object but also the subject of the economy. 4) The free trade unions have taken up this idea and organized.[4]

Thus workers were considered essential to the functioning of the economy and its future recovery. Up until that point, the article addressed the social importance of architectural developments in general. Rode's spatial manifesto then switched specifically to the BWU exhibition and the central position of the workers and unions who make buildings "happen." The purpose of the construction unions was emphasized as serving the community, building the character of the public sector union members, and raising the standard of living of workers. The text then described specific sections of the BWU display that keyed into installation shots. Rode summarized the purpose of the show at the end of his article as one of both showing accomplishments and searching for new forms of expression in the areas of a social economy. It concluded with a list of credits for Gropius,

Bayer, and Moholy-Nagy.[5] Taken together, the different parts of Rode's article in *Soziale Bauwirtschaft* created an inextricable connection between the enterprises of artists and those of workers.

Prelude to BWU: *The Deutscher Werkbund Exhibition*

Bayer shared many of the enthusiasms of the New Vision. He laid the foundation for his radical photo exhibition designs at BWU the year before when he designed, among other sections, the photography display for Germany's contribution to the *Exposition de la Société Des Artistes Décorateurs* in Paris in 1930. The German entry was organized by the Deutscher Werkbund, and officially called *Section Allemande*, but it was essentially a Bauhaus exhibition.[6] Due to the fact that it was partly organized by four famous Bauhaus artists (Gropius, Bayer, Marcel Breuer, and Moholy, all of whom left the school in 1928), the Werkbund exhibition was the beginning of a developing implication that the Bauhaus's best years were behind it and that these were the "geniuses" who should define what it had been, despite the school staying open until 1933. It can thus be read retroactively as a staging ground for the iconic Bauhaus exhibition at the Museum of Modern Art (MoMA), New York, in 1938.

These facts have led the Werkbund exhibition to become canonical in the emerging scholarship on exhibition cultures. But when compared to the truly radical innovations and fusions of photo/text/physicality of BWU of the following year, the Werkbund show appears less ambitious. True, Bayer's jutting wire suspension supports for the photographic blowups were masterful and highly innovative (see Figure 6.1, top). Yet niche after niche of the BWU demonstrated a desire to not just use these techniques to celebrate or promote a single organization, but to truly stimulate the mind through using the eye and the hand. The designers promoted deep thought about real issues and problems and through that process espoused a political position—that unions are beneficial institutions, that workers should join unions, that the public should support unions—by using radically non-conventional photographic practice.

Photo Display and Lissitzky at the BWU

BWU was installed in one large room, 900 square meters, and, as mentioned, part of a much larger, sprawling exhibition: the *Deutsche Bauausstellung* (the German Building Exhibition), held at the Ausstellungshallen am Funkturm

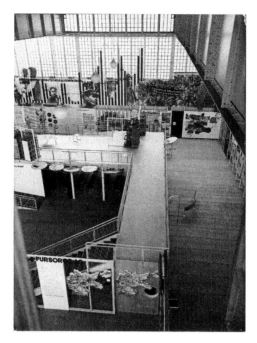

Figure 1.1 Herbert Bayer, Walter Gropius, László Moholy-Nagy, *Exhibition of the Building Workers Unions* (1931), installation view. Photo: Walter Christeller, courtesy Bauhaus Archiv, Berlin. Bayer: © 2020 Artists Rights Society (ARS), New York / VG Bild-Kunst, Bonn. Gropius: © 2020 ARS, New York / VG Bild-Kunst, Bonn. Moholy-Nagy: © 2020 Estate of László Moholy-Nagy / ARS, New York.

in Berlin, from May to August in 1931 (Figure 1.1). The intended audience for the *Deutsche Bauausstellung* was a general one, and the purpose was interpreted at the time as one to "give over to the general public new ideas and new architectural thinking."[7] Organizers achieved this through a large variety of display rooms. In addition to the BWU, thematic rooms included subjects ranging from urban planning and housing to issues of rural settlements. The organizers, at least according to the reception from socialist-leaning quarters at the time, considered buildings as amalgams capable of summarizing many of the current economic problems facing Germany, as well as the most fruitful solutions to those problems:

> Five million unemployed. Loss of sales markets. Idleness in all industries. Collapse, hunger, poverty. The best heads are looking for a way out, a valve, which could ease the mental and physical pressure. We know that economic, social, cultural and political aspirations hang together to form a unit. [...] Which is better suited to identify society, the social, economic and technical context that the new liberating ideas can produce, as the general house, the building?[8]

In other words, as the social, cultural, and political aspirations "hang together," they form a dynamic cluster. In the case of the *Deutsche Bauausstellung*, a locus of these forces that could help understand how they functioned productively together was "the building." And in the case of this specific exhibition within, the BWU, the locus was those who build, that is, the men and women who contributed their efforts as roofers, painters, bricklayers, etc.

As with the documentation of many historical exhibitions, there is an acutely repetitive nature to the way this exhibition has been presented in previous scholarship. Until the publication of the Jorge Ribalta's *Public Photographic Spaces* (2008)—when mentioned at all—the same aerial views of the Gropius-designed upper ramps were usually the only ones reproduced of this exhibition, sometimes with one or two additional close-ups.[9] However, the Bauhaus Archiv in Berlin has a deep well of documentation relating to this particular display, one which allows for one of the closest possible readings of Bauhausler engagement in fusing Russian Constructivism—which by 1921 advocated that Soviet artists would work on utilitarian projects—and the New Vision photography to create a dramatic and daring integration of photos, physicality, and information. A clearer linkage than has previously existed is needed between the most radical—and particularly the most radically haptic—of the Constructivist spatial designs of Lissitzky, Bayer and Moholy's appropriation and transformation of those designs. There has been ample research on the often-frosty relations between Lissitzky and Moholy, particularly in the photographic sphere.[10] Much has also been written on the touch-feel nature of Lissitzky's innovations, some of which will be discussed below. However, previous Bayer/Moholy analyses tend to emphasize *visually* stimulative innovations in their exhibition designs. BWU demonstrated just how far the Germans, not just the Russians, were evolving in the tactile direction through the early 1930s.

The crowd-frieze on the upper level of the ramp of BWU established a clear connection to Lissitzky's lauded photo-fresco for the *Pressa* exhibition in Cologne three years earlier, *The Task of the Press Is the Education of the Masses* (1928), which was 11 feet high and 72 feet wide. If standing on the left side of the BWU frieze, one could see the way large boards were placed, one in front of the other, to form the montage, a similar technique to Lissitzky's. Those were then montaged over the huge graph that collided with it from the left, with large photographic blow-ups of individual workers related to the Baugewerksbund and the Roofers Association. An individual worker figure was cut out to loom overhead, seeming to almost hold the slogan that juts out on an actual three-dimensional flag: "The construction industry is a key industry! It also provides bread for the other branches of industry." (Figure 1.2)

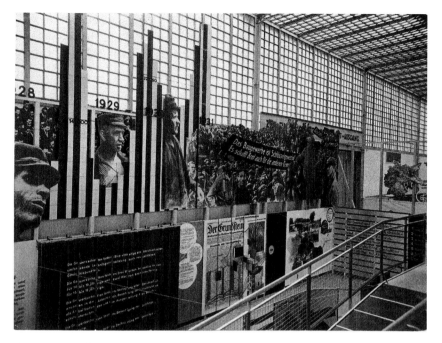

Figure 1.2 Herbert Bayer, Walter Gropius, László Moholy-Nagy, *Exhibition of the Building Workers Unions* (1931), installation view. Photo: Walter Christeller, courtesy Bauhaus Archiv, Berlin. Bayer: © 2020 ARS, New York / VG Bild-Kunst, Bonn. Gropius: © 2020 ARS, New York / VG Bild-Kunst, Bonn. Moholy-Nagy: © 2020 Estate of László Moholy-Nagy / ARS, New York.

Another Lissitzky-influenced moment of this dual-level display at the BWU involved the use of multipart photo printed boards, or "laths," on the bottom level. The use of vertical laths on the background walls in Lissitzky's earlier exhibition space for the *International Art Exhibition* in Dresden (1926) formulated the crux of his attempt to visually activate the spectators of the show. This design approach used laths painted white from the left, and black from the right, on a gray wall. In Lissitzky's words, when "the pictures appear on white, black or grey—they acquire a threefold life."[11] This was Lissitzky's method of transferring a certain amount of control over the viewing experience to the spectator:

> With every movement of the spectator in the room the impression of the walls changes—what was white becomes black and vice versa. Thus an optical dynamic is generated as a consequence of the human stride. This makes the spectator active.[12]

Thus spectators became like actors on the stage—in plays of their own making. It is, in many ways, a Brechtian impulse. Berthold Brecht posited that his interactive

forms of epic theater turned "the spectator into an observer, but arouses his capacity for action."[13] And on the intellectual level of *Verfremdunseffek*t (or alienating effect), "human social incidents" are portrayed as something "that calls for explanation, is not to be taken for granted." There is a productive give-and-take between the viewer and the information.[14]

The manner of the laths' installation at BWU clearly relied on Lissitzky's viewer-response theories and demonstrated his unmistakable influence on the BWU. The laths were located below and left from the large horizontal frieze of the Baugewerksbund. Enough of the image from each side is readable in the installation shots to see that in the center were a group of men cutting bricks; when the viewers moved to the left they saw a man standing in front of a pile of bricks; when the viewers moved to the right, they saw another set of smiling workers, this time facing forward (with one of the workers from center photo just visible). Lissitzky defined this effect as the "optical dynamic" or "play of the walls."[15] The control that the viewer would have maintained over the

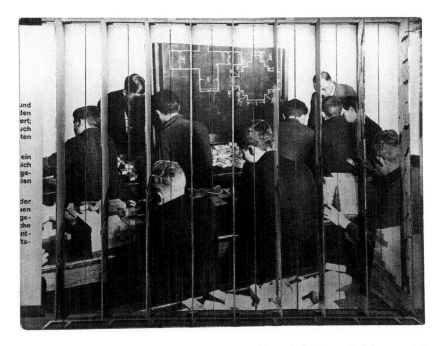

Figure 1.3 Herbert Bayer, Walter Gropius, László Moholy-Nagy, *Exhibition of the Building Workers Unions* (1931), installation with frontal view of slats. Photo: Walter Christeller, courtesy Bauhaus Archiv, Berlin. Bayer: © 2020 ARS, New York / VG Bild-Kunst, Bonn. Gropius: © 2020 ARS, New York / VG Bild-Kunst, Bonn. Moholy-Nagy: © 2020 Estate of László Moholy-Nagy / ARS, New York.

visual experience of a photo-frieze construction like this actually exceeded the 1928 *Pressa* frieze and referred back to Lissitzky's radically activated spaces from 1926 to 1928, which also involved touch-and-feel elements, such as support systems for paintings that could be moved around by visitors (Figures 1.3–1.5).

It is undeniable that Lissitzky desired and succeeded with the lath and moving wall system in transferring a substantial amount of experiential control from the artists and organizers to the viewers, and the influence of that earlier-developed system bears itself out in these photo displays in the BWU space, where prints were sliced in deference to a dynamic viewing experience and where the viewers could become like "actors in the space."[16] The moving louvers that made up the lower-level photo-fresco were apparently mechanized and rotating, which accounts for how there could be yet a fourth surface—a black background with white writing visible.[17] So some viewer control was ceded here to mechanization. Yet people could still choose to see different photographs in the selection depending on where they were standing and move slowly or rapidly from side to side to form different images for themselves.

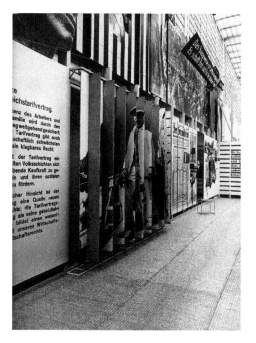

Figure 1.4 Herbert Bayer, Walter Gropius, László Moholy-Nagy, *Exhibition of the Building Workers Unions* (1931), installation with left view of slats. Photos: Walter Christeller, courtesy Bauhaus Archiv, Berlin. Bayer: © 2020 ARS, New York / VG Bild-Kunst, Bonn. Gropius: © 2020 ARS, New York / VG Bild-Kunst, Bonn. Moholy-Nagy: © 2020 Estate of László Moholy-Nagy / ARS, New York.

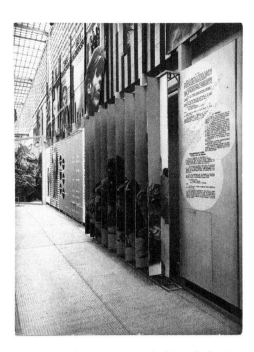

Figure 1.5 Herbert Bayer, Walter Gropius, László Moholy-Nagy, *Exhibition of the Building Workers Unions* (1931), installation with right view of slats. Photos: Walter Christeller, courtesy Bauhaus Archiv, Berlin. Bayer: © 2020 ARS, New York / VG Bild-Kunst, Bonn. Gropius: © 2020 ARS, New York / VG Bild-Kunst, Bonn. Moholy-Nagy: © 2020 Estate of László Moholy-Nagy / ARS, New York.

Through the encouragement of spectator movement, Lissitzky fully embraced the desire on the part of the Russian formalists such as Viktor Shklovsky to create what Eleanor Hight summarizes as "an attack on human complacency" in the viewers of images,[18] a position advocated by the German New Vision artists. Referring to Lissitzky's quote in the opening paragraph of this chapter, related to making the spectators "active," he goes on to state how those viewers were also "physically *compelled* to come to terms with the exhibited objects," and that is in relation to his 1926–8 moving picture frame systems, which created visitors-as-curators.[19] In those systems, viewers could choose to cover one work while examining another. Moholy and Bayer embraced this direct physicality in their designs, but to an extent rarely seen until BWU. German Dadaists certainly delved into the linkages of the haptic and the revolutionary impulse earlier, as explored by Walter Benjamin in his paralleling of tactility and shock.[20] But the New Vision artists like Moholy and Bayer, underscored by the very name of their artistic movement, were more often associated with purely vision-based innovations. At BWU, they pushed beyond visuals into the haptic, an audience

stimulant that later "Photofascist" displays would either eliminate or exert control over.[21]

In various other areas of the room, display functions fully engaged the modality of touch or juxtaposed touch experiences with heightened visual stimuli (Figures 1.6 and 1.7). An interactive poster display related to *Bauhütte*—the builder co-ops grouped under the umbrella of the VsB—allowed for intense handling and the satisfaction of re-curating.[22] Eighty pullout info-posters of the various *Bauhütte* were arranged inside a large metal frame, so visitors could view and read at their leisure. Above the *Bauhütte* posters, disks with printed photographs stimulated the visitors' eyes while they were shuffling through the posters. The "photo-disks" on the left included a painter of exteriors, the metal of the pole holding up the disk merging with the window frames he was depicted as painting, resulting in a *trompe l'oeil* viewing experience. Viewers would move from receiving straight information to seeing more propagandistic quotes, often diagonally arranged in large-scale typography, trumpeting the achievements

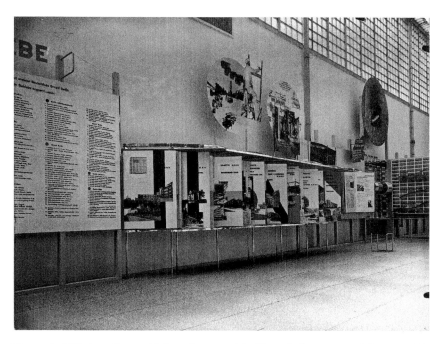

Figure 1.6 Herbert Bayer, Walter Gropius, László Moholy-Nagy, *Exhibition of the Building Workers Unions* (1931), installation view. Photos: Walter Christeller, courtesy Bauhaus Archiv, Berlin. Bayer: © 2020 ARS, New York / VG Bild-Kunst, Bonn. Gropius: © 2020 ARS, New York / VG Bild-Kunst, Bonn. Moholy-Nagy: © 2020 Estate of László Moholy-Nagy / ARS, New York.

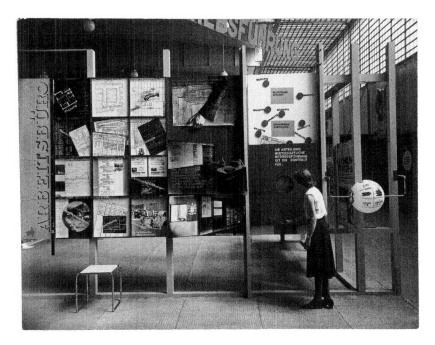

Figure 1.7 Herbert Bayer, Walter Gropius, László Moholy-Nagy, *Exhibition of the Building Workers Unions* (1931), installation view. Photos: Walter Christeller, courtesy Bauhaus Archiv, Berlin. Bayer: © 2020 ARS, New York / VG Bild-Kunst, Bonn. Gropius: © 2020 ARS, New York / VG Bild-Kunst, Bonn. Moholy-Nagy: © 2020 Estate of László Moholy-Nagy / ARS, New York.

of the VsB ("100,000 Dwellings, or 1/10 of Berlin"). Installation shots indicate that many of the displays depended on such interactivity, such as that of a demonstration in the *Arbeitsbüro* (workers' office) display where an unknown woman uses moveable elements, buttressed on her left by photographs of the offices as well as informational panels.

In the *Soziale Bauwirtschaft*, Otto Rode posited that the manner in which the entire *Bauausstellung* was installed encompassed a kind of "situational awareness" (*Situationserfassung*),[23] one that "throws the question to the viewer: How can today's economic condition be managed?"[24] The crucial difference between "simultaneous collective reception"—to borrow a term from Walter Benjamin via Benjamin Buchloh (1984)—and situational awareness seems to be heavy reliance on hegemonic visuals versus a more dynamic engagement with the haptic. Situational awareness in the BWU exhibition demanded participation from multiplicity of the viewer's senses concurrently, including touch, sight, and even sound from the rotating panels. But in this case, the goal was not just to engage the viewer in avant-garde art by persuading touch (as with Lissitzky's 1926 installation at

Dresden); it was to engender awareness of practical problems that needed solving. To repeat from the guide cited earlier in the chapter: How will today's economic condition be managed? This was an attempt at multisensory empowerment, ideally leading to the active support of unions. According to another article in the *Soziale Bauwirtschaft* journal by Helmut Niendorf, the audiences were, in a sense, bifurcated: the unions could speak to their members about services available to them and concurrently speak to the broader audience about how the unions contributed to society through participation in economic activities.[25]

New Vision at the BWU

As Bayer explained to his biographer about the BWU, "[m]any new techniques were developed for this project."[26] The BWU constituted a particularly dynamic fusion of New Vision and Constructivist influences, including Lissitzky's aforementioned practices. Those constructivist elements integrated with German New Vision photography and design techniques to create intensely potent moments throughout for the spectator. In addition to the haptic/touch opportunities within the show, suspended photo-disks popped up below the viewer's feet at several points, providing surprises (Figure 1.8).

The New Vision proponents like Moholy believed that such unexpected viewpoints in photographs would lead to deeper engagement in whatever it was that was depicted, similar to Shklovsky's call for anti-complacency. As Moholy said of one of his own strangely angled photographs, "[f]ormerly regarded as distortion, today a startling experience! An invitation to re-evaluate our way of seeing. This picture can be turned around. It always produces new vistas."[27] In the case of the BWU photo-disks, the viewers could physically turn *themselves* around (witness the visible foot in the installation shot Figure 1.8) and evaluate these strange images from different perspectives. What they were actually seeing here were prescriptions for addressing worker's injuries, first aid options, and the types of environments in which first aid should be administered. In effect, this display moment exemplifies the avant-garde's willingness at this point in the history of exhibition design to put their most experimental techniques at the service of the most mundane details of everyday life. The result would presumably be an informed and sympathetic public, as well as a working class more informed about their options and services available to them.

Bayer provided firm connections between constructivist public spaces and New Vision–inspired spaces, as did Moholy-Nagy in his organizational role at

Figure 1.8 Herbert Bayer, Walter Gropius, László Moholy-Nagy, *Exhibition of the Building Workers Unions* (1931), installation view. Photo: courtesy Bauhaus Archiv, Berlin. Bayer: © 2020 ARS, New York / VG Bild-Kunst, Bonn. Gropius: © 2020 ARS, New York / VG Bild-Kunst, Bonn. Moholy-Nagy: © 2020 Estate of László Moholy-Nagy / ARS, New York.

Fifo. He had direct exposure to Lissitzky's work at *Pressa*, where he himself was put in charge of a small, little-discussed, and, according to him, conventional book display. By that point Bayer had mostly distinguished himself as the director of print and advertisements at the Bauhaus from 1925 to 1928. Lissitzky's innovations of multidirectional display, however, genuinely excited him. His related all-seeing eye, part of a perceptual graph he developed for the *Deutscher Werkbund* exhibition print materials in 1930, reappeared in morphed form in one of the BWU displays, about the system for auditing financial transactions at the VsB. The eye was a key icon for him in the quest to demonstrate how the field of vision in an exhibition space could be expanded. Rather than across the usual centerline, why could one not view displays above and below? Particularly if the images jutted into one's visual sphere, rather than just hung in a flat salon-style? This iconography was repeated in his 1937 article "Fundamentals of Exhibition Design." Pages 23–5 of the original document show three different ways that the perceptual sphere can be expanded: with the eye moving up and down, with the

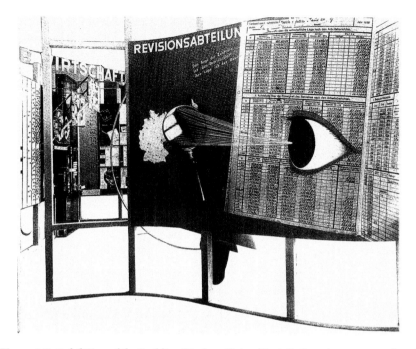

Figure 1.9 *Exhibition of the Building Workers Unions'* installation view, as reproduced in *Soziale Bauwirtschaft* (June 8, 1931): 177.

designer expanding the potential space both up and down, and with 180 degrees (Figure 1.9).

But there were key differences in the emphases of the Werkbund exhibition versus BWU, as one sought to promote a group of artists and the other to promote labor unions. As the BWU and its umbrella exhibition were posited to be for the general public, one must be reminded of the *perceived* challenge of creating a potentially exciting/inciting experience for all, given the dense and highly specific nature of some of the material in the BWU show, as characterized by Alexander Dorner:

> As there [were] a lot of statistical materials, diagrams, etc., which did not lend itself [*sic*] to interesting pictorial treatment, the designers applied animation, moveability, peepholes, walls opening up and closing, transparencies, etc., and encouraged the visitor to move things himself by pressing buttons to light up the display material, etc. Giant photographs and montages were used extensively, as well as all available materials like glass, metal, chromium, etc. From the bridge, display material was laid out so that it could be looked at by leaning over the rail.[28]

In other words, visitors might not assume to be enraptured by the more didactic information, as supportive as they might be of construction workers. Yet, once

there, as they were presented with so many stimulating haptic and near-haptic choices, as well as options to control the material, the information likely would have become more engaging. People did not just see facts about the various *Bauhütte*, but they saw those facts while pulling out posters and flipping them over; they saw changing documents as the woman pulling the lever did; and in another installation shot not reproduced here, an unidentified man stood in front of a display of images explaining how organizational changes had improved the VsB, turning the images like a wind-up toy. All of these acts encouraged viewers to experience bureaucratic institutions in a more empowering way, the opposite of the hegemonic effect. This again recalls Shklovsky's stimulation through "defamiliarization."[29] Exhibitions, particularly interactive ones, have a decided advantage in defamiliarizing because of this three- and four-dimensional experience. Diving down experientially deeper, one might imagine that the viewers here, as result of the diversity of techniques outlined above, were given an experience that, in effect, aped the work that the laborers were involved in making, creating, and constructing. For Shklovsky, this active impulse could reverse an individual's propensity toward stagnation, including stagnation of knowledge. In Eleanor Hight's commentary about Shklovsky's theories, "defamiliarization became associated with revolutionary struggle"[30] starting in the late 1910s. While the haptic version of defamiliarization has been substantively explored in relation to Soviet visual art—especially vis-à-vis Lisstizky—it should be remembered that the German artists were also exploring this in a deep and substantive way until they were stopped in the early 1930s.[31]

Chaos Tamed[32]

A close analysis of the timeline of the early 1930s should remind one of how high the stakes were in trying to maintain mass enthusiasm and support for labor unions at displays like the BWU. The organized labor movement as distributed between the Social Democrats (or SPD) and the Communist Party (or KPD) could still be effective—even while under systematic attack by the Nazis[33]—until shortly before the Hitler chancellorship began in January 1933. For example, in 1932 the leftists successfully repulsed an assault by the storm troopers against working-class residential districts, club premises, and workers organizations and meetings.[34] Even immediately post chancellorship, the unions were considered by the Nazis as the final frontier of resistance, and were subject to arrests, intimidation, and the frequent occupation of their premises by brownshirts.

However, the left's inability to unite for longer-term goals, and their lack of a full understanding of the Nazi threat, hobbled them. The esteemed German historian Detlev Peukert described this period of 1930–2 as the "the reversion to authoritarianism," characterized by the weakening trade unions, suppression of collective wage bargaining, and marginalization of the Social Democratic Party:

> The trade unions [. . .] were paralyzed as an anti-Fascist force. The employers' campaign, falling membership and high unemployment had all reduced their capacity for action, and the weapon of the general strike, which had been wielded successfully back in 1920, had become of questionable usefulness. The formation of the Hitler cabinet [. . .] provided the labor movement with a last chance of issuing a call for collective action [. . .] but by now the leaders of the KP, the SPD, and the General German Trade Union Federation had become resigned to the outcome.[35]

In fact, the unions had become so focused on strict self-preservation that they agreed in 1933 to help coordinate a Nazi idea of taking May 1 off as a national holiday for the first time.[36] On a messaging level, this allowed the Nazis to conflate nationalism and labor in the mind of the populace. On a practical level, it assisted the Nazis in their devious and methodical plan to take over each of the trade union offices simultaneously the very next day. Brownshirts were installed in each of the offices, and those offices were immediately absorbed into the Nazi hierarchy. Goebbels wrote in response his diary on May 3: "It all goes like clockwork."[37]

That eerily au courant reality of systematically weakening unions—considering similar attempts to suppress the activity of labor unions in the United States today—brings to bear the contemporary urgency of understanding an exhibition like BWU, which took place right at the crucible of the years of conservative rise in Germany.

Another means to illuminate this particular exhibition as a climax before the denouement is to turn to Jeffrey Schnapp's summation of how public spaces were expanded and reshaped in the 1930s to contain mass audiences.[38] First, public spaces increased the prevalence of statistical data and visualizations as a means of mass persuasion; numbers count "as never before" and are translated visually as bar charts, graphs, and tables—and this is an apt description of BWU. But secondly, he theorized that those spaces intensified the cult of singularity as masses look for direct connections with authority figures; architecture is "summoned" to provide the needed stage set. And thirdly, the spaces translated the interplay between hero and masses: this became a hallmark of Hitler and Mussolini-orchestrated display environments. Schanpp summarizes this final

tendency: "In the 1930s, larger than life becomes everyday life."[39] BWU, however, negated the "cult" of singularity associated with these final two formulations through its foregrounding of collectivity. Within all the anonymous photography, the only blown-up figures were workers, that is, at BWU the heroics still lay strictly in a plurality of workers, not within a singular cult personality. Schnapp's points address what those spaces *would* become as the 1930s progressed, but at the time of the BWU in 1931, they had not yet arrived. By the time of *Die Kamera* in 1933, those spaces had arrived.

Awareness into Action

Despite its inherently anti-Fascist messages and methodology, BWU garnered attention in the Italian press as an important exhibition even while Mussolini was still in power, for example, in Giuseppe Pagano's extraordinary and richly illustrated special issue on exhibitions in *Casabella-Costruzioni* in 1941.[40] In recent literature it has been largely relegated to mentions in Bayer's monographs. It warrants a more prominent place in photography's histories, and in the history of experimental exhibition design, as a key segue between Lissitzky's accomplishments beginning in the mid-1920s and the disintegration of those experiments under Fascism. Lissitzky had aspired to wring people out of experiential passivity through his self-named "demonstration" rooms. By the early 1930s, Moholy and Bayer were integrating his moving elements, lath systems, and haptic opportunities into their already-established New Vision innovations of jarring perspectives. The Nazis then cherry-picked, smoothed out, and perverted the techniques of photo blowups and montages, ridding themselves of much of the diversity of scale, playful ruptures in experience, and the intimacy of the touch-feel niches in favor of the singularity of the monumental and the scopic, although the 1937 exhibition *Give Me Four Years* would become an exception to some of these tendencies, as shown by Michael Tymkiw's recent book *Nazi Exhibition Design and Modernism* (2018). Photography historian Ulrich Pohlmann has analyzed how photographic scale and viewpoint assisted the Nazis in conveying their odious ideology:

> Under National Socialism, exhibitions became the ideal stage for presenting constructed realities. Thus, for example, it must not be forgotten that the visual depiction of political mass demonstrations was left to the official visual media, whose photographic overviews were produced from carefully selected vantage points high above the crowd and usually did not reflect the perspective of the

participants. At exhibitions that were popular mega-events in their own right, these mass demonstrations could be relived. The visitors' senses were subjected to a totalitarian form of theatrical direction that turned an imaginary reality into a permanent condition with the help of photography and its ability to generate room-filling panoramas. In these giant photographs, the political "movement" became a monument; life as a historical event petrified into a metaphor for eternity—at least for the duration of an exhibition.[41]

The Nazi use of large-scale photography was dominated by the visual and the passive—the "scopic" as Fiss has called it—and the physical engagement of viewers with substantive information was replaced with petrification. The latter effectively functioned as the opposite of Rode's situational awareness as he defined *Deutsche Bauausstellung* in *Soziale Bauwirtschaft*: that the exhibition as constituted as a whole would throw questions to the viewer of how economic conditions should be managed. Such questioning implies a process of self-examination, with solutions hopefully to be found within a dynamic collective. This process was not of interest to the Nazis.

In sum, BWU as a case study reveals the complex circumstances embedded in a transitional moment of exhibitionary practice, one that precisely paralleled one of the most incendiary political conversions of the twentieth century. First Lissitzky and then Moholy and, for a time, Bayer were in pursuit of a visual equation: the one that would lead to a more aware populace, yes, but also a more active populace, one that would organize and define itself through the collective. Why? Because the political consequences were so significant. *BWU* proves the ambition that indeed existed for substantive political engagement to take place through the most radically experimental of photo-based spaces; just, achingly, not quite enough. Despite Germany's tragic failure in early 1930s to maintain a society with power invested in the collective, it was not a foregone conclusion. The injection of the haptic in public spaces at that moment was not simply for idle experience or entertainment—as one often sees today[42]—but for individual and collective empowerment beyond the immediate sphere of the specific space. The physical choices made available to the attendants of BWU crystallized the political options that were about to be revoked in Germany. In Italy, that had long since been the case.

Notes

1 Portions of Chapter 1 were originally published in Vanessa Rocco, "Activist Photo Spaces: 'Situation Awareness' and The Exhibition of the Building Workers Union

(Berlin, 1931)," *Journal of Curatorial Studies* 3, Issue 1 (2014): 26–48, doi: 10.1386/jcs.3.1.26_1.

2 "Exhibitionary Complex" is a chapter title in Tony Bennett's book *Birth of the Museum* (Routledge, 1995). Barbara Kirshenblatt-Gimblett then updates the idea and applies it to more contemporary contexts in her essay "Exhibitionary Complexes." *Museum Frictions: Public Cultures/Global Transformations*, eds. Ivan Karp et al. (Durham: Duke University Press, 2006), 36–45.

3 BWU is starting to gain traction as a touchstone exhibition. In addition to this author's aforementioned essay, Patrick Rössler has recently published Patrick Rössler, "Die Ausstellung als begehbares Informationsdesign. Das Bauhaus und die Präsentation der Baugewerkschaften auf der 'Deutschen Bauausstellung' 1931," in Hellmuth Th. Seemann and Thorsten Valk (Hrsg.), *Entwürfe der Moderne. Bauhaus-Ausstellungen 1923-2019* (Göttingen: Wallstein, S., 2019), 173–95.

4 Otto Rode, "Bauausstellung und Bauhüttenschau," *Soziale Bauwirtschaft* (June 8, 1931): 169.

5 Rode, "Bauausstellung," 178.

6 Paul Overy, "Visions of the Future and Immediate Past: The Werkbund Exhibition, Paris 1930," *Journal of Design History* 17, no. 4 (2004): 337–57.

7 Rode, "Bauausstellung," 163.

8 Rode, "Bauausstellung," 163.

9 For an exception, see Olivier Lugon, "La photographie mise en espace: Les expositions didactiques allemandes," *Études Photographiques* 5 (1998): 97–118.

10 Lissitzky wrote a letter dated September 15, 1925, claiming to have introduced Moholy-Nagy to camera-less photography, which he and Lucia Moholy disputed. See Lissitzky-Küppers, *Life Letters Texts*, 66–7. Victor Margolin has documented the relations between the two men in interwar Germany vis-à-vis Constructivism in *The Struggle for Utopia* (Chicago: University of Chicago Press, 1997), 44–79.

11 Sophie Lissitzky-Küppers, *El Lissitzky: Life Letters Texts* (London: Thames and Hudson, 1968), 366.

12 Lissitzky-Küppers, *Life Letters Texts*, 366.

13 See reference to Brecht in fn 53.

14 Perhaps even more on point vis-à-vis touch-and-feel impact is Anthony Squiers, who frames the phenomenology of Brecht as attempting to "change relations of objects. . . . He tries to present objects in a way which forces the audience to relocate them in the web of relation they use to understand the world around them." *An Introduction to the Social and Political Philosophy of Bertolt Brecht: Revolution and Aesthetics* (Amsterdam: Brill/Rodopi, 2014), 144. Many thanks to Shawn Powers for this reference.

15 Lissitzky-Küppers, *Life Letters Texts*, 366. For an extensive discussion of the history of Lissitzky's development of wall constructions that change with the viewer's position, see Maria Gough, "Constructivism Disoriented: El Lissitzky's Dresden and

Hannover Demonstrationsraume," in Nancy Perloff and Brian Reed (eds.), *Situating El Lissitzky: Vitebsk, Berlin, Moscow* (Los Angeles: Getty Research Institute, 2003), 97–107.

16 Gough, *Situating El Lisstizky*, 123, n80.

17 Ulrich Pohlmann, "El Lissitzky's Exhibition Designs: The Influence of His Work in Germany, Italy and the United States, 1923–1943," in Margarita Tupitsyn (ed.), *El Lissitzky: Beyond the Abstract Cabinet: Photography, Design, Collaboration* (New Haven: Yale University Press, 1999), 60.

18 Eleanor Hight, *Picturing Modernism: Moholy-Nagy and Photography in Weimar Germany* (Cambridge, MA: MIT Press, 1995), 198.

19 Lissitzky-Küppers, *Life Letters Texts*, 367.

20 Walter Benjamin, "The Work of Art in the Age of Its Technological Reproducibility," 1936 in Michael W. Jennings and Howard Eiland (eds.), *Walter Benjamin: Selected Writings, Volume 3 (1935–38)* (Cambridge, MA: Harvard University Press, 2002), 119.

21 The importance of "touch" to maintaining an active participatory role has been explored vis-à-vis Lissitzky's spaces most effectively by Gough, "Constructivism Disoriented," 114. She recounts the filmmaker Dziga Vertov visiting one of the Lissitzky spaces with the vibrating laths, as well as vitrines with turn options and painting frames that could be moved—the *Abstract Cabinet* in Hanover—and describing the feeling as one of "groping" around—implying that he both lost himself, but was concurrently reminded of his own corporeality.

22 My thanks to Dara Kiese for her assistance in clarifying the role of the co-ops.

23 This term, sometimes translated as "Situation Awareness," is also used to describe airplane flight training simulations and other military exercises.

24 Rode, "Bauausstellung," 177.

25 Helmut Niendorf, "Die freien Gewerkschaften auf der Bauausstellung," *Soziale Bauwirtschaft* (June 8, 1931): 179–81.

26 Arthur Cohen, *Herbert Bayer: The Complete Work* (Cambridge, MA: MIT Press, 1984), 364.

27 Moholy-Nagy, László, *Painting, Photography, Film*, trans. Janet Seligman (Cambridge, MA: MIT Press, [1927] 1969), 61.

28 Alexander Dorner, *The Way Beyond "Art": Problems in Contemporary Art: The Work of Herbert Bayer* (New York: Wittenborn, Shultz, 1947), 205.

29 Viktor Shklovsky, "Art as Technique," in Lee T. Lemon and Marion J. Reis (eds.), *Russian Formalist Criticism, Four Essays* (Lincoln: University of Nebraska Press, [1917] 1965), 3–24.

30 Hight, *Picturing Modernism*, 198.

31 The haptic as catalyst for action is clearly also related to Bertholt Brecht's Verfremdunseffekt, or alienation, in epic theater, which "turns the spectator into an observer but arouses his capacity for action." John Willett, ed., *Brecht on Theater: The Development of an Aesthetic* (New York: Hill and Wang, 1964), 37.

32 Buchloh, citing Kemp, discusses how Nazi organizers of *Die Kamera* compared their "calm" and "unproblematic" montages with the Russian's "confusion." Buchloh, in Ribalta (ed.), *Public Photographic Spaces*, 57.

33 For a detailed timeline of Nazi aggression against labor unions, see Richard J. Evans, *The Coming of the Third Reich* (New York: Penguin Press, 2004), 355–7.

34 Detlev Peukert, *The Weimar Republic*, trans. Richard Deveson (New York: Farrar, Straus, and Giroux, 1989), 268.

35 Peukert, *Weimar Republic*, 258 and 269.

36 Aside from the theories of complacency, inability to cooperate with Social Democrats, or self-preservation, Erich Fromm theorized that although the German working class in the 1930s voted left, many of them were simply not willing to fight aggressively for the ideals of that political position, surprising their more radical leaders. Erich Fromm, *Escape from Freedom* (New York: Rinehart, 1941), 280–1.

37 *Goebbels' Diaries*, ed. Elke Froehlich, 32 vols. (Munich, 1993-2008), cited in Peter Longerich, *Goebbels: A Biography* (New York: Random House: 2015), 222.

38 Jeffrey T. Schnapp, "Projections (Some Notes on Public Space in the 1930s)," in Jordana Mendelson (ed.), *Encounters with the 30s* (Madrid: Museo Nacional Centro de Arte Reina Sofia, 2013), 34.

39 Schnapp, "Projections," 38.

40 Romy Golan led me to this invaluable resource. Giuseppe Pagano, ed., "1925-1940," *Casabella-Costruzioni*, special double issue, no. 159–60 (March–April 1941): 34–6.

41 Ulrich Pohlmann, "'Not Autonomous Art but a Political Weapon': Photography Exhibitions as a Means for Aestheticizing Politics and Economy in National Socialism," in Ribalta (ed.), *Public Photographic Spaces*, 298.

42 See Judith H. Dobrzynski, "High Culture Goes Hands-on," *New York Times Sunday Review* (August 11, 2013): 1, 6–7. Kirchenblatt-Gimblet also explores the obsession with multisensory stimuli in contemporary display spaces in "Exhibitionary Complexes," 38.

"Acting on the Visitor's Mind"

The *Exhibition of the Fascist Revolution*, Rome, 1932[1]

Il Duce gazes up (Figure 2.1) at some part of the exhibition room—one can't be sure of which. He appears concurrently transfixed and aroused. Seeming bureaucrats, mostly in suits, surround him. The exhibition still looks to be in mid-installation, with a worker in the lower left corner, standing near a ladder and pointing upward. The photographs are montaged everywhere; on the surface, they are documentary style, but are punctuated by non-photographic structures of Mussolini's favorite motifs: swords, monumentalized men in action, and the Italian word for war—*Guerra*. Mussolini likely understood in this moment that the key combination of perceived "fact-based" documentary photographs, with his preferred Fascist messages embedded within intimidating architectural/ sculptural structures, will act most productively upon the future spectators' minds. It is the essence of the hegemonic message: manufacturing inspiration.

Cold Politics/Hot Revolution

While Hitler's Nazi party was still struggling after gaining and then losing seats in the Reichstag, the *Mostra della Rivoluzione Fascista* (Exhibition of the Fascist Revolution, or MRF) was inaugurated at the Palazzo delle Esposizioni in Rome on October 28, 1932. It was an elaborate ruse created to celebrate the tenth anniversary of Benito Mussolini's "March on Rome" and the completion of the Fascist Revolution in Italy. In fact, his official rise to power in 1922 was more cold politics than hot revolution: anticipating the imminent bloodshed in an urban battle between the state's army and Mussolini's thuggish Black Shirts— who had been inciting deadly political street violence for years[2]—King Vittorio Emmanuelle III concocted a compromise allowing Mussolini to ascend legally to the post of prime minister. Not only that, but Mussolini's audacious terms

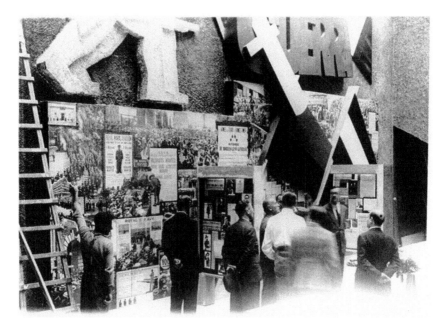

Figure 2.1 Il Duce visits the works for the preparation of the *Exhibition of the Revolution*, Sala A, 1932. © Archivio Centrale dello Stato (ACS), Fondo MRF (Aut. 1593/2019).

of forming his own government were met. A planned attack on Rome became instead a highly choreographed parade of Black Shirts for the purpose of showing unity between Mussolini and the King, who observed the parade together.[3]

Mussolini's desire to solidify his more glorious notion of violent revolutionary ascension in the minds of the masses propelled the *Mostra* event forward. In this exhibition, Il Duce's mastery of aestheticized politics would reach its apotheosis, as the mass-media forms of documentary photography, illustrated magazines, and poster sloganeering were married to grandiose architectural forms, simultaneously to overwhelm the visitors and falsely convince them of their part—that is, that they actually played a role—in a larger, sanctified narrative. Thus the exhibition designers succeeded in infantilizing the audience through techniques of immersion. And the size of the audience experiencing this phantasmagoria should not be underestimated: it reached nearly four million during its two-year run, no less than 10 percent of the entire Italian population, epitomizing the perversion of what Buchloh has clarified as the formerly Benjaminian leftist concept of "simultaneous collective reception."[4] To place in perspective, it is the current attendance equivalent of thirty million-plus Americans all experiencing the same cultural event, which only happens

regularly in our now-fragmented society on the occasion of a major awards show, the Super Bowl, or the opening weekend of a comic book film.[5]

This exhibition has been oft-written about from different perspectives, and scholars such as Marla Stone, Jeffrey Schnapp, and Romy Golan will be cited. The difference here is establishing a specific genealogy: showing the perversion of those leftists techniques represented by the BWU at the *Mostra*, and the source of inspiration the *Mostra* in turn provided to the Nazis in the quest for cultural hegemony. This will entail exploring rooms in the *Mostra* beyond the usual ones analyzed (by the scholars above), as well as the rarely analyzed 1937 and 1942 reiterations of the show in later chapters of the book.

The Organization of the *Mostra*

The *Mostra* was the brainchild of Dino Alfieri, who was serving as president of the National Fascist Institute of Culture when he conceived the project. It was initially intended as a 1929 exhibition to mark the decennial of the first *fascio di combattimento* (the founding Fascist cells of 1919), but gradually the value of marking the decennial of the March on Rome and its attendant nationalizing myths emerged. Alfieri established headquarters at the Palazzo delle Esposizioni on the Via Nazionale, in the center of Rome, and assembled a curatorial team. Each room would be the domain of one artist and one "historian." The historians were not academics, but rather old guard Fascists. The artists, in contrast, were not required to have the same strict Fascist pedigrees; so—perhaps surprisingly— many of the most experimental painters and architects of the time were selected for the visual realization of the exhibition, including several established Futurists.[6] The plan included a sequence of fifteen rooms running counterclockwise along the periphery of the building on the ground floor (*Terreno*), charting Fascism's development chronologically from 1914 to 1922 ("Sala's" or Rooms A to Q).[7] In the center were the purely thematic and non-chronological rooms (R through U): the Salon of Honor, Gallery of the Fasci, The Room of Mussolini, and the Altar of Martyrs. In addition were rooms numbered 1–5, on the first floor (*Primo* or *Superiore*), denoted as *bureaucratic rooms*.[8]

In planning the exhibition, Alfieri engaged in another bold and unconventional practice: he put out a national call for relevant objects and ephemera (documents, pamphlets, photos, and clippings related to the movement's ascent) to be included in the displays. He thus involved the masses directly in telling what they thought of as their story of the new national history, with the anonymity of the

photographers working in a very different way than the principle of collectivity at BWU. The *Mostra* was a brilliant demonstration of Gramsci's principle: the hegemonic power harnessing the interests and enthusiasms of the subjugated in order to engineer consent. Diane Ghirardo succinctly summarizes this effect as one where the "bold avant-garde graphic and architectural language . . . usurped potential competing interpretations of the events recounted by the sheer force of their presence."[9]

Amazingly, the closing date for submissions was just one month before the opening of the exhibition, and nearly 20,000 artifacts were received from local party offices around the country, collected from individuals and organizations alike.[10] On a practical level, this meant working around the clock, and may explain why some rooms had a more haphazard sensibility than others. The rooms that did succeed on a visual level—and which will now be discussed at length—were masterful at conveying a hegemonic message.

Most previous visual analyses of the *Mostra* have been architecturally based, focusing on the most audacious constructions: on the façade of the four *fasci* designed by the young architects Mario De Renzi and Adalberto Libera; the neon-lit, circular Altar of Martyrs created by Libera and Antonio Valente; and in particular the Sala O by Giuseppe Terragni.[11] Those that have explored the uses of photography have also understandably focused on Terragni's daring integration of dynamic architectural forms that jutted aggressively in and out of the viewer's perceptual space with enormous photo-enlargements in Sala O.[12] In addition to an analysis of Sala O, this chapter will give lesser-explored rooms equal billing, particularly those that actively foregrounded photography and photomontage such as rooms A, G, P, and number 1. These also encompassed experimental permutations of photography and architectonics, and showed the extent and rapidity of the Italian Fascist absorption of avant-garde display techniques from abroad, many of which were discussed in Chapter 1. Spin-off MRFs in 1937 and 1942 will be analyzed in later chapters.

Salas A, G, and #1: Notions of Documentary

On entering the *Mostra* visitors were guided to Sala A, dedicated to the First World War and entitled "Conflagration of Europe/Foundation of the 'Italian People.'" The artist Esodo Pratelli and the historian Luigi Freddi organized the collaboration of design and intellectual material. Tensions existed here, as in most rooms, between a drier, more familiar historical presentation of material—

traditional glass-encased wall vitrines containing photos and clippings—and more dynamically composed murals. One mural, below the gigantic caption "1914" combined interlocking triangular wall panels with straight documentary photos of the war front (Figure 2.2). A larger corner mural, entitled "The Impact of Armies," juxtaposed an abstracted pair of soldier's boots stomping down on multiple photomontaged images of soldiers and citizens, with many of the abrupt ruptures, overlaps, and clashing perspectives associated with 1920s' Soviet photomontage and typified by Lissitzky's photofrieze at *Pressa* and the worker montage at BWU.

The dominant mural of the room was to the right of the "Armies" corner: the vastness of this montage vis-à-vis human scale is quite clear in the opening documentary photograph of Il Duce himself being given a tour. Huge letters spelling *Guerra* (War) rake across the center, with the diagonal image of a sword slicing through the middle of the letter G. Constructed Masonite soldiers goose-march above the *Guerra* on either side, and diagonally raking flags anchor the rest of the mural, which contains a swirl of international draft posters. The posters were montaged with documentary images of the mobilizations in France, Russia, and Britain, partially contained on architectural structures jutting out at right angles from the mural. This was a way to envelop the viewer within a

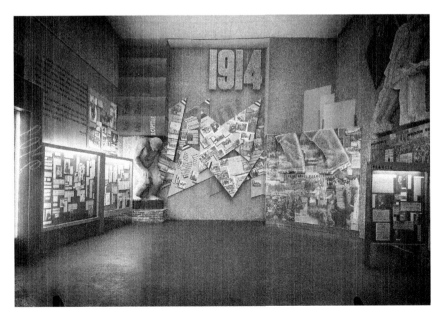

Figure 2.2 Sala A of the *Exhibition of the Fascist Revolution*, 1932. © ACS, MRF, fasciolo 1 (1932), Scatola 202, neg. # 36 (Aut. 1593/2019).

photographic structure, a similar design plan to the one used more masterfully by Lissitzky in *Film und Foto* where he used a skeletal wooden structure.[13]

The stated goals of Sala A in the official guidebook demonstrate the organizers' perception throughout the *Mostra* of the intense visual and propagandist power inherent in combining architectural elements with photographic ones, an opportunity afforded by the exhibition format. That "the *documentary material* . . . was to be implanted architectonically with unchallenged domination over every other element" and that the documents would therefore work a "suggestive, vital and emotional acting on the visitor's mind."[14]

It is essential to see what one might consider a contradiction in terms here: in the opinion of the *Mostra* organizers, items that were considered "documentary" in nature would be in a stronger position to work themselves upon the visitors' minds (and souls) in specific ways than other types of images, and those ways would be emotional not cerebral. In other words, what was generally being established—in that era of the late 1920s and early 1930s[15]—as the very definition of documentary as neutral and recounting facts was used at the *Mostra* for the opposite purpose of manipulating facts. This may have been perceived as a successful strategy by the Fascists because of a more pronounced acceptance of the "truth value" of photography at the time. Clearly, among photo-historians and beyond, a critical view has developed of the truth claim in the last two generations, and whole bodies of literature have been written to quibble with it, rightly so.[16] Nevertheless, in 1932, it is likely that many observers would still have had a default position more akin to the renowned film critic Andre Bazin who famously wrote in 1945 that photography = "resemblance."[17] Undoubtedly the Fascist organizers of MRF were counting on most visitors holding that position. Even a sophisticated practitioner like the pioneering Soviet photomonteur Gustav Klutsis stated in 1924, when espousing the replacement of graphic design elements with photographic elements: "What this replacement means is that *the photographic snapshot is not the sketching of a visual fact, but its precise record. This precision and documentary character of the snapshot have an impact on the viewer that a graphic depiction can never attain* (italics in the original)."[18] It appears that he had strong feelings about truth value in photography. This journal and its later incarnation, the Novyi LEF, were influential journals beyond the Soviet Union, particularly among popular writers in Germany, so the reach of these theoretical constructs was significant.[19]

The organizers were clearly convinced that architectural elements would work productively to manipulate the viewer's perception of photographic elements or, as Gramsci might phrase it, "educate" the consent.[20] Sculptural

elements with photographic embeds could be equally manipulative: not as physically enveloping as large-scale architecture, but still imposing and just as insidious.

Sala G, designed by Marcello Nizzoli and Dante Dini, focused on the year 1919 and the founding of the aforementioned *fasci di combattimento*, which Mussolini created as a "logical continuation of the war years and the battle for renewal."[21] The material was presented on a more human scale than the explosive and fragmented mural style used in A, O, and other rooms. But in certain ways its appropriation of avant-garde techniques was even more direct, particularly in its application of crowd photographs, facial close-ups, newspaper clippings, and typopgraphy (including the words "movimento dei combattenti") directly onto constructed humanoid figures. Lissitzsky employed an almost identical type of montaged figure in the *Pressa* exhibition (Figure 2.3), and again it must be underscored that Sironi, with so prominent a role at MRF, was also a designer at *Pressa*.[22] The human body has been taken over and is now literally comprised of image, text, and propaganda. But the crucial difference between Sala G and Lissitzky's "factography"—the dynamic use of documentary imagery—which worked to engage the viewer was the presence of the larger figure echoed on its left by three smaller montaged figurines, giving the sense of a leader with his minions following. All three have their right arms jutting outward, with two of the three holding objects that clearly denote weapons (Figure 2.4). Hence, a figure that had been formed in Lissitzky's design to resemble a worker, with one hand raised in a solidarity sign and the other holding a lunch pail, has for *Mostra* been armed and morphed into a group of obedient soldiers. The hope of an activated worker in the first version has been militarized in the Italian Fascist version.

The anthropomorphic features extended to other parts of the room (Figure 2.5). In a dramatic example, this highly simplified, angular board cutout juts an "arm" upward, covered with the slogan *Proletari, Siate Uomini E Non Mandre Umane!* The translation is "proletarians, be men and not human herds!"—ironic as the center square making up the body of the figure is filled with an amorphous mass of men waving an Italian flag. The only other component making up the inside of the figure is a cropped, squared-off image of Mussolini comprising the head. The arm gesture echoed the one made by Mussolini in a photo blowup perpendicular to the figure, under the large caption "Congresso Fascista," ostensibly creating an image of Mussolini as a leader addressing the minions, while concurrently placing Il Duce's head on the mockup of an everyman. There is perhaps no better way to win—and more

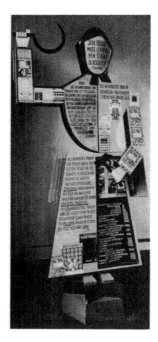

Figure 2.3 El Lissitzky, *The Press and the Soviet Woman*, from the *Pressa* exhibition, Cologne, 1928. © 2020 Artists Rights Society (ARS), New York.

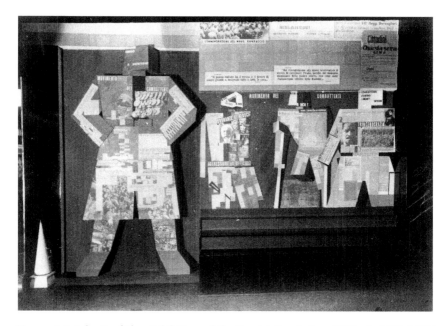

Figure 2.4 Sala G of the *Exhibition of the Fascist Revolution*, 1932. © ACS, MRF, fasciolo 1 (1932), Scatola 202, neg. #110 (Aut. 1593/2019).

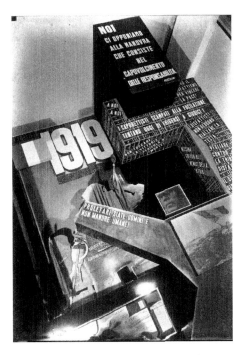

Figure 2.5 Sala G of the *Exhibition of the Fascist Revolution*, 1932. © ACS, MRF, fasciolo 1 (1932), Scatola 202, neg. #113 (Aut. 1593/2019).

importantly maintain—the acquiescence of the subjugated than to role-play that "I am one of you."[23]

Schnapp has been at the forefront of exploring the psychological dynamic created by this visual interrelationship between Il Duce as individual and the masses, both in the exhibition spaces and in the study of illustrated magazines. In the large-scale foldouts of the premier Fascist magazine *Rivista Illustrata*, there were "seemingly infinite multitudes rallying around a visible or invisible leader."[24] Schnapp evocatively refers to this mode of imaging mass crowds as "oceanic": "moments of collective fusion within the framework of the political sublime." This is one of the modes for, deftly phrased by him, "imag(in)ing the formation of the body politic." Why is this mode also applicable to the spatial elements in Sala G? There existed the possibility of the exhibition visitor standing—literally—between the visible leader and an echoed bodily formation of him filled with multitudes. Therefore the visitor is absorbing the *imaged* body politic and can concurrently, and easily, *imagine* himself both waving the flag with his brethren and listening to Il Duce as if part of the audience of the speech, reaching a doubly exalted state of the sublime.[25] Any imag(in)ing taking place

IL 1921

Il 1921 è veramente l'anno che determina il trionfo del Fascismo e la decadenza del Socialismo. Conquiste fondamentali da parte fascista sono: l'adozione di un preciso e completo programma economico sindacale, l'enorme sviluppo dei Fasci che al Congresso di Roma sommeranno a 2200, il successo nelle elezioni politiche che portano alla Camera 50 dei 100 candidati Fascisti, con a capo Mussolini; la trasformazione del movimento in Partito. Nel campo avverso si hanno invece i due congressi di Milano e di Livorno che frantumano il Pus in centristi, unitari, massimalisti e comunisti, con relativa espulsione delle prime tre formazioni dalla Internazionale comunista.

Il Fascismo è tuttavia braccato dagli avversari, che ricorrono all'eccidio come arma abituale; l'anno è contrassegnato infatti dai più sanguinosi conflitti che tutto il periodo del dopo-guerra ricordi: Empoli, Sarzana, Modena, Valdottavo, Casal Monferrato; e dai più spaventosi massacri: quello di Giovanni Berta, quello del Teatro Diana a Milano, con 21 morti e centinaia di feriti, quello di Cittadella, dove, per colpa delle

Pezzo per pezzo si monta la statua dell' " Italia Armata ", dello scultore Marini.

Le sagome ideate dal pittore Nizzoli per la seconda sala del 1919 hanno ancora un aspetto fantomatico.

— 24 —

Figure 2.6 Sala G of the *Exhibition of the Fascist Revolution* (from Alfieri and Freddi, *Mostra*, 24), 1932. Collection Archives, Harry A.B. & Gertrude C. Shapiro Library, Southern New Hampshire University, Manchester NH. © ACS, Fondo MRF (Aut. 1593/2019).

while experiencing a two-dimensional magazine would likely be heightened and magnified by the three-dimensionality of an exhibition space. Not only that but scholars have the benefit of seeing the incredible scale of this figure—as it was being constructed—with workmen standing next to it, a "phantom appearance," as Alfieri describes it, reproduced in the original MRF catalogue (Figure 2.6).[26]

Other fascinating combinations of photography and graphic design dotted the show. This was in line with the Soviet-developed concept that design elements would always be more convincing if embedded with photography due to the injection of realism, as evidenced by Klutsis's earlier quote. The difference—at least in the early years of Soviet design—lies the intent behind the impact on the viewer. Rather than a didactic goal, the Fascists used that impact to engineer consent among the subjugated.

A striking example existed in Sala #I, the section (called #1a in Alfieri's catalog) devoted to Fascists abroad (Figure 2.7). A rough-hewn drawn Madonna figure holds her child aloft over montaged documentary photographs of actual crowds and Roman architectural masterpieces. She strides over the diagonal tag line in all capital letters *SONO OGGI FIERI E FEDILI GLI ITALIANA ALL ESTERO*

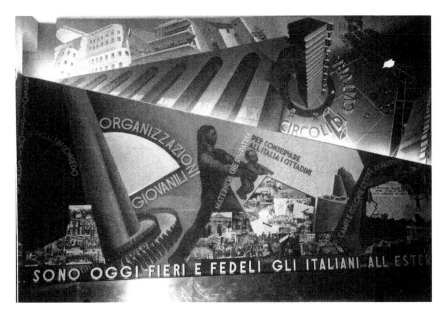

Figure 2.7 Sala 1 of the *Exhibition of the Fascist Revolution*, 1932. © ACS, MRF, fasciolo 1 (1932), Scatola 203, neg. # 249 (Aut. 1593/2019).

(today here are the proud and faithful Italians abroad). Cartoonish, futuristic-looking structures align the top register over her head. It's as if the city of the future hovers the great city of the past, with the future generations anchored in between. Thus the designers accomplish that always-needed feat in Fascist propaganda of making people feel nostalgia and progress at precisely the same moment, with the added punch of religious archetypes. This fusion perfectly fulfills Paxton's criteria for Fascist messaging: progressive techniques/reactionary messages. Only here, futuristic and reactionary messages were co-mingled. Sala 1's other walls were likewise covered with murals, with a continued use of aggressive three-dimensional sculptures popping off the walls, such as a set of three hunched workers under a traveling slogan of those leaving their native villages (Figure 2.8), appearing downtrodden that they must emigrate. As the slogan says, these are the "emigrants without names" who "enrich the countries of others." A dichotomy is created between the past, where the Italian poor were forced to emigrate, and the present, where emigrants become proud carriers of the story of Fascism and Mussolini's success. In the middle of the room containing these sculptures, a bronze sculpture with Mussolini's head sticking three-dimensionally out of a slab was placed, looking unnervingly like a death mask. Subsequent areas in the room include informative maps pinpointing where emigrants abroad were going.

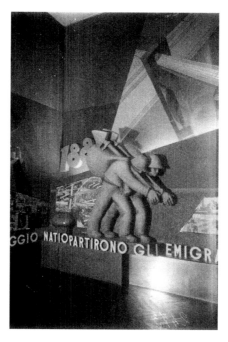

Figure 2.8 Sala 1 of the *Exhibition of the Fascist Revolution*, 1932. © ACS, MRF, fasciolo 1 (1932), Scatola 203, neg. # 248 (Aut. 1593/2019).

Sala (Rooms) O & P: "Shock and Awe"

The direct appropriation of Lissitzky's *Pressa* design mentioned in Sala G above is less surprising when one remembers that Mario Sironi, designer of Sala P, organized the Italian Pavilion at *Pressa*, and thus had firsthand knowledge of Lissitzky's innovations. Although it is clear how much the Italians learned from Soviet design, throughout the *Mostra*, particularly in Sala O, socialism would be consistently vilified. In addition to whole-scale room arrangements—such as that of knives piercing Socialist flags in Sala O as discussed later—there were individual pieces of ephemera that people could experience in a more one-to-one manner such as the poster "Se il gigante si ferma" or, essentially, "The Giant Stops." This directly links stark Communist iconography such as the hammer and sickle, doubling as the sunrise in background, with laziness, work stoppage, and economic interruption. An exaggerated, muscular, and therefore clearly able-bodied railroad worker ceases manual labor to take a siesta while the masses are crushed.[27] Strike-related imagery was particularly fertile for Italian audiences; they had a dramatic recent strike history including what was known as Bienno

Rosso (two red years). It culminated in 1920 with mass factory occupations whereby workers locked themselves in and ran factories themselves; 500,000 alone in Turin, capital of Italian car production. There was rioting and looting in addition to strikes, an anathema to shopkeepers in the North. The middle-class audiences being shipped in to the *Mostra* from the tourist agencies were likely receptive to the "lazy" message.

Sala O was the climactic moment of the visitors' trip through these outer-periphery rooms. Along with historical contributions by Arrigo Arrigotti, Terragni, a 28-year-old wunderkind and proponent of the Rationalist movement in Italian architecture, which merged International Style tenets with fierce nationalist aims, designed it. Sala O was devoted to the key year of Mussolini's consolidation of power, 1922, but its historical program ended before the actual March on Rome. The room was an integration of architecture and photography of such rich and dense complexity that it has been routinely singled out from the rest of the MRF for analysis. As espoused by Herbert Bayer's 180- and 360-degree perception graphs, and applied by Lissitzky in the 1930 *International Hygiene Exhibition*, Terragni set out to stimulate the viewer's senses from all angles. This included the core organizational element of the ceiling, which contained a room-long, criss-cross X (roman for ten and a prevalent icon throughout the show). It was covered in the flags of the Socialist and Anarchist parties antagonistic to Fascism that were nailed into place with daggers, symbolizing—with a lack of subtlety characteristic of this room—the defeat of those last opponents to Fascism (Figure 2.9).

Following the trajectory of one side of this X, the right side, a wall unfolded with an enormous tripartite profile of Il Duce. Looking as if it had been roughly hewn, pharaoh-like, from granite, but actually outlined in metal, it threw off a large shadow due to its three-dimensionality. Diagonally slashing slogans abutted the profile, including one touting the "Organization of the Forces of the Young." The profile "looks" toward a photo enlargement, again plastered on the wall on a diagonal, of one of the Roman-columned buildings upon which Mussolini preferred to make his speeches, in front of massed crowds (see Figure 2.9 on the upper right). As Schnapp has pointed out, emblems such as architectural sites, ruins, churches, and squares were routinely used to anchor the oceanic crowd scenes that Mussolini loved to reproduce in the popular press like the aforementioned *Illustrata Rivista*. Those scenes consoled the viewer with the negation of an amorphous, unruly crowd and the presentation of an orderly *national* crowd, "shaped by a sense of place and tradition."[28]

Crowd photographs played an even larger role in the area of Sala O most widely written about: the mural running under the left side of the X, see again

Figure 2.9 Sala O of the *Exhibition of the Fascist Revolution*, 1932. © ACS, MRF, fasciolo 1 (1932), Scatola 203, neg. #172 (Aut. 1593/2019).

Figure 2.9, with its airplane turbines constructed of photographs of the mobs who assembled in the days leading up to the March on Rome, and the hugely enlarged handwritten words of Mussolini, quoting poet Giosuè Carducci: "'those who oil the wheels of motion with blood' achieve the supreme goal: the greatness of their Homeland."[29] This area forms a central part of Buchloh's critique of how the progressive and dialectical Soviet factography, such as that displayed by Lissitzky at *Pressa*, was taken over for the purposes of "prescribing the silence of conformity and obedience" inherent in later Stalinist-condoned photo weeklies, Nazi displays, and at the *Mostra*.[30] Terragni effectively masked the totalitarian aims here behind the notion of technological progress, a favorite trope of Italian Fascism inherited from Italian Futurism. Indeed, the "progress" associated with inventions like the automobile had been equated with wars, explosions, and the metal of shrapnel since the very first Italian Futurist Manifesto by Marinetti.

At the tail end of the X trajectory was a display of several newspaper enlargements, including one of *Il Popolo d'Italia*, ensconced within metallic wall covering, jutting out at dynamic angles.[31] The industrial material of metal sheathing evoked the nearby turbines, and in installation shots looks starkly modern even by today's standards, reflected in the shiny surface of the dark floor.

This emphasis on not only new formal elements but also new materials like metal and steel was key in Mussolini's mind as he stated in the MRF guidebook: "Make it new, ultramodern and audacious therefore, free from melancholic echoes of the decorative styles of the past."[32] Progressive techniques, but again with those regressive messages of nationalism embedded within. Metallic metaphors were a particular favorite of Mussolini's, even used to describe why he chose to call his thugs *combattimenti* instead of something else: "in this hard and metallic word there was all the program of fascism, the way I dreamt of it, the way I wanted it."[33] As mentioned in the Introduction, Sironi had used enlargements of *Il Popolo* in metallic vitrines several years earlier, but had nowhere near the design acumen of jutting directly into the viewer's space of the Terragni Sala O.

In addition to these monumental architectural gestures, various niches created their own tour de force of architectonic photography, achieving the goals laid out for Sala A in the guidebook to act on the viewer's mind. One niche presented a massive "metal man" surrounded by sloganeering against the paralyzing strikes that were blamed on the Socialist trade unions, thereby repeating the "lazy" message. Coming out of the niche, the towering letters spelling out the Italian for "legalist strike" (*Sciopero legalite*) formed a huge web above, which was described as wrapping "itself around the nation," suffocating the economy.[34] This area again included Il Duce's favorite visual flourish, massive crowd scenes montaged upon one another to evoke the sense of an oceanic mass. In this case they hovered above cartoon-like constructed metal flames licking up toward them, along with headlines about the burning of the Socialist newspaper *Avanti*'s headquarters, a cause célèbre of the Fascists (Figure 2.10). On April 15, 1919, two subsets of the Fascists burned down the headquarters in Milan, which Mussolini claimed was "spontaneous"; three years later, after the March on Rome, it happened again.[35] The headlines in this niche were repeated over and over again, with the prominent *Avanti*'s masthead and the byline about the fire. Those repeated flowery mastheads were wedged under an aggressive, sans-serif slogan jutting in a perpendicular manner into the viewer's space, screaming out "The Conquest of Palazzo Marino and the Fall of the Socialist Municipalities."

All of these spaces show the extent to which the photographic "document" can be used to promote almost any message if constructed in certain ways within dynamic and physically imposing elements, including sculptures, architecture, and architectonic-like captions. And how the medium's presence was thought by organizers to increase the conviction with which the crowd might receive that message.

Figure 2.10 Sala O of the *Exhibition of the Fascist Revolution*, 1932. © ACS, MRF, fasciolo 1 (1932), Scatola 203, neg. #170 (Aut. 1593/2019).

Terragni's strategy here is akin to the affection the Futurist artists in general had for the military theory of "shock and awe" first strike, mass aerial attacks. Pioneered by the Italian commander Giulio Douhet—not by President George W. Bush—as early as 1909, the crux of the doctrine encouraged mass aerial strikes in order to eliminate stalemates and demoralize civilians. Douhet found the Futurist artists to be "kindred spirits of technological determinism," and actually wrote about them in *Gazzetta del Popolo* in 1914.[36] Although recent scholarly connections between Douhet and the Futurists have focused on airplane pictures (aeropittura), his "war in three dimensions" for the purpose of coercing populations applies evocatively to exhibition spaces such as the *Mostra*; one could argue more so than airplane pictures. Such spaces create surround sound-like sensations, on all four sides of the spectator (up/down/left/right).

The chaotic sensations created by Terragni's dynamics were then cleverly smoothed out by entrance into Mario Sironi's Sala P (Figure 2.11). While Sala A and Sala O's photomontages caught the viewer up in a noisy vortex, P's enormous frieze image of the gathering for the March on Rome—while still montaged—attempted to ease the viewer into quieter submissiveness, and prepared him or

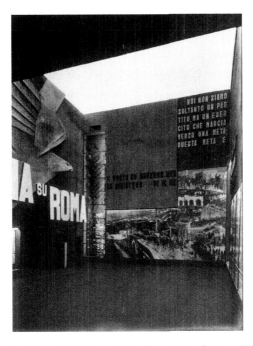

Figure 2.11 Sala P of the *Exhibition of the Fascist Revolution*, 1932. © ACS, MRF, fasciolo 1 (1932), Scatola 203, neg. # 184 (Aut. 1593/2019).

her for the more abstract, less photographic, and sanctified space of the Altar of Martyrs, which would conclude the exhibition. Sala P's enormous photo blowup was a fairly straightforward, three-dimensional experience for the individual viewer with more direct escapist absorption. It combined Roman arch architecture and photographed masses, but most prominently, minions marching through the street in an easily readable diagonal, with a caption above: "We are not just a party but an army that marches towards a goal: this goal." On the wall to the left, a gigantic and aggressively rendered eagle stares transfixed at the frieze, and out of view of this installation shot, huge, three-dimensional chains are broken, with more hovering captions.

It was this type of perspectival photomural in Sala P that the Nazis would use more effectively than radical montaging. Indeed, Goebbels and Goering were noted visitors to the *Mostra*, and an appreciation of the impact of photo-enlargements in architectonic spaces can be clearly discerned in the first Nazi photo show, *Die Kamera*, although most of the applications would be quite different than the MRF.[37] *Die Kamera* would achieve its hegemonic goals through well-ordered images, rather than through the emotionally chaotic reach-outs so prominent in the parts of the *Mostra* other than Sala P.[38]

The exhibition then begins to segue into its closing rooms. Although the focus here will not be heavy on the Altar of Martyrs due to its lack of photographic elements, it is important for understanding the exhibition overall that this altar was the *Mostra*'s ending point. Between the blood-red cross in the middle, the light show all around with "Presente" written repeatedly, and the automated sound effects, this spectacle embodied what Pohlmann aptly described as "a sacred votive room where Fascist ideology and Catholicism melded into a cryptic rite."[39] Yet again, the cross-fertilization from Italy to Germany opened doors. The Nazis would use religious overtones very effectively in many of their designs. In Germany's case, it would be more slyly done: religious references not as overt as in Catholic Rome, but as an undercurrent to bring spectators into an ecstatic state. A case in point will be discussed in Chapter 5 with the altar-like construction of Hall of Honor in *Give Me Four Years' Time*.

One of the most illuminating quotes from a contemporaneous review of the *Mostra* by the influential Fascist cultural critic and Rationalist theorist P. M. Bardi makes it clear why exhibitions were so important to the regime. Exhibitions themselves were considered a new mass medium, in the same category as photography, cinema and radio, all linked and reinforcing one another in a newly '"journalistic civilization," and one can witness here the critic advocating for passivity, advocating for not having to make too much of an effort these days:

> Exhibition technology has assumed a new character. . . . We are in an era in which cinematography has dispensed with the reading of novels, in which the radio brings music into the home . . . the desire not to tire oneself in order to know and to understand . . . such things give our journalistic civilization a morality all its own: the *fashion of the exhibition* is a typically twentieth-century one.[40]

What perhaps chills one most here is the assumption of not wanting to "tire oneself" in order to understand. This critic was supportive of the exhibition, and therefore was celebrating mass media as intentional spoon-feeding; and the *Mostra della Rivoluzione Fascista* was that, no matter how dynamic the design or how often was invoked the image of energized collectivity throughout. Because at its very core, it was an inflexible, top-down message, although cleverly cloaked—which makes it a textbook case of Gramsci's hegemonic, the sly winning over of the subjugated. A more recent attempt to understand the consequences of this interrelationship is undertaken by Nicholas O'Shaughnessy in his book *Marketing the Third Reich*. He refers to it as the "engineering of consent—the troubling matter of how public opinion can be manufactured, and

governments elected, via sophisticated methodologies of persuasion developed in the consumer economy."[41] I would propose that this back and forth was also applicable to exhibition culture, and went beyond persuasion—which inherently implies an authentic debate—and into that matrix where consent mixes with coercion.

These exhibitions were ploys to engineer consent among the public, partly through shock and awe and partly through the snake oil of inclusion: the differentiation of messages to the middle and working classes, in addition to the military. The guidebook may say that the desire was to act upon the viewer's mind in a *suggestive* and vital way, but by the time he or she exited the *Mostra*, little to no room was left for inner dialectics. These well-honed Fascist techniques of visual subjugation would be unnervingly perfected by the German Nazi machine, beginning almost exactly one year after the 1932 opening of the Mostra in Rome.

Notes

1 Portions of Chapter 2 were originally published as Vanessa Rocco, "Acting on the Visitor's Mind: Architectonic Photography at the Exhibition of the Fascist Revolution," in Ribalta (ed.), *Public Photographic Spaces*, 245–55.

2 Simonetta Falasca-Zamponi analyzes the statistics of Mussolini-incited bloodshed, with 500 to 600 dead in the year 1921 alone. However, the number of casualties swells to the tens of thousands when beatings and injuries are included. See *Fascist Spectacle: The Aesthetics of Power in Mussolini's Italy* (Berkeley: University of California Press, 1997), 34, n144.

3 For an excellent recitation of these events, including the surprisingly meek and intimidated response of the King, see Falasca-Zamponi, *Fascist Spectacle,* 1–2.

4 I quote the Buchloh reprint in Ribalta, but an earlier printing was Benjamin Buchloh, "From Faktura to Factography," in Richard Bolton (ed.) *Contest of Meaning: Critical Histories of Photography* (Cambridge, MA: MIT Press, 1989), 49–81.

5 Example figures for recent comic book film openings that I obtained were for "Avengers: Age of Ultron" (2015). It made $200,000,000 in its opening weekend, and if you use average ticket prices of $8.17 (from Box Office Mojo) you get 25,000,000 tickets sold. Without exception, these were considered to be astonishing numbers by those who compiled them.

6 The founder of Futurism, Filippo Marinetti, was a supporter of Fascism in its earliest stages. See latest scholarship on the movement, including its political interests, in Vivien Greene, ed., *Italian Futurism, 1909-1944: Reconstructing the*

Universe (New York: Solomon R. Guggenheim Museum, 2014), particularly the essay by Claudia Salaris, "The Invention of the Programmatic Avant-Garde," 22–49.

7 I will be retaining the word "Sala" to describe the rooms.

8 The ACS website uses Roman numerals I, II, III, IV, V for these rooms. On the floor plan they are clearly listed 1, 2, 3, 4, 5, see Dino Alfieri and Luigi Freddi, *Mostra della Rivoluzione Fascista: Guida Storica* (Bergamo: Italian Institute of Graphic Arts, 1933/reprinted in Milan), n.p. This can be confusing due to Sala I and Roman numeral I looking identical in notation despite being different rooms.

9 Diane Ghirardo, "Architects, Exhibitions, and the Politics of Culture in Fascist Italy," *Journal of Architectural Education* 42, no. 2 (February 1992): 69.

10 Marla Stone, *Patron State: Culture and Politics in Fascist Italy* (Princeton: Princeton University Press, 1998), 137–8, citing Alfieri and Freddi, *Mostra*, 53.

11 Diane Ghirardo edited a special issue of *Journal of Architectural Education* in February 1992 about the *Mostra* that included useful essays on the topic by Libero Andreotti, Schnapp, and Brian McLaren.

12 One exception is Antonella Russo's book, which contains reproductions of other rooms, discussed further below.

13 See illustrations 2–3 in Pohlmann, "El Lissitzky's Exhibition Designs," 55.

14 Alfieri and Freddi, *Mostra*, 72; my italics.

15 Mary Warner Marien, *Photography: A Cultural History*, 3rd ed. (Saddle River: Pearson, 2011), 280. To expand on this, the first generally acknowledged use of the term "documentary" by critic John Grierson was applied by him to Robert Flaherty's film *Monoa* in 1926, so it was fairly new as a discrete concept at the time of the exhibitions in this study. However, a *LEF* article, which will be cited below, had dabbled in the terminology already in 1924.

16 For a rundown of the salient arguments see Tom Gunning, "What's the Point of an Index? Or Faking Photographs," in Karen Beckman and Jean Ma (eds.), *Still/Moving: between Cinema and Photography*, (Durham: Duke University Press, 2008), 23–40, including scientist-philosopher Charles Peirce's indexicality.

17 And therefore frees the rest of the arts from the "resemblance complex." Andre Bazin, "The Ontology of the Photographic Image," in Bazin, *What Is Cinema* (Berkeley: University of California Press, 1967), 13.

18 Christopher Phillips, *Photography in the Modern Era: European Documents and Critical Writings, 1913-1940* (New York: Metropolitan Museum of Art/Aperture, 1989), 211. The italics appear to be by Klutsis. Buchloh's earlier use of this quote in "Faktura" states the attribution as more likely to Rodchenko and has no italics. See "Faktura," in Ribalta (ed.), *Public Photographic Spaces*, 43. Either way, this quote is notable that in both cases it uses documentary=fact, which is usually first attributed to Grierson vis-à-vis film in 1926.

19 Walter Benjamin and Bertolt Brecht were known readers, for example.

20 Gramsci, *Prison Notebooks*, 259.

21 Falasca-Zamponi, *Fascist Spectacle*, 34.

22 Pohlmann's essay "El Lissitzky's Exhibition Designs," made me aware of this similarity to the figures designed for *Pressa* by Mikhail Plaksin; see p. 59, n33. Another montaged figure in *Pressa* was entitled *The Press and the Soviet Woman*, where the figure held a hammer and sickle.

23 As an example, the millionaire-since-birth Donald Trump has perfected this faux-symbiosis with the everyman in our own time.

24 Jeffrey T. Schnapp, "Mob Porn," in Jeffrey T. Schnapp and Matthew Tiews (eds.), *Crowds* (Stanford: Stanford University Press, 2006), 1.

25 Animal research has looked into this through "mirror neurons" research, whereby animals act and observe acts through the same neuron, although the research is still controversial. Thanks to my colleague Dr. Jay Kosegarten, Associate Professor of Psychology at Southern New Hampshire University for bringing my attention to this field research.

26 Alfieri and Freddi, *Mostra*, 24.

27 This striking piece of ephemera is 1 of approximately 20,000 *individual* artifacts documented from the 1937 iteration of the show and in the collection of ACS. While there is no guarantee that "The Giant Sleeps" was installed in 1932, the bulk of the 1937 artifacts certainly appeared there. Twenty thousand artifacts are also the number of objects documented as pouring into the 1932 show's callout for submissions. Stone, *Patron State*, 137–8.

28 Schnapp, "Mob Porn," 20. Schnapp has also described how these "masses" in "constant movement" deny both reflective distance and historical process. See Jeffrey T. Schnapp, "Fascism's Museum in Motion," *Journal of Architectural Education* 42, no. 2 (February 1992): 93.

29 Alfieri and Freddi, *Mostra*, 188.

30 Buchloh, "From Faktura to Factography," 69.

31 Mussolini used the newspaper to trumpet the militaristic positions he supported, beginning in 1914 with exhortations for Italy to join the war.

32 Cited in Schnapp, "Fascism's Museum in Motion," 89.

33 Falasca-Zamponi, *Fascist Spectacle*, 216, n137.

34 Alfieri and Freddi, *Mostra*, 185.

35 Falasca-Zamponi, *Fascist Spectacle*, 34, n141.

36 Emily Braun, "Shock and Awe: Futurist *Aeropittura* and the Theories of Giulio Douet," in Greene, *Italian Futurism*, 269.

37 For a list of other prominent visitors to the *Mostra*, see Antonella Russo, *Il Fascismo in mostra* (Rome: Editori Riuniti, 1999), 48.

38 Those chaotic reach-outs were clearly different than Lissitzky's in that the intent was the promotion of hegemonic violence rather than shock and rupture to promote learning and awareness.

39 Pohlmann, "El Lissitzky's Exhibition Designs," 60.

40 P. M. Bardi, "Esposizioni," *Bibliografica Fascista* (November 1932): 701, cited in Stone, *Patron State,* 128. The excised part of this quote is likewise telling: "Political Representations act as well-chosen cues for artists; the possibilities for realizations are infinite and [the exhibition's] educational effectiveness has been established as solid and practical." Bardi, "Esposizioni."

41 In *Marketing the Third Reich: Persuasion, Packaging, and Propaganda* (New York and London: Routledge, 2018), Nicholas O'Shaughnessy wants no less than to "accord persuasion the status of history's core dynamic," 2. He has chosen to use the evocative word "engineering" of consent, which I have adopted from him. It should be noted that the "manufacture" of consent is an older concept and the subject of a book by Edward S. Herman and Noam Chomsky, *Manufacturing Consent* (New York: Pantheon Books, 1988).

3

Nazis in Ascendance

Die Kamera, Berlin, 1933[1]

Work on people until they accept our influence.
> —Joseph Goebbels, speech to Berlin press, March 1933

(Italian) Fascism is modern and has close ties with the people. We should learn from it.
> —Goebbels, diary entry, June 1933

In addition to the hegemonic statements above, another Goebbels mantra articulates precisely why he considered the camera an ideal tool for constructing hegemonic systems: "The experience of the individual has become the experience of the people, thanks solely to the camera."[2] Photography made it much easier to concoct the fiction of collectivity and belonging to a group effort, even if the actual policies were top-down. One could see oneself—or could more easily imagine oneself—as one among not just dozens but also hundreds or thousands. Films and photographs made this possible, and in the 1930s on a larger scale than ever before.

Goebbels was not at all hesitant about presenting his hegemonic tactics to the press, centered on achieving buy-in from the "people." The day after his appointment as a minister of the Reich, on March 15, 1933, he gave a speech to the Berlin press, where he outlined the mission of his new ministry of propaganda and the goal of the government to no longer "leave people to their own devices":

> Education is essentially passive, while propaganda is active. We can't stop at telling the people what we want to do and informing them about how we're doing it. This information must be accompanied by active propaganda on the part of the government, propaganda aimed at winning people over . . . work on people until they accept our influence, until they begin to grasp in terms of ideas

that what is taking place in Germany does not just *have* to be accepted but that they *can* accept it.[3]

In other words, consent to new policies was the preferred route, before force would even be considered, but they were certainly not mutually exclusive. Eventually, even if people were forced to accept certain conditions, they would likely welcome that force. "Work on people until they accept our influence" is the essential meeting point of the two poles of hegemony Gramsci discussed: consent and coercion. After that press conference Goebbels went to Italy to see the MRF and then wrote the diary quote in the above epigraph.

Political Conditions in Autumn of 1933

Hitler's rise to the chancellorship in January 1933 was followed quickly by an insidious takeover of the labor unions on May 1, smashing the last avenue for mass *political* protest. By October the Editors Law—discussed further below— had guaranteed the infrastructure for Nazi rule of press outlets, squelching the last avenue for *editorial* protest. The result, by autumn of 1933, was an all-encompassing dictatorship "the likes of which had never been seen," which brought all areas of propaganda and culture under central control.[4] The exhibition *Die Kamera,* being mounted in the late autumn of 1933—dramatically rapid for a show of this size—effectively synthesized this omnipresence, as well as the revolutionary fervor of the Reich in the early stages of its official power. Organizers of *Die Kamera* also played a key role in systematically restructuring all domains of photography in Nazi Germany, a structure that would last well after the Nazi period.[5] In keeping with the hegemonic drive, it was imperative that these consolidations all seemed organic.

Exhibition Design from BWU to *Die Kamera*

Bayer provides a case study of photographic exhibition design moving from avant-garde to Fascist. The level of innovation that Bayer demonstrated at BWU in 1931 eventually became problematic for him due to his ongoing obsession with controlling viewers' experience. Leading a viewer to what Bayer called a "planned [. . .] reaction" certainly made his concepts more easily co-optable by totalitarianism. How can one explain the designs of this seemingly left-leaning

figure of the Weimar period ultimately facilitating Nazi propaganda? Perhaps the answer exists somewhere in Bayer's desire and ability to systematize Lissitzky's breakthroughs.

Bayer's biographer Gwen Chanzit has explored the fact that Bayer reportedly found Lissitzky's innovations at *Pressa t*o be liberating, but "chaotic," and saw a clear path to applying a more systematic approach to the Russian's new large-scale montages, anti-symmetrical hangings, and suspension technologies.[6] In the case of Lissitzky's designs like the Dresden laths and the *Pressa* conveyor belts (see Fig. 0.2), that chaos had activating power, power that at BWU in 1931 still had the possibility of subverting any direct control of the viewer's individual physical experience, because the viewer could pick and choose experiences through touch and feel. The *Mostra* was likewise chaotically dynamic, but minus the viewer's choices. Bringing more complete order to the chaos of fragmented, ruptured moments in exhibition design effectively suppressed those very powers of critical distance and active viewer engagement. Ordering the chaos, in effect, shoved many of these techniques into the embrace of National Socialism, especially the desire to map out both the visitor's pathway and his or her perceptual experience.[7] In an extensive article about exhibition design in 1961, Bayer described the design one of his Nazi-era exhibitions, *The Community* in hegemonic terms: "the movement of the public in a planned direction was the central theme of the plastic concept of the exhibition."[8] He never mentions that the National Socialists commissioned this exhibition, in keeping with his long history of denying responsibility for assisting his patrons.[9]

Indeed, the "last great" Bauhausler collaboration of the BWU exhibition was an association that, in Bayer's opinion, held the threat of compromising his self-perceived artistic neutrality in Nazi Germany.[10] It offered affirmative support to some of the major trade union organizations in Germany—unions being one of the first and primary targets of the Nazis. And it did so not only through the powerful display of images discussed in Chapter 1 but through the display of voluminous statistics related to the growth of the building trade unions and their expanding memberships, a level of irrefutable evidence of union strength that the Nazis would likely have found discomfiting.

Bayer was undoubtedly one of the linchpins between the productively radical and the reactionary at this pivotal moment in the history of German photographic exhibition culture. His work in advertising likely pushed him toward the latter and characterized much of the overly didactic design work he later did for the MoMA in New York in the 1940s, including *Road to Victory* and *Airways to Peace*. An excerpt from his "Fundamentals of Exhibition Design"

demonstrates his conflation of "enlightenment, advertising, education, etc." in the use of synesthetic effects. This text is startling in the way he travels with such ominous elegance from the most radical ideas of the leftist avant-garde to the most reactionary desires of the right in the 1930s:

> [T]he theme [of the exhibition] must be clearly expressed [. . .] by means of comparison, survey, sequence, exhibition and representation. The theme should not retain its distance from the spectator, it should be brought close to him, penetrate and leave an impression on him, should explain, demonstrate and even persuade and lead him to a planned and direct reaction. Therefore we may say that exhibition design runs parallel with the psychology of advertising.[11]

Thus the desired destruction of the "aura" of distance—an aura which theorist Walter Benjamin (2002) believed had created an elitist distance between art and its audience—is present in Bayer's text in the desire to destroy that distance, but with an end goal to enforce agreement rather than to engage. It therefore gets closer to Hitler's hypothesis about propaganda in *Mein Kampf*, which also embraces the methodology of selling something:

> All propaganda must be popular and its intellectual level must be adjusted to the most limited intelligence among those to whom it is addressed . . . [it] must be limited to a very few points and must harp on these in slogans until the last member of the public understands what you want him to understand by your slogan.[12]

Recent research in the psychology field—discussed further in the Epilogue—has made much of the fact that the more a piece of information or slogan is repeated, the more it is believed, no matter how counterintuitive. This "illusory truth" concept enjoyed a resurgence due to the "fake news" controversies of 2016, but clearly Hitler understood these psychological functions long before that.

Given that Bayer was so involved in BWU, which was authentically progressive, it is not unwarranted to say at this point that BWU represented the peak of a highly productive experimental phase in photographic spaces in Germany that then unraveled. The surest evidence of this lay in the comparison of what came less than two years later in the form of the Goebbels-organized exhibition *Die Kamera* (Berlin, 1933).

The contrast in both the motivation and the technical realization between the BWU and *Die Kamera* is truly staggering. Although Bayer did not design the exhibition of *Die Kamera* (the often-reproduced atrium was designed by Wilhelm Niemann), he did design the catalog for this and a subsequent Nazi show, *Wunder des Lebens* (Wonders of Life) (1935), a clear expression of the

body culture which was a key concept of promotion by the Nazi apparatus and a brochure for *Deutschland* (1936). His configuration of worker/solider/ farmer over crowds was retrofitted for later Nazi shows.[13] Generally, there is an assumption of a perceived ignorance on Bayer's part about the ideological goals of these shows. Bayer himself claimed his work to be universally "apolitical," but as installation shots of *Deutschland* make clear—with a gargantuan blowup of Hitler hovering over the entryway—the narrative of the exhibition was hardly subtle (see Figure 5.1), thereby making Bayer's statement seem retroactively absurd.[14]

Organization of *Die Kamera*

Indeed, it speaks to the perceived power of photography, and particularly photography on display, that one of Goebbels's first priorities upon becoming the Minister of Public Enlightenment and Propaganda in March 1933 must have been organizing *Die Kamera*—as he would have had only eight months to realize the show. However, a fascinating reality about mounting the exhibition with such lightning speed was related to the fact that it was originally intended to be a sequel of sorts to the modernist triumph of *Film und Foto*. The show was initially planned by the Werkbund, the formerly progressive/liberal arts and crafts society that also organized *Fifo* in 1929. By 1933 the Werkbund had been fully co-opted by the Nazis and thus *Die Kamera* could function perfectly as a "recapitulation" of the exhibitions *Kipho (Kino und Photographische Ausstellung,* Berlin, 1925), *Pressa,* and *Fifo* but with the international components excised.[15] The *Pressa* and *Fifo* exhibitions have already been discussed, but the *Kipho* exhibition underscores the intertwining of the two mediums of photography and film in 1920s display culture, which will be discussed further in Chapter 4.

In addition to the *Die Kamera* exhibition positioning itself as a repudiation of former exhibition practices—even while stealing many of their installation techniques—remarks in the press release for *Die Kamera* make clear that, due to its vast reach, it was "no accident" that the medium of photography was chosen, and its affiliation with "progress" was touted as part of the reason. ("Our lives today are unthinkable without photography.") This was in keeping with the Nazis mastery of camouflaging their regressive policies behind notions of progress: "regressive ideas, progressive techniques."[16] As the first joint undertaking between the Ministry and the German Labour Front—that being the Front that took over after the Nazi destruction of the free trade unions in May 1933—*Die Kamera* and its catalogue held great symbolic importance (Figure 3.1).

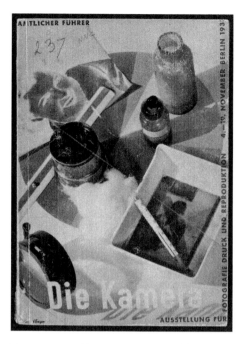

Figure 3.1 Herbert Bayer, cover of *Die Kamera: Ausstellung für Fotografie, Druck und Reproduktion* (Berlin: Ausstellunghallen am Funkturm, 1933). Courtesy Rare Book & Manuscript Library, Columbia University, New York. Bayer © 2020 Artists Rights Society (ARS), New York/VG Bild-Kunst, Bonn.

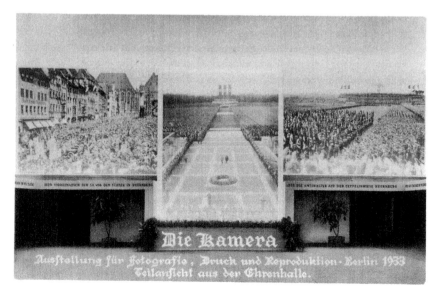

Figure 3.2 *Die Kamera*, postcard of installation view, 1933. Courtesy Museum Ludwig, Cologne/Photography Collection.

As a final contrast between BWU and *Die Kamera*, in the stations of the BWU, every potential method of diversified viewer participation was undertaken to convey information about a large variety of labor-based activities: knobs were turned, placards were flipped, louvered photographic blinds altered, split-level displays required up-and-down viewings, and photo-disks appeared suddenly at one's feet. These devices, and photographs both large and small, were intended to provide information through shocked re-orientation. Collectivity as an organizing principle was inherent due to lack of emphasis on the authorship of each individual photograph, as well as the presentation of collective-initiated subject matter, such as numerous, large-scale but unnamed photo blowups of real working men (as in Figure 1.2). In extreme contrast were the display decisions in *Die Kamera*, a rebuttal to collective give-and-take, which instead utilized the methodology of the hegemonic: engineered consent of the public (Figure 3.2).

Volk as the Hegemonic Core of *Die Kamera*

Instead of the principle of dynamic collective action embedded in BWU, the primary ideological premise of *Die Kamera* that emerges is *Volk*, or *volkgemeinschaft*, which Peter Fritzche defines as "a national community."[17] *Volk* is not immediately apparent as an antagonistic concept to collectivity, but at its root it is much more foundationally passive.

When one thinks of folk art, it seems safe to say that photography is not the first medium to come to mind. Folk art is generally assumed to be place-specific, three-dimensionally tactile, and "unlearned," so to speak (self-taught). And yet, the Nazis concocted a bizarre *Volk* definition of photography, in order to justify keeping out international examples of it—a necessary rationalization for a country that had a very strong tradition of international photographic exhibitions, as seen in the Introduction. Note the determined voice of Heiner Kurzbein, an intimidating-looking figure who attended the opening in full Nazi garb, towering over Goebbels (Figure 3.3, left) in his role as director of the Illustrated Press, Department of the Ministry of Public Enlightenment and Propaganda. His exhibition catalogue essay for *Die Kamera*, in effect, develops a new German vocabulary of *photo-Volk*:

> For the first time, the art of photography, which is a true folk art (Volkskunst), is oriented around a common front: to assist in the nation's rise and in carrying the German idea to the tiniest cottages, the most distant frontiers. Since a true

art cannot be international but always grows up from the depths of the soul of the people (Volkseele) and is closely bound up with blood and soil—precisely an art like photography, which is so eminently a folk art (Volkskunst), must draw its strength to the greatest possible extent from race and homeland.[18]

So, a nation's "rise" and the art that responds to it do not bubble up from collective work; rather it comes from some mysterious place in the soul. But then if one digs deeper into this statement, artistic inspiration does not come from the people themselves at all. It comes from the soil, as well as an abstract concept of "blood," which it then becomes apparent is a stand-in for race. The blood-and-soil metaphor closely mirrors the language Mussolini borrowed from Carducci in the huge blow-up of his letter in the MRF. In other words, in both Italy and Germany, blood and race are equated with soil and Homeland. Long-standing metaphors in Austria of "God and soil" were also adjusted to "blood and soil" under the influence of the Nazis even before that country's 1938 *Anschluss* (annexation by Germany).[19]

After these different applications of *Volk* (*Volkskunst, Volkseele*), Kurzbein surmises that "*Die Kamera* will be the first demonstration on a grand scale of just how deeply rooted the art of photography is."[20] This is one of the more bewildering

Figure 3.3 "Die Ausstellung 'Die Kamera' in Berlin 1933," *Das Atelier des Photographen* (1933): 131. Courtesy of Microfilm Collection, Fine Arts Library, Harvard University.

perversions—with many to choose from—by the Nazis, of a specific art form. It is almost a default to think of photography as decidedly *unrooted*, as well as a method for spreading ideas outward, due to its mass reproducibility. And yet, the Nazis managed to create an argument whereby photography, like everything else, was purely a means to redirect influences inward. So rather than underserved or under-told stories going from the rural environments to larger notice, the centralized ideas of the state would be filtered down to the "tiniest cottages" within Germany. And somehow, despite this top-down approach, in their interpretation this still meant photography was deeply rooted—as if an already existing deep-rootedness was simply being revealed by the central state. This is how top-down appears as bottom-up, another example of hegemonic manipulation.

This reverse strategy would also become evident in the planning of the *Die Kamera* tour, which went from Berlin into the more provincial area of Stuttgart. It was a poorly designed second venue and an "object lesson in what happens when a propaganda notion travels from the capital to the provinces"; Bayer also becomes part of that discussion of how the show was "lesser" because his catalogue design was severely compromised in subsequent venues.[21] There were another twelve to fifteen venues planned, but they were scrapped after the assassination of some SA leaders who had been represented through portraits in the exhibition. Due to this reality—one that might be perceived as signaling a failure—history would then have to be rewritten in future exhibitions: a hassle too much apparently. A closer look at the Berlin venue, however, allows for a substantive reading of how the Nazis intended to use photography as representative of *Volk*.

Layout of *Die Kamera* including Influence of the *Mostra*

The entrance hall made use of gigantic photomontages but for the single purpose of absorbing the viewer into a unified audience and a strictly determined visual narrative, that of direct participation in Nazi parades and spectacle. The escapist sense of belonging was in stark contrast to Lissitzky's *Pressa* and BWU friezes which demanded that viewers consciously engage in putting the fragmented bits together. Also in contrast to the anonymity of earlier German montages, all sixteen images in the entrance hall were press photographs taken by a single man, Hitler's official photographer, Heinrich Hoffmann. Minister Kurzbein's "Tour" at the press preview, transcribed in a press release, described those photographs as the history of the Nazi movement in "unsurpassed lifelike representation."[22] And why not? For the Nazis, staging was "lifelike," and an everyday occurrence.

As Karen Fiss has explored, both the dominating visual effects and the scale were key to Nazi spectacles, for they confirmed the "scopic inscription of a unifying and totalizing will."[23] For the Nazis, larger was always better; as the rallies depicted at *Die Kamera* showed, they were designed as "mass ornaments." The participants in these spectacles of speech—at least from Hitler's perspective—were not "so much [. . .] listeners as an enormous ornament," to be surveyed by Hitler and others as "particles"; an ornamentation also conveyed effectively through large-scale photographs of those events—events described as such by Siegfried Kracauer.[24] However, in his analysis of *Triumph of the Will*, Kracauer also seems sensitive to the hegemonic concept driving these spectacles, a receptivity on the part of the people: "Mass ornaments they appeared to Hitler and his staff, who must have appreciated them as configurations symbolizing the readiness of the masses to be shaped and used at will by their leaders."[25]

The presumption clearly expressed by the designers of *Die Kamera* was that viewers of the exhibition would choose a spot, freeze, and place themselves within the reproduced spectacle: the opposite effect of what Bayer and Moholy originally intended with their touch-feel stations and moving laths at BWU, which promoted, indeed demanded, motion and movement.

The very opposite of movement was the point in *Die Kamera's* Hall. Accounts from contemporaneous reviewers to *Die Kamera* dramatically underscore the desired effect of these blowups on the populace, that "thousands of visitors enter. . .every hour" that they come in engaged in conversation, stand before the "documents" of the "growth of a movement"—images described as "colossal"— and "before they realize it fall into silent devotion."[26] The reviewer in *Photo-Fachhändler* then uses the fascinating rhetorical device of turning to visitors and asking them questions: "are you one of the many who have flocked here for the Führer?"[27] And then proclaims that film and photography are the "carriers of the images of the national rise for all times," comparing previous media unfavorably to this great "photo art." Despite the show having a short run (less than two weeks), if the author's quantitative analysis is even close to correct, that's potentially hundreds of thousands of people being successfully in(corpo) rated into this mythology by the end of 1933—not an insignificant number.

A further account in the same *Photo-Fachhändler* article points to a similar reverent silence in the Hall of Honor, the hall following the reception hall. In this case the subject is an anti-Communist message of Nazi soldiers shot and killed by the Red Front. A slogan in the Fraktur script preferred by the Nazis, reading, in translation: "Comrades whom Red Front . . . shot dead"[28] is superimposed over a diagonal column of SA soldiers, shown in the extreme angle preferred by

New Vision photography. The reviewer of the exhibition, the same that remarked on the supposed reverent silence in front of the photo blowups of the Führer, commented: "Here no further words are spoken; here there is only silence. A silence that commands reverence for those who were shot, stabbed and murdered by Red Front. . . . There is no one who is not shaken by the harmony of word and image."[29] The anti-Communism that dictated many of the design decisions in the Italian Sala O was clearly thought to be similarly resonant at *Die Kamera*.

Religiosity also wafts through this reviewer's perception of the two rooms: silence/reverence/devotion. Goebbels likely saw the effectiveness of Mussolini's Altar of Martyrs, with its militaristic theme of sacrifice to the cause, its blood-red cross encouraging a kind of religious silence, and repeated "Presente" in neon lights. Not only that, he would have seen it in time to influence the design at *Die Kamera*, responsible for a German version of word-and-text harmony in rooms such as the Hall of Honor. There was a carefully orchestrated trip to Rome in late May and early June 1933, two months after Hitler appointed him Minster of Public Enlightenment and Propaganda and during the period when Goebbels coalesced his future plans for the Nazis cultural bureaucracies. Goebbels made notes in his diary on June 4 about visiting the MRF: "Fascism is modern and has *close ties with the people*. We should learn from it";[30] "close ties with the people" being another way of expressing the sentiment of *Volk* and clearly helpful to the hegemonic parameters of consent and coerce. Goebbels was also inspired by Italian political-aesthetic "coordination," which he would undertake in founding the Nazi Reichskulturkammer in September 1933.[31]

The day before Goebbels visited the MRF, according to his diaries, he also took a meeting with the director of LUCE (L'Unione Cinematografica Educativa) to understand Mussolini's filmic apparatus. The director had visited Berlin in early April.[32] LUCE and its functions will be discussed extensively in Chapter 4. Hermann Goering, head of the Luftwaffe, also reportedly attended the MRF before Goebbels, as he was on a trip to Rome slightly earlier.[33] This demonstrates expansion of the Italian cultural messaging down to German military personnel, although Goering was also a self-proclaimed arts enthusiast.

Returning to the press release of *Die Kamera*, as mentioned it included a transcribed "tour" of the exhibition by Heiner Kurzbein, within a recounting of preview events including several slide presentations. The press release also specified that the installation had only been completed in the middle of the night, reflective of the enormity of the task in such a short period of time.[34] The tour started with a description of the massiveness of the reception hall photographs discussed above, with an emphasis on actual measurements,

stating an average surface of forty square meters. Kurzbein also stresses in the press release how "true to nature" the photographs are, to the point where the viewers feel embedded in them "as if standing in the presence of the persons and events depicted."[35] And this served the Nazi needs perfectly. If the viewers had no opportunity for critical distance while standing in front of such photographs, and the photographs therefore transported them directly to the mass hysteria of a single rally, then the energy of those rallies could reverberate endlessly, as long as the photographs could be reproduced. Not only were they presumed by that audience—for example, Kurzbein—to have truth value,[36] these were spectacles similar to those in Nazi films, in which "social conflicts and economic contradictions were seemingly eliminated."[37]

This quote above is in fact about *Triumph of the Will*, a film that will be discussed at greater length in Chapter 4. However, this same goal was outlined for *Die Kamera* in its exhibition catalog: the point of the exhibition was to help people overcome the idea that there was any class struggle at all. This ruse of a classless society was a powerful tool in the hands of the Nazis. Indeed the Nazi-organized May Day worker celebration that took place the day before they liquidated the unions was celebrated even in liberal newspapers for the inspiring sight of all classes "jumbled up."[38] The press release for *Die Kamera* also hammered home that the exhibition as a whole demonstrated a complete lack of class tensions in German society. The fact that exhibition bureaucrats would let words about class seep into a public document shows how much more productive it can be to look at images in aggregate—or "jumbled up" as they are in an exhibition—rather than individual images. They would never be able to make such a sweeping statement convincingly about a single image.[39]

Hence was the cultivation of a feeling of "will-less participation" by the masses.[40] It was an essential phenomenon of these Nazi spectacles and therefore warrants an aside before continuing with the "tour" of the exhibition." As much as participation was not will-less, the Nazis aspired to an environment in which it felt will-less. It created a direct relationship with Nazi cinema of the time and the type of sensations that Riefenstahl choreographed for the viewer's consumption. The Nazis did not simply want to present their take or their *version* of reality to their viewers. They wanted to completely uproot human experience, supplant it with their ideology, and make it seem organic. Kracauer has explored in depth the propagandistic echo-chamber methods that allowed them to succeed:

> Proceeding ruthlessly, they not only managed to prevent reality from growing again, but seized upon components of this reality to stage the pseudo-reality of

the totalitarian system.. . . Reality was put to work faking itself, and exhausted minds were not even permitted to dream any longer.[41]

No dreams, as well as no history. Nazis were masters of the most extreme effacement of the basic human impulses of dreaming and remembering. In a pointedly telling anecdote from the Italo-German wartime cultural attaché Giame (sometimes Giaime) Pintor—who traveled frequently between Italy and Germany—Pintor uncomfortably recounts obedient young soldiers from the front who admit having lost all sense of generational identity and who have become "tranquil" killing machines.[42] This may seem too strictly top-down an analysis to count as a hegemonic construct, but the Nazis perfected a spectrum of propagandistic impacts across generational lines. Portions of the population— the unwilling—were silenced or self-exiled; many consented gladly to the messages; some took advantage of the images to "look away" from unpleasant realities; some submitted to willing coercion; and in the minds of eyewitnesses of the time like Pintor, it appeared that certain youth were borderline brainwashed by messages, visual and otherwise.[43]

Predating the premier of Riefenstahl's *Triumph of the Will* by two years, the photo-enlargements in *Die Kamera* created a similarly persuasive pseudo-reality. Real people participating in the events are hyper-staged; they then have ecstatic experiences—shouts, cheers, waving hands—enhanced by crowd-manipulation such as exhaustingly long wait times for speeches that builds anticipation, and claustrophobically close quarters;[44] this then becomes a choreographed "reality." Those real-time bits are used in a medium deemed to be documentary in character, which then becomes the method to convince everyone filing through the exhibition that everyone else is submitting to the ideology with genuine passion and fervor. Kracauer proposes that a similar impulse motivated the Nazis to cling to newsreel footage and work it into their wartime dramas, because newsreels "testified to the authenticity of the film as a whole."[45]

After the reception hall and the militaristic Room of Honor came a "History of Photography" section, of the type that would later be purged from Nazi exhibitions as history became something more and more to be effaced. It was located just to the left of entrance hall. Erich Stenger's development of historical exhibitions from his own photographic collection had been a prime feature of the avant-garde exhibitions of the 1920s, including *Fifo* and several of its predecessors such as *Kipho* (1925) and the *Deutsche Photographische Ausstellung* in Frankfurt (1926). He also contributed a valuable essay to the exhibition catalogue of the latter explaining the cross-pollination of pioneering French and German ideas in the early years of photography's history, and citing a Berlin newspaper in

January 1839 as announcing Daguerre as the first to experiment with a living subject. Unfortunately he allowed his timeline at *Die Kamera* to be incorporated into a purely nationalistic narrative of photography's history, both in the show and in his exhibition catalogue essay "Die Fotografie Im Dienste Der Forschung" (Photography in the Service of Research). Stenger also engaged in this German-centric revisionist history for his book *Photographie in Kultur and Technik* (1938), described later as a "deplorable example of history writing," crediting Johann Heinrich Schulze with photography's origins.[46] This was translated into English as *The History of Photography: Its Relation to Civilization and Practice* (1939), a book that would later be disavowed by its English publisher.[47]

Subsequently in the layout the viewer came to photography in service of architecture as well as landscape photography (or Heimat). As the viewer plunged deeper into the exhibition, they would face such sections as "The Face of the German People," a seeming riff on August Sander—who actually chafed against the Nazi regime—and his work *Face of Our Time* (1929). Injecting Pohlmann's read into this, he outlines that this section on the "Face of the German People" contained the cloyingly Aryanized work of Hitler favorite Lendvai-Dircksen, described as a symbol of "anti-intellectual indigenous existence."[48]

As Leesa Rittelmann has noted in her recent essay "Facing Off," Lendvai-Dircksen and Sander created photobooks almost concurrently but from radically different political positions. Yet both examined physiognomy as indicative of German identity. On the one hand, this can be read as a similar perversion of the left as was seen taking place in appropriating from exhibitions like BWU, but separate from that it is also a reminder that the clean breaks one may wish for vis-à-vis modernism and Nazism are instead highly complex.[49] Although Lendvai-Dircksen's images were not reproduced in the *Die Kamera* catalogue, she was listed on page 115 in the index of artists as a photojournalist, which seems a bit odd given her heavy pictorialist style but not completely anomalous. An almost contemporaneous portrait of pretty youths from her book *Das deutsche Volksgesicht* (1932) coincides with the Volk types—typified by the girl's hair buns—described in the exhibition's literature, so one can surmise the stylistics of what was in the exhibition (Figure 3.4).[50] As additional evidence of the typologies displayed in the exhibition, in his enthusiastic review of *Die Kamera*, Renger-Patzsch made mention of the German Volk being represented in a "self-contained series of highly impressive images . . . completed after years of work."[51] Lendvai-Dircksen was an enthusiastic proponent of *volkische* photography, demonstrated by her publication of the essay "On the Psychology of Vision," in *Das Deutsche Lichtbild*. In the essay she espouses that a culture "is

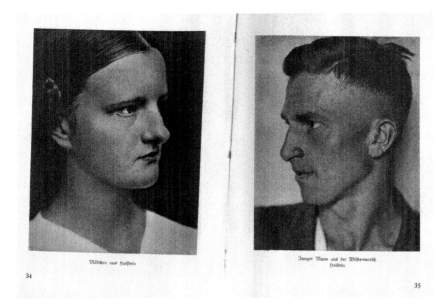

Figure 3.4 Erna Lendvai-Dircksen, *Das deutsche Volksgesicht* (Berlin: Drei Masken Verlag, 1932), 34–5. Courtesy Private Collection.

always bound to the landscape of its origin, it takes root . . . and if transplanted, it adopts or dies."[52] She has numerous subsequent references in the essay to the problems of "foreign" influences in photography. So again, the photography has to take root in the Homeland.

The racial overtones of *Die Kamera* continued in a section on "Hitler Youth," aimed at the general public but of "particular interest to the racial scientist."[53] The "Tour" author (anonymous) does not elaborate about specific photographs, but does characterize photography as essential to this racialized task: "Here, photography demonstrates its great importance in the context of racial science."[54] Indeed, photography was routinely used to undergird Nazi theories of controlling heredity through eugenics, a debased and debunked theory widely disseminated through the Nazi-illustrated press in an attempt to establish its legitimacy. The heart-wrenching and well-known photo of an elderly man getting his nose measured for confirmation of heredity was one of numerous photo-essays on the subject in the interwar period.[55] The latter cover appeared in June 1933, therefore concurrent with *Die Kamera* exhibition planning. Eugenicists even during the Weimar era in the 1920s wanted to apply their studies to "improving the biological quality of the Volk" but it was illegal to use sterilization to achieve that goal until 1933.[56]

Professional photography (Berufsphotographie) had a section that included both "artistic sentiments" and commercial pursuits such as architectural, industrial,

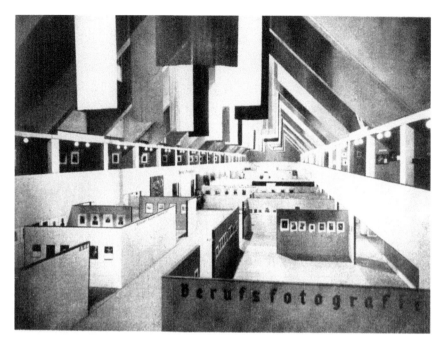

Figure 3.5 *Die Kamera*, installation view, 1933. Courtesy Museum Ludwig, Cologne/
Photography Collection.

and advertisements. Featured photographers included the pictorialist Hugo Erfurth
and the conservative Neue Sachlichkeit photographer Albert Renger-Patzch. Then
the illustrated press (Bilderberichterstattung) (Figure 3.3, on right) was described—
an area of the show that I will elaborate on shortly—as well as "phototelegraphy."
The installation shot of this section has the appearance more of a science fair than
the more innovative photo blowups in the entry hall. In other words, *Die Kamera*
started off big and dynamic, and then seemingly aimed to exhaust the viewers into
ennui with rows and rows of standardized Nazi content (Figure 3.5). The viewers
then move on to science photography, then on to the photo industry, and the actual
production of cameras. But at this point, more needs to be said on the subject of the
illustrated press at *Die Kamera*, starting with the Editors Law.

Photojournalism as Case Study from *Die Kamera* and the 1933 Editors Law

The role of the illustrated press at the exhibition, and the great attention paid to
it in the show's press release, offers a case study of the tremendous import that

Nazis placed on photographic manipulation of public perception at the time. Scarcely one month before the opening of *Die Kamera* the Nazis passed the Editors Law:

> The Propaganda Ministry, through its Reich Press Chamber, assumed control over the Reich Association of the German Press, the guild which regulated entry into the profession. Under the new Editors Law of October 4, 1933, the association kept registries of "racially pure" editors and journalists, and excluded Jews and those married to Jews from the profession. Propaganda Ministry officials expected editors and journalists, who had to register with the Reich Press Chamber to work in the field, to follow the mandates and instructions handed down by the ministry. In paragraph 14 of the law, the regime required editors to omit anything "calculated to weaken the strength of the Reich abroad or at home."[57]

This was in keeping with the generalized centralization of propaganda and culture throughout the autumn, with the creation of the Reich Press Chamber under Nazi ally Max Amann of the Eher Publishing House. He was able to do this subtly, through such tactics as switching government advertising contracts to Nazi-specific newspapers, thus starving rivals of key revenue. This dovetailed with readers being fearful of stigmatization if they read overtly liberal newspapers. The effects were startling, whereby non-Nazi papers' circulations nosedived and the arena of public opinion evaporated.[58] For just two examples, the *Berliner Tageblatt* went from 130,000 to 75,000 by the start of 1934, and the *Vossische Zeitung* went from 80,000 to 50,000 in the same time period, although the illustrated weekly *BIZ* was still achieving higher circulation numbers than the daily newspapers.

The Editors Law also made editors personally responsible for the content of their papers. The Law was a Goebbels's collaboration with Otto Dietrich, head of the Nazi press bureau, and was concurrent with the large-scale purchase of various presses by Amann. As the law was systematically applied, it allowed for the dismissal of 1,300 Jewish and left-leaning journalists by early 1935 and thus a stranglehold on nearly all circulated press outlets.[59]

Dr. F. K. Herrmann's essay in the *Die Kamera* catalog, "The Photograph in Photojournalism" with a telling militaristic opening layout (Figure 3.6), claimed that in the exhibition, German photojournalists presented themselves for the first time "as a unified group" (*zum ersten Male als gescholssene Gruppe auf*).[60] The essay demonstrates that the very aspects which excited the avant-garde about the illustrated press—its ability to reach a mass audience—were precisely what the Nazis considered low-hanging fruit for their program of engineering

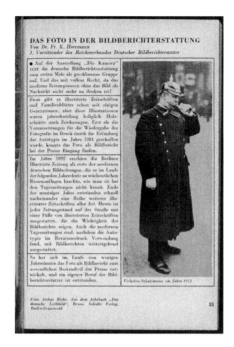

Figure 3.6 "Das Foto in der Bildberichterstattung," in *Die Kamera: Ausstellung für Fotografie, Druck und Reproduktion* (Berlin: Ausstellunghallen am Funkturm, 1933), 31. Courtesy Rare Book & Manuscript Library, Columbia University, New York.

consent. Herrmann lays out the argument that images are more "compelling" than words "because of the objectivity": "Thanks to the immediate impact of its realism . . . a photograph is simply the true-to-life event itself."[61] Ironically, especially given the surgical precision of the Editors Law, he goes on to say this realism "enables him (the viewer) to form his own opinion more easily."

The sentiment is reminiscent of the aforementioned quote now attributed to Klutsis (formerly to Rodchenko) who analyzed the inability of any graphic design alone to carry the same amount of power as a design also containing photography: "*the photographic snapshot is not the sketching of a visual fact but its precise record.* This precision and documentary character of the snapshot have an impact on the viewer that a graphic depiction can never attain."[62] That is, the impact was attained primarily because of the pieces of reality involved and the persuasive power such reality would hold over the viewer. One sees in such primary documents that the truth value of photography was still presumed to be highly persuasive at the time.

And yet, in continuing with Dr. Herrmann's statement, the ability to manipulate photographs "carries with it a certain danger." He's implying here that

the danger is from someone other than the Nazis. It is, in essence, propagandistic counterpropaganda:

> Even now—just a few months ago—when the critical change of government took place in Germany, the false accounts of atrocities promptly started up again, and news photographs were their centerpieces. It isn't hard to imagine the effect a campaign like this is likely to have on those whose thinking is primitive.[63]

Thus is delivered, from Herrmann's Nazi viewpoint, a now-familiar accusation of "fake news" by the Nazis against those journalists' reporting atrocities. These so-called treasonous accounts demonstrate "how carefully" the profession must be handled so it serves the general interest of the state.[64] The essay ends with an expression of gratitude that Nazis have "solidly anchored its issues and concerns" in the new *Schriftleitergesetz* (Editors Law). The primary editorial interest of the Nazi press is clear in a perusal of its coverage in 1933: such as in *Illustrierte Beobachter* about the boycott of Jewish stores, the arrest of Communist writers, and documentation of those writers in prison.[65] Interestingly, given Herrmann's statement above about unfair press coverage lying about "atrocities," these stories are all clearly definable as atrocities.

Magazine editor Stefan Lorant (of the *MIP*) kept riveting on-the-ground images from this foreboding period before the Final Solution, which also underscores the similar tactics at this Fascist moment between photographic circulation in print and photographic circulation in display culture—a masterful employment of the echo chamber.

Look But Don't Touch

Moving into other sections, Hall VI seemed incongruously interactive for the Nazis, and one of the only productive—or "means of production" being explored—holdovers from the BWU show from Chapter 1. For example, a display called "The Production of a Book" included the handwritten manuscript, the plates, and the letterpress. Also two darkrooms were opened. Visitors could watch typesetting demonstrations, and a bookbindery was displayed. The key element that was missing—which was present in the BWU—was that no direct touch experiences by viewers were apparently present, or at least mentioned in primary sources; hence, the instruction appeared to remain on the level of the scopic, with no haptic disruptions to the dictated narrative (quote: "the exhibition visitors are given an opportunity to *watch* as their own images is

reproduced, printed, and further processed").[66] A handmade paper process could also be observed but appeared to maintain the "look but don't touch" stance that contrasts *Die Kamera's* methodology with BWU's which was meant to stimulate interactivity, not just hegemonic acceptance.[67]

The visitors then received information about copyright, and were shown lithographic processes, and key locations around Berlin where photographic practices were located. Then, the entire exhibition concluded with *Heimat* (or Homeland) photography. The Homeland Photography movement tended toward two types of images: one of seemingly simple and völkisch Aryanized peasants with an intimate relationship with the land (blood and soil) and others of sentimentalized rolling mountains, implying a pure and beloved fatherland, although the latter mountaineering impulse was more common in Austria. Indeed, in the aftermath of the Anschluss in March 1938—which partly happened due to Italian acquiescence and created a newly shared border between the Germans and the Italians—the long-standing Austrian tradition of *Heimat* was expected to become more about the racial purity of provincial communities; whereas previously Austrian photographers had placed more valued emphasis on the folkloric, that is, nostalgic Austrian fantasies were more steeped in simplicity than purity. By 1934, all "German" photographers were already being encouraged to emphasize photographs of racial types. In a 1934 article, photographer Liselotte Strelaw specifically referred back to the photographs in *Die Kamera* as ideal photographic models for presenting racial types.[68] Examples of *Heimat* abounded in the *Die Kamera* catalogue, including youthful, in-color lederhosen kitsch with little blonde boys peeling fruit. Bayer's photograph of a happy skier utilizes New Vision techniques of the oblique upward angle, increasing the emphasis on his powerful forearms and a striped sweater pulled up to reveal a bit of bicep. His broad shoulders and expansive grin are then framed by ski poles presumably stuck in the snow behind, where he has confidently staked his ground (Figures 3.7 and 3.8).

Heimat photographs such as these fit so perfectly into the German photo-philosophy because as photo historian Rolf Sachsse phrased it, it helped the Nazis convince the populace to turn a blind eye or what Sachsse has called *Die Erziehung zum Wegsehen* (education in looking away).[69] If one is "somewhere else" like in the happy lands of blond youths and clean mountains, social injustices can be more easily overlooked. "Looking away" is key to the consent—or bottom up—part of the hegemonic equation and easily achievable. Many people undoubtedly found comfort in looking at pictures of pretty mountains rather than grappling with convulsive geopolitical changes in the post–First World War world. Add

Figure 3.7 Dr. Kröhnke, Untitled, in *Die Kamera: Ausstellung für Fotografie, Druck und Reproduktion* (Berlin: Ausstellunghallen am Funkturm, 1933), 46. Courtesy Rare Book & Manuscript Library, Columbia University, New York.

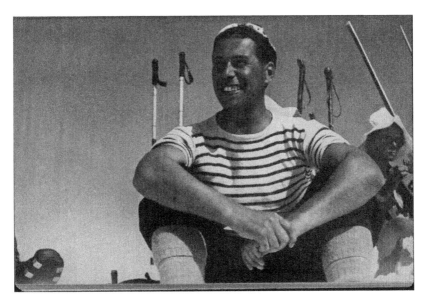

Figure 3.8 Herbert Bayer, Untitled (Portrait of Skiier?), in *Die Kamera: Ausstellung für Fotografie, Druck und Reproduktion* (Berlin: Ausstellunghallen am Funkturm, 1933), 65. Courtesy Rare Book & Manuscript Library, Columbia University, New York. Bayer © 2020 ARS, New York/VG Bild-Kunst, Bonn.

to that a top-down prescription which demanded providing images of as many pure, white, mountains as possible.[70]

Thus the *Die Kamera* press release tour of the exhibition concludes: "this exhibition demonstrates that it is impossible to imagine our culture without photography. For it has conquered worlds."[71] The nomenclature militarizes photography as the Nazis did with many of its cultural initiatives, talking about photography as a "weapon" or using an "army" of photographers.

Critical Reception of *Die Kamera*

The "falling into silence" in the review mentioned earlier, as well as additional reviews, refract how *Die Kamera* was being received and interpreted for audiences by the German press. Clearly, due to the "Editors Law" consolidation of the press, every one of these reviews is unabashedly biased. But the bias does not preclude "learning moments"—indeed the biased reviews highlight how fruitful the Nazis and by extension the Nazi press considered the crossroads of photography and exhibitions, and the publicity surrounding them. Thus prejudiced reviews can in fact serve a useful purpose. It is productive to revisit the *Photo-Fachhändler* reviewer (identified only as "ER") in that the writer claims to be placing the readers in the same physical realm as the spectators. He or she speaks of the "enormous" and "colossal" photographs being overwhelming to the "thousands" of visitors who fall silent in their presence. And that seeing the Führer in this way makes "you" think "you hear him!" In an unnerving style, the reviewer then creates a mock conversation with the spectators: "are you one of the many who . . . flocked here to the Führer?"[72] For ER, the exhibition space is as key for creating the same communal space as that of the rallies being depicted.

The writer then discusses how photography and film are now essentially the "carriers" of nationhood and that "with seeing eyes these giant pictures will get shown the influence of the elemental force of concentrated energy."[73] The perceived effectiveness of the photo-mural in creating communal space had been commented upon in an earlier issue (May 1933) of another photography journal *Der Photograph*, but about American uses of the form. In "Monumentalphotos als Wandschmuck," the author admires large-scale Edward Steichen photographs decorating a room in Rockefeller Center in worshipful prose: ". . .life-size, removes the limiting character of the walls and makes them almost transcendent." He goes on to describe the spectators looking *through* the walls rather than *at*

them, into "another world." Trieb then calls for similar installation methods to be adopted in Germany.[74]

This monumentality and absorption was undoubtedly an effective additional tool in the "education of looking away." The Nazis became expert over time at reverberating the hysteria of the mass rally using film and photography. Exhibitions with colossal photo blowups allowed them to replay, in effect, the Nuremberg rally to tens of thousands of additional audience members by allowing them to be in another world, while film screenings of *Triumph of the Will* would allow hundreds of thousands of additional people to do the same. And although films could reach larger audiences through concurrent screenings, in the exhibition space, there is the advantage of consuming presumed truths in a more physically communal manner, where one can see fellow attendees—one of the reasons Chapter 4 focuses on the power of film *within* an exhibition space. Even if fewer contemporary audiences now believe in the direct mirror-reflection idea of photography, they— those in power in the 1930s—advocated for its power, and they used it, and it appears to have worked in helping to engineer consent.

Das Atelier des Photographen is one of the most useful of the press outlets to examine, because, unlike the other two, they consistently illustrated their articles. Its published review of *Die Kamera* includes two installation shots, as well as the image of Goebbels attending the exhibition with Kurzbein (see Figure 3.3). In this review, Dr. Wilhelm Rossmann proclaims that the exhibition is very much of its time and he emphasizes the press as the reason people are "now" so impacted by photography: because of the thousands of newspapers and millions of people reading them. He also posits that the exhibition will be placed "in a special way" at the service of nation-constructing.[75] The reviewer gives a rundown of various sections including reportage and professional photography. But he also includes an entire section on *Heimat*, where the "amateurs" show their "pretty sophisticated art" with landscapes and faces, helping people with such questions as the following: Who knows Berlin? Who knows Germany? And that only the "majors" could be shown.[76]

It is clear from the number of times that these Nazi bureaucrats point to the "realism" of the photographers as the basis of their appeal in *Die Kamera* literature, that they understood the usefulness of blanketing large-scale public spaces with a pseudo-reality. Large-scale rallies were staged like photographs; large-scale photographs of those staged rallies were mounted in exhibitions; and large-scale screen projections of the same rallies were shown in theaters. They constructed an echo chamber and reinforcement, as Kracauer surmised: nowhere to turn, nowhere to run, even if one wanted to—and a lot of people didn't.

The Italians likewise wished to mimic the emotionalism of rallies within an environment they could completely control. They had a somewhat more unorthodox approach to their theories of public space use, which historian Marla Stone equates with the cinema. As Stone has theorized: "Mass exhibitions also drew on the syntaxes of film and experimental theater: there was little attempt to hide the ephemeral quality of the constructions"[77] and to continue about exhibitions: "As in film, the viewer was placed in the middle of the scene, not outside it." The distinction between viewer and objects was blurred, and thus is generated identification between the two.[78] That blurring had already occurred in the *Mostra* with walls, architectural flourishes, and interactive sculptures jutting into the viewer's space. Chapter 4 will develop how the echo chamber swirling around the public played out in exhibitions of both Italian and German films of the mid-1930s.

Notes

1 Passages of Chapter 3 were originally published in Rocco, "Activist Photo Spaces."
2 Cited in Pohlmann, "El Lissitzky's Exhibition Designs," 61, and Christine Poggi, "Mass, Pack, and Mob: Art in the Age of Crowds," in Schnapp and Tiews (eds.), *Crowds*, 180.
3 Text of the speech reprinted in Longerich, *Goebbels: A Biography*, 213. Italics are Goebbels's.
4 Evans, *Coming of the Third Reich*, 461
5 Pohlmann, "Political Weapon," 278, uses this very point to puzzle over why more work has not been done on the exhibition, although Olivier Lugon has included the show in his recent *Art History* article. Olivier Lugon, "Photography and Scale: Projection, Exhibition, Collection," *Art History* 38 (2015): 386–403. doi: 10.1111/1467-8365.12155
6 Gwen Finkel Chanzit, *Herbert Bayer and Modernist Design in America* (Ann Arbor and London: UMI Research Press, 1987), 120.
7 Lissitzky also made some conservative attempts toward mapping in his Abstract Cabinet, but not to the extent of Bayer's later work in the United States. The American work is another primary way one can see hegemonic concepts seeping into his exhibition designs.
8 Herbert Bayer, "Aspects of Design of Exhibitions and Museums," *Curator* 30 (1961), reproduced in Cohen, *Herbert Bayer*, 364.
9 Patrick Rössler explores Bayer's continued use of modernist tropes in his magazine designs for *Die Neue Linie*, but despite supporters like Dorner trumpeting how

long he was able to "defy" Fascist influences, his covers like a romanticized one of Mussolini in January 1928 show this view to be "at best naïve." *Die Neue Linie: The Bauhaus at the Newsstand* (Leipzig: Kerber Verlag, 2009), 87–8.

10 Cohen, *Herbert Bayer*, 295.

11 Herbert Bayer, "Fundamentals of Exhibition Design," *PM (Production Manager)* 6, no. 2 (1939–40): 17. I used this quote in my 2012 College Art Association conference presentation "Radical Photo Spaces" and have since seen it used very effectively by Kristie La at the conference *Exhibition as Medium* (Harvard, March 2013).

12 Adolph Hitler, *Mein Kampf*, trans. Ralph Mannheim (Boston: Houghton Mifflin, 1943), in Pohlmann, "Political Weapon," 290.

13 Pohlmann, "Political Weapon," note 65, in Ribalta, *Public Photographic Spaces*.

14 Paul Hill and Thomas Cooper, "Herbert Bayer," in *Dialogue with Photography* (New York: Farrar, Straus & Giroux, 1979), 111–31. Many thanks to Geoff Batchen for recommending this citation as it importantly used Bayer's own words on the subject.

15 Rolf Sachsse, "Propaganda für Industrie und Weltanschauung," in *Inszenierung der Macht. Äxthetische Faszination im Faschismus* (Berlin: NGBK, Dirk Nishen Verlag, 1987), 276, n12.

16 See cite of Paxton, *Anatomy of Fascism*, note 2 in Introduction (correction above).

17 Peter Fritzsche, *German into Nazis* (Cambridge, MA: Harvard University Press, 1998), 36. He further defines the seductive appeal of Nazi *Volk* on pages 209–10: "What was appealing about the Nazis was their vision of a new nation premised on the Volk, which corresponded both to the populist nationalism of the middle classes and socialist sensibilities of the workers."

18 Heiner Kurzbein, "Die Fotografie im nationalen Deutschland," in *Die Kamera: Ausstellung für Fotografie, Druck und Reproduktion* (Berlin: Ausstellunghallen am Funkturm, 1933), 9. Also see Elizabeth Cronin, *Heimat Photography in Austria: A Politicized Vision of Peasants and Skiers* (Vienna: Photoinstitut Bonartes, 2015), 169, for examples of how metaphors of "God and soil" were increasingly changed to "blood and soil" in 1930s Austria under the influence of the Germans.

19 Cronin, *Heimat,* 169.

20 "Die Kamera wird zum ersten Male in grossen Umfange zeigen, wie tief die Fotokunst national verwurzelt ist." Kurzbein, *Die Kamera*, 10.

21 Sachsse, "Propaganda für Industrie und Weltanschauung," 279–80.

22 *Die Kamera*, "Press Release" (November 1933), Collections, Agfa Fotohistorama, Cologne, 2. In addition to a transcription of the tour and a lecture by Kurzbein, the release transcribed the content of slide presentations by Willy Stiewe, Erich Stenger, and Johannes Albrecht.

23 Fiss, *Grand Illusion*, 164–75.

24 Sigfried Kracauer, *From Caligari to Hitler: A Psychological History of the German Film* (Princeton: Princeton University Press, 1947), 94–5. This passage is also quoted in Fiss, *Grand Illusion*, 168. Italics are mine.

25 Kracauer, *From Caligari to Hitler*, 302.

26 Attributed to "ER," "Ausstellung 'Die Kamera' in Berlin," *Photo-Fachhändler* no. 16 (1933): 488: ". . .geraten unversehens in eine Andacht."

27 *Photo-Fachhändler*, 488.

28 The words are attributed to the Horst-Wessel-Lied or the Horst Wessel Song. Wessel was a Nazi paramilitary commander, and this song became the Nazi anthem.

29 *Photo-Fachhändler*, 488.

30 *Goebbels Diaries*, ed. Froehlich, cited in Longerich, *Goebbels: A Biography*, 229.

31 On the Nazi Reichskulturkammer (Chamber of Culture) inaugurated in September 1933 see Ruth Ben-Ghiat, "Italian Fascists and National Socialists: The Dynamics of an Uneasy Relationship," in Richard Etlin (ed.), *Arts, Culture, and Media under the Third Reich* (Chicago: University of Chicago Press, 2002), 260.

32 The visit in Berlin is from Goebbels's diary entry dated April 9, 1933.

33 See Russo, *Il Fascismo in mostra,* 49 on Goering's visit.

34 *Die Kamera,* "Press Release," 2.

35 *Die Kamera*, "Press Release," 2.

36 Susan Sontag's fascinating essay "Image-World" opens with some thoughts on Feuerbach, introducing the "modern" idea that images are actually preferable to reality or hold more authority. Susan Sontag, *On Photography* (New York: Doubleday, 1989), 153.

37 Pohlmann, "Political Weapon," 287.

38 Fritzsche, *German into Nazis*, 227, citing *Berliner Morgenpost*, fn12.

39 Hans Biallas, "Die deutsche Arbeitsfront und Die Kamera," in *Die Kamera: Ausstellung für Fotografie, Druck und Reproduktion* (Berlin: Ausstellunghallen am Funkturm, 1933), 13.

40 Pohlmann, "Political Weapon," 287.

41 Kracauer, *Caligari to Hitler*, 299.

42 "they were beyond ideology itself." Ben-Ghiat, "The Dynamics of an Uneasy Relationship," 273, citing Giame Pintor, "Profeti senza fede," in *Primato* (February 1, 1943). He later became known as a resistance fighter. Martin, *The Nazi-Fascist New Order*, 256.

43 A fascinating parallel to this spectrum was presented recently on the *PBS Newshour* in a series on Putin's Russia (July 10, 2017). On the question of whether the new nationalist Russian identity has been "manufactured," a Tatar leader who led protests against Putin's 2014 annexation of Crimea described its existence as one big act of "intimidation": "to silence some and keep others ignorant; turn them into zombies so they think the same thing . . . we can't say this is a stupid population . . . they're just living in a constellation of fear and the propaganda machine rolls

over them like a steamroller." Ilmi Umerov has intimate understanding of this phenomenon, having been thrown in an insane asylum by the Russians for his resistance.

44 Donald Trump used similar tactics to evoke orgasmic responses from his crowds during the 2016 campaign. See firsthand accounts of crowds "moaning" upon sight of his plane—after waiting for hours in the heat—in Jeff Sharlet, "Donald Trump: American Preacher," *New York Times Magazine* (April 17, 2016): 42.

45 Kracauer, *Caligari to Hitler*, 297.

46 Pohlmann, "Political Weapon," 288.

47 Erich Stenger, *The History of Photography: Its Relation to Civilization and Practice*, trans. Edward Epstean (Easton: Mack Printing Company, 1939). There is a note in the front matter by Epstean about the publisher disavowing sponsorship of the book due to political conditions in Europe.

48 Pohlmann, "Political Weapon," note 42 in Ribalta, *Public Photographic Spaces*, 288.

49 Leesa Rittelmann, "Facing Off: Photography, Physiognomy, and National Identity in the Modern German Photobook," *Radical History Review* 106 (2010): 137–61.

50 Cronin, *Heimat*, 153.

51 Albert Renger-Patzsch, "The Camera and Landscape Photography," in *Kunst der Nation* (November 1933). Translation by Daniel Magilow.

52 Erna Lendvai-Dircksen, "Zur Psychologie des Sehen," *Das Deutsche Lichtbild* (1931): n.p. My thanks to Dan Magilow for sending his recent translation of this text.

53 *Die Kamera*, "Press Release," 2.

54 *Die Kamera*, "Press Release," 2.

55 Robert Lebeck and Bodo von Dewitz, eds., *Kiosk: A History of Photojournalism* (Cologne: Museum Ludwig/Agfa Foto-Historama, 2001), 166.

56 Carol Squiers, *Perfecting Mankind: Eugenics and Photography* (New York: International Center of Photography, 2001), 16.

57 United States Holocaust Memorial Museum. "Editor's Law" Holocaust Encyclopedia. www.ushmm.org/wlc/en/article.php?ModuleId=10005143. Accessed on August 8, 2017.

58 For useful specifics on more circulation numbers see Robert Evans, *The Third Reich in Power* (New York: Penguin Press, 2005), 144.

59 Evans, *Third Reich in Power*, 144. One fascinating exception to this capitulation, until 1939, was the *Frankfurt Zeitung*. Evans analyzes how the paper evaded some of the restrictions, particularly on their foreign correspondents, due to their stellar international reputation.

60 Fr. K. Herrmann, "Das Foto in der Bildberichterstattung," in *Die Kamera: Ausstellung*, 31. There is a striking note on that page about how the illustrated BIZ achieved weekly circulation numbers unlike anything the daily papers had seen.

61 Herrmann, in *Die Kamera: Ausstellung*, 32–4.

62 Klutsis (?) in Phillips, *Photography in the Modern Era*, 211–12.

63 Herrmann, in *Die Kamera: Ausstellung*, 36.

64 Herrmann, in *Die Kamera: Ausstellung*, 36.

65 See various spreads in Lebeck and Dewitz, eds., *Kiosk*, 168.

66 *Die Kamera*, "Press Release," 4.

67 See Vanessa Rocco, "Pictorialism and Modernism at the Dresden Internationale Photographische Ausstellung," *The History of Photography* 33, no. 4 (November 2009): 383–402, which explores the "look but don't touch" methodology in most art exhibitions, but also argues that certain early twentieth-century photography exhibitions attempted to negate that for educational purposes and encourage viewers to engage directly in displays, such as knob-turning vitrines.

68 Cronin, *Heimat*, 151.

69 Many thanks to Elizabeth Cronin for bringing my attention to this, Cronin, *Heimat*, 133.

70 So even while "nice" Heimat was being fed to the public, the photographic journals were admitting that what the genre was really about was race. See Cronin, *Heimat*, 133. This creates an interesting parallel to right-wing contemporary propaganda, where images of blonde victims of immigrant crimes—case in point, Kate Steinle— are the most sought after victims to contrast with the immigrants perpetrating crime on those blondes.

71 *Die Kamera*, "Press Release," 4.

72 *Photo-Fachhändler*, 488.

73 *Photo-Fachhändler*, 488.

74 I found this source due to a content footnote in Pohlmann, "Political Weapon," 286, n35. My italics.

75 Dr. Wilhelm Rossmann, "Die Ausstellung 'Die Kamera' in Berlin 1933," *Das Atelier des Photographen* 40, no. 11 (November 1933): 131.

76 *Das Atelier des Photographen* (1933), 133.

77 Stone, *Patron State*, 131.

78 Marcia Landy, *Fascist Film: The Italian Commercial Cinema*, 1931–43 (Princeton: Princeton University Press, 1986), 27.

"A Fundamental Irony"

International Art in the Age of Nationalism at the Venice International Film Festivals, 1932–6[1]

It is the bureaucracy which exercises coercive power.
—Antonio Gramsci, *Selections from the Prison Notebooks*, 1929–35[2]

Political dictatorships, despite the default definition as a one-person tyrannical enterprise, are unsustainable without bureaucrats buying in. Films are likewise often thought of as dictatorships through the person of the director. Yet, large-scale films are by necessity made by bureaucracies. That reality of production runs particularly deep in films made by the state. Twentieth-century Fascism pushed film products as an especially useful space for cultural hegemony, and the Italians amplified this power in the 1930s through the organization of festivals, most notably the still-active Venice Film Festival that was originally a component of the Biennale exhibitions.

In the 1930s, there was actually considerable optimism on the left for film's revolutionary potential. Indeed, the German philosopher Walter Benjamin noted a "highly progressive reaction" on the part of the masses toward filmic experiences as opposed to "backward" attitudes toward painting. In his famed essay "The Work of Art in the Age of its Technological Reproducibility," he attributed this to a changed relation between the masses and the art achieved by reproducibility, and also the expanded possibilities of "simultaneous collective reception" discussed at length in Chapters 1 and 2.[3] Buchloh has offered the most articulate clarification of this idea in his essay "From Faktura to Factography": "In order to make art *'an informed analysis of the concrete tasks that social life poses'* . . . entirely new forms of audience address and distribution had to be considered."[4] The quote within a quote is attributed to A. V. Babichev, the leader of the Working Group for Objective Analysis at

INKHUK in the Soviet Union, which promoted construction over composition and is largely responsible for coaxing a group of already-established artists to abandon painting for what he considered more productive pursuits like photography and design.

By the time Benjamin wrote and revised the epilogue of his "Reproducibility" essay in 1936, however, he had seen the dangers of the medium's inducements: the manner in which the masses come face to face with themselves and become convinced that they are given an avenue of expression. To quote from that epilogue: "Fascism attempts to organize the newly proleterianized masses while leaving intact the property relations which they strive to abolish. It sees its salvation in granting expression to the masses—but on no account granting them rights. The masses have a right to changed property relations; Fascism seeks to give them expression in keeping these relations unchanged."[5]

Granting mass expression is one method toward winning the consent of subordinates. The revolutionary potential noted by Benjamin was eventually redirected into hegemonic consent and coercion. The Italian film exhibitions mounted biannually, then annually, throughout the 1930s demonstrate a progression from one to the other. And the German bureaucratic apparatus played a pivotal role in this progression, as the Venice Film Festival became the backdrop for numerous film and cultural accords signed between the two nations, especially from 1935 to 1938. This included the founding of the International Film Chamber (IFC), which encompassed other European nations as well, with statutes adopted in November 1935; the bilateral film accord signed in Munich in 1937 to help each other's markets but which also "underscored the regimes' new political relationship through propaganda films;" and the 1938 German-Italian Cultural Accord.[6]

The "Mass" Politics of the Biennale

Having established itself as one of the premier international sites of art exhibition, the Biennale di Venezia, especially beginning in 1930, was a welcome opportunity for the Fascist regime to realize its promotional spectacles. In Marla Stone's words: "during the 1930s, the Fascist regime patronized and advanced a successful mass exhibition formula."[7] She goes on to make a fascinating statement regarding the Fascists' inherited—from the Futurists—antipathy toward permanent museums, leading to an "active, temporary, and innovative exhibition format," borne out by transitory shows such as the MRF.[8]

A marked desire is shown to shift the paradigms of high culture so that more of the Italian populace felt embraced by the previously intimidating event of the Biennale. The regime's central ruse of inclusion informed the cultivation of additional Biennale audiences. The Fascist organizers achieved this primarily by including popular forms of media that had been formerly excluded (film, music, decorative arts, public art), and by harnessing the tools of the marketing and leisure industries to attract new groups to the Biennale. This "democratization" of mediums achieved a key hegemonic goal: understanding the priorities of subordinates. The Fascists understood the anti-elitist desires of a certain audience, and realized them through this set of exhibitions. Mussolini was, after all, the son of a blacksmith and a political outsider who got his start taking advantage of unemployed and disaffected war veterans. He was well positioned to promote anti-elitist stances.

The Fascist drive "to involve a broader public . . . was often resolved by a plan to control the major organizational and exhibiting structures of art."[9] Exciting a broader public while also controlling the levers of power are two ingredients of cultural hegemony. The new methods of inclusion encompassed both more popular media and new modes of advertising these displays to the public.

The first Venice International Film Festival (L'esposizione Internationale d'Art Cinematografica all XVIII Biennale Venezia) (Figure 4.1) was inaugurated at the Biennale in August 1932. The film festival would go on to become independent of the Biennale, as the still extant and prestigious Venice Film Festival, but initially it was viewed as a new audience magnet for the Biennale as a whole. And it succeeded mightily, with attendance increasing at the film festival from 25,000 in 1932 to over 40,000 in 1934, so adding tens of thousands of new visitors that might also attend the other parts of the Biennale. Indeed, the overall Biennale attendance in 1932 of 250,000 jumped to 450,000 in 1934 as the advertising outreach to the expanded middle class extended to such platforms as telephone directories and train stations.[10]

This chapter may seem like a deviation from physical and/or walking experiences in exhibition spaces in relation to other chapters. But the secretary of the Biennales, sculptor Antonio Maraini, made a point in his 1932 opening speech at the film festival that the grand contribution of this festival was that cinema was to be seen in relation to an art exhibition. He consistently referred to the film festival as "an exhibition," the "first time" the medium of cinema had ever been granted such access.[11]

He was, however, wrong on this point. There was a long-established history by this time in twentieth-century Europe of exhibiting films in photography

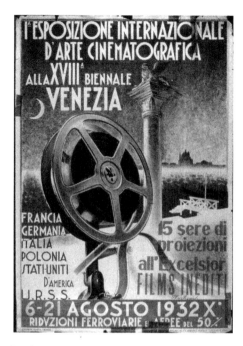

Figure 4.1 Poster for the First International Film Festival, Venice, 1932. Courtesy Archivio Storico della Biennale di Venezia, Fondo Manifesti.

exhibitions. The two mediums were routinely paired in many of the largest overviews of photography, particularly in Germany, beginning with the seminal *Iphad* in Dresden, 1909—which in many ways began the modernist path toward *Fifo* (1929) by combining "high" and "low" photo practices. This tradition continued through the previously mentioned exhibition *Kipho*. *Kipho* was mounted in a hall near a radio tower, the ideal example of a modern structure and a symbol of the changed environment in which photography would now be shown.[12] The emphasis on the "productive" and expansive aspects of photographic and filmic media which would come to define Moholy-Nagy's writings of the early to mid-1920s could be seen in this exhibition through its attempts to demystify and democratize its subject.[13] In her book *Film und Foto der Zwanziger Jahre*, Eskildsen published an illustration of the film studio set constructed at *Kipho,* unveiling the collective process of filmmaking to the general public. A short film promoting the exhibition was shown at movie houses, to attract a broad and diverse audience to the exhibition.[14]

Erich Stenger, whose extensive historical collection included over 500 daguerreotypes, and nineteenth-century prints by William Henry Fox Talbot, David Octavius Hill and Robert Adamson, and Julia Margaret Cameron[15]

organized the historical section of *Kipho*, the first large exhibition he had lent to, and later described his own contribution:

> Rich material from the history of cinema should be rounded out by historical photographic contributions. I was implored here for this purpose and I selected for each vitrine and glass case beautiful works. It soon became clear, that I could show things worth seeing, and so I have yearly since the *Kipho*, interrupted by the beginning of the second world war, and in years since several more times.[16]

His reputation as a stellar educator through his collection would be severely compromised in the 1930s once he lent his wares to Nazi shows like *Die Kamera*.

At *Fifo* the avant-garde film program was very much in harmony with the New Vision flavor of much of the displayed photography, including Russian montage filmmakers, French surrealist filmmakers, and German Expressionists. *Kipho* was the real antecedent to *Fifo*, although *Kipho* had film apparatuses on display, while *Fifo* had a full-fledged program of avant-garde screenings that complemented the New Vision photography. The BWU likewise included a small theater tucked under one of its undulating ramps (Figure 4.2), a model to be used later in the 1937 German photography exhibition *Give Me Four Years' Time*.[17]

The Venice Film Festival took a more ambitious stance of folding films in with exhibitions, but was building on a history rather than creating a new one. In sum, it is reasonable to think of the experience of the audiences at film festivals such as Venice as considerably more communal—like an exhibition space—than if they were going to a single, stand-alone film. These are clusters of films, seen in aggregate, over a specific number of days. Critics at the time specifically remarked on this point. Critic and author Ernesto Cauda expounds on the difference of seeing a group of films in an exhibition setting, rather than as singular experiences, in *Rivista Italiana di Cinetecnica*: "The initiative taken in presenting films from all over the world on the same footing as works of pictorial art reveals intelligent understanding and a courageous lack of bias in welcoming the most modern and revolutionary of the arts."[18] He seems to be using a well-established vehicle of elitism—the bourgeois exhibition—to shoot that very elitism down.

Stone, in another potent observation, also notes that the Fascists borrowed the "syntax of film"[19] in many of their exhibition spaces—in other words, in the arrangements and relationships among *things*: the walls come tumbling down between spectators and artifacts in both films and in the types of exhibition spaces preferred by the Fascists. In addition, both mediums—films and exhibitions—embraced ephemerality, especially in the way Fascists chose to mount exhibitions in purposefully temporary-looking spaces, with scaffolding and supports exposed

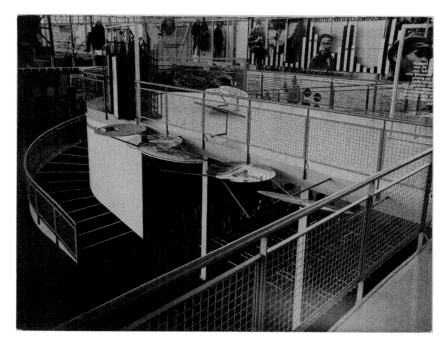

Figure 4.2 Herbert Bayer, Walter Gropius, László Moholy-Nagy, *Exhibition of the Building Workers Unions* (1931), installation view. Photo: Walter Christeller, courtesy Bauhaus Archiv, Berlin. Bayer: © 2020 Artists Rights Society (ARS), New York / VG Bild-Kunst, Bonn. Gropius: © 2020 ARS, New York / VG Bild-Kunst, Bonn. Moholy-Nagy: © 2020 Estate of László Moholy-Nagy / ARS, New York.

and visible to the viewer. Thus, it is productive to examine a set of film festivals *as* exhibition spaces, as artifacts consumed in a communal way. And it is especially useful as one delves deeper into the 1930s to see how the content of the Venice Film Festival morphed and changed. In looking at a cluster of overall film slates from Germany and Italy, as well as picking out some specific films for closer analysis, the complexity of solidifying the propaganda machine becomes apparent, especially in some key differences between propagandistic consolidation in the two nations. Some of the films in the early years retained surprisingly subversive and even antiauthoritarian elements, but those were wrung out as the mid-1930s approached—particularly in the German slate—just as in the exhibition spaces.

Backstory of the Italian and Germany Film Industries

Before the First World War, Italy had been a leading and international film power.[20] "In Germany, for example, Italian films—which ranged from elaborate

costume epics to realist street films—brought in profits close to those earned by American and French movies."[21] Then, unsurprisingly, output dropped during the war years. After Mussolini came to power in 1922, he professed a preference for documentary filmmaking, which he considered the "best and most suggestive means of education and persuasion."[22] He also considered realist aesthetics as compatible with nationalism. However, as posited by historian Ruth Ben-Ghiat, certain intellectuals believed that exposure to foreign spectacles, including American ones, would be positive for fostering film appreciation throughout the populace.[23] So Italian film development in the Fascist period developed a robust multipronged approach: documentary propaganda to please Il Duce and avowed Fascists and more lavish entertainment to please the masses, with plenty of room for overlap. These would clearly dovetail in the Italian slate selections at Venice.

The main German production company, UFA, was founded in 1917, to create a bulwark during the war against foreign film imports. Post–First World War it became a very successful enterprise in creating films that felt directly tied to other German aesthetic movements, such as the German Expressionist aesthetic in the film The *Cabinet of Dr. Caligari* (Robert Wiene, 1920). UFA continued in its creation of classic cinema throughout the 1920s by directors such as Fritz Lang, F. W. Murnau, and Josef von Sternberg. Upon the Nazi takeover in 1933, Lang and others (including Billy Wilder) fled the country and Goebbels merged various production companies under one state-controlled UFA umbrella. UFA would go on to produce approximately half of the films in the German Venice slate starting in 1935. Both countries had realized by the late 1920s what a threat the flood of American films into their markets represented, hence the two primary film institutions discussed in this chapter (LUCE and UFA) signed an agreement as early as 1928.[24]

The First Venice Film Festival: Diverse Politics Leak Through

The first Biennale Film Festival was a two-week affair from August 6 to August 21, 1932. It was largely the brainchild of the Count Giuseppe Volpi, who was the president of the Biennale, and Luciano De Feo the director general of Istituto de Nazionale LUCE—an acronym created by Il Duce himself from L'Union Cinematografica Educativa, the premier outlet for Italian Fascist propaganda—from its founding in 1924 through 1928. Funding LUCE appealed to Mussolini's desire to use film for education and political indoctrination of the masses.

Despite the founding appeal (mission statement) based on that indoctrination, some recent scholarship has argued that LUCE was not truly propagandistic until the 1930s.[25] Nevertheless, it is significant in any analysis of Italian filmic propaganda that the founding director of Il Duce's main cinematic arm was also the founder of the Venice Film Festival. And although LUCE's focus was on (shorter) documentaries, there was awareness on the part of industry that feature films could be just as hegemonically useful at carrying effective regime messages as documentaries, by burying their "prescriptive messages" within a compelling narrative.[26]

The "commission/committee" of the Venice Film Festival was comprised of an international panel, including Charles Delac of France, famous censor Will Hayes of the United States, and Walther Plugge, a German. The festival was non-competitive, and the first film shown was American: Rouben Mammoulian's *Dr. Jekyll and Mr. Hyde* (1931). The first festival was astonishing for its variety. The German film critic H. H. Wollenberg—who lived in exile in London starting in 1933 but was an engaged and appalled witness of the methodical Nazi takeover of UFA and the rest of the German film industry—proclaimed in his analysis of the 1932 German selection "What a year it was!"[27]

Through its very heterogeneity the 1932 slate displayed a surprising lack of political dictates. There was little to indicate that the kick-off festival was organized by Italian Fascists to contribute to the glorification of a Fascist regime. It is important to note that, according to Ben-Ghiat, Antonio Maraini argued that only the Biennale should allow this heterogeneity in Italy, for the purpose of improving taste. So this venue is unusually productive for gauging Italian exposure to other cinemas. The international selection included staunchly antiauthoritarian films such as Germany's *Maidens in Uniform* (*Mädchen in Uniform*) 1931. The film develops a lesbian crush at an all-girls school as its main plot point and was directed by a lesbian Leontine Sagan, based on a play by a lesbian, Christa Winsloe.[28] Just as astonishing vis-à-vis its inclusion was its intensely antiauthoritarian stance, in presenting the school principal as highly militaristic in her vocabulary, while clearly positioned as the villain of the film. In his essay "Austria and Germany" in the tome *Twenty Years of Venice*, Wollenberg opined that it was "the most impressive" Germany entry and probably of the entire year.[29] The film was very much viewed as an international hit, reviewed even by the *New York Times* in September of 1932 as enjoying "remarkable success" and "glowing praise" in Berlin, Paris, and London before travelling to New York.[30] In his review, a skittish-sounding Mordaunt Hall emphasized that the anti-militaristic themes dominated over any "exposition of unnatural affection."

Also surprising during this 1932 debut festival were the following: a Soviet film about young hobos at a Soviet camp as a prize winner (Ekk's *Road to Life*); a Rene Clair film (*A Nous la liberté*), 1931, with a plotline that can only be described as socialist-worker-oriented; and an Italian romantic comedy *Gli uomini, che mascalzoni* (*All Men Are Rascals*) starring the young and dazzling Vittorio De Sica.

With some subversive content leaking through, the Italian comedies during the Fascist period offer a case study in the complexity of cultural output in the 1930s. Their white-telephone frilliness seems discordant to the overall cultural atmosphere under Il Duce, but as Marcia Landy has explored, they were integral to the "politics of containment," another way of viewing hegemonic escapism.[31] Particularly successful in this genre was Mario Camerini, the director of *All Men Are Rascals*, a man Landy describes as "not naïve" regarding the defeat of the worker class in Fascist Italy; he is specialized in their fantasies and desires.[32]

The film garners its comedic elements from workers straying from their appropriate milieus, into which they need to be reclaimed. *All Men Are Rascals* bases its narrative on convincing rhythms of the workplace. Although De Sica's character strays from his "role" as chauffeur—pretending to be the wealthy owner of the car to impress a shop girl—the mistaken identity comedy ends with family harmony and working-class solidarity compensating for "social and economic impotence."[33] As mentioned earlier, these experiences effectively cancel out differences between producers and consumers in cinema, allowing a streamlined and direct identification between the two. Neither the characters nor the audience have an opportunity to be made aware of their own impotence—this was the masterful ruse of Mussolini's, and later Hitler's, propagandistic output. The newspapers picked up on this, as one specific review from the Naples-based paper *Roma* (August 9, 1932) has Vittorio Ricciuti making enthusiastic pronouncements about the De Sica comedy that it is really just about Neapolitans feeling sentimental for days gone by[34]—regressive message packed in progressive techniques.

Although this first festival is listed as non-competitive, there were "peoples' choice" awards of sorts, which were likewise surprising when considered retroactively. They awarded best director to Nikolaj Ekk for *Road to Life,* 1931, which was described by Theodore Dreiser as hardcore reality;[35] and best film to Rene Clair, despite an anecdotal attempt to change its title to sound less socialist in Italian to "a ME la liberta," in other words, freedom for *me*, instead of *us*.[36]

Exceptions to this surprisingly left-wing bent included Riefenstahl's *Das blaue Licht* (*The Blue Light*, 1932), her directorial debut that, according to anecdotal evidence, was what initially attracted Hitler to her work. The film contains much of the escapist *Heimat* iconography discussed in Chapter 3: mountain climbing, gorgeous vistas, and clichés pointing to the purity of the German people. Kracauer's exposition feels reminiscent of Lendvai-Dircksen's oeuvre (Figure 3.5):

> Close-ups of genuine peasant faces thread through the whole of the film; these faces resemble landscapes molded by nature itself, and in rendering them, the camera achieves a fascinating study in facial folklore. While the peasants are merely related to the soil, Junta is a true incarnation of elemental powers.[37]

However, compared with her later output, the plot does read as slightly subversive, with an inherent critique of the crushing provincial conformity brought to bear on the beautiful creature of nature played by Riefenstahl herself (Figure 4.3).[38] In addition, she collaborated on the script with Béla Balázs, the Austro-Hungarian born filmmaker and theorist very much influenced by the Soviets. Riefenstahl anecdotally had his name removed from the film credit retroactively because he was Jewish. As with *Die Kamera*, where on occasion older aesthetics not definable

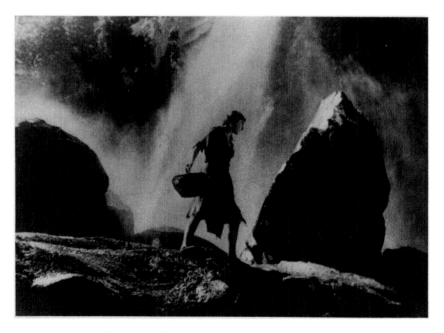

Figure 4.3 *The Blue Light* (director Leni Riefenstahl), 1932. Courtesy Stiftung Deutsche Kinemathek.

as Nazi—such as Bayer's New Vision catalogue cover—would leak through, the 1932 version of the festival demonstrates that Fascist leaders did not yet have an monolithically right-leaning grip on content, and indeed were willing to carry over effective methods from the left, if it met their hegemonic needs. This is particularly notable when one considers that unlike Hitler, Mussolini had been in power for ten years.

The 1934 Festival: First Year after the Reich

More countries participated in 1934, including Austria, Czechoslovakia, Denmark, France, Germany, Great Britain, Italy, Holland, Spain, United States, Sweden, Switzerland, Turkey, the Soviet Union, and even India. Japan also participated but only in the documentary section. This was also the first competitive edition. Germany's submissions in its first year of film products created under the Reich demonstrate the increasingly centralized tenor of film production. What the Italians desired to show off their own products on their home turf continued to straddle escapist continuity in its feature film selections, while increasing the intensity of the Fascist didactics of the documentaries, Mussolini's preferred genre.

In contrast to his effusive words about 1932, Wollenburg describes the "melancholy interest" of scanning the titles of films during the Reich, beginning in 1934, and also to scan filmmakers who had previously produced films for Germany but were at that point submitting for other countries due to the Nazi takeover, including Fritz Lang, Max Ophüls, and Billy Wilder.

The Germans had only two feature films: *Reifende Jugend* (*Ripening Youth*) by Carl Froelich and *Flüchtlige* (*Refugees*) by Gustav Ucicky. The documentary entries included three abstract films by Oskar Fischinger, *Carmen* by Lotte Reininger ("a film in silhouettes"), *Was ist die Welt* (What Is the World) by Sven Noldan, and *Deutschland Zwischen Gestern und Heute* (Germany between Yesterday and Today), a cultural look at the German people by Wilfried Basse. It was described as a cross-section of documentary and "assemblage," as used in the genre of the city symphony film.[39]

Froelich's film was based on a play by Max Dreyer, a writer who pledged allegiance to Hitler. By 1933 when it was made, Froelich was an old-timer who, in Kracauer's words, "did not mind occupying a key post in the Nazi film industry."[40] Wollenburg describes this Froelich film as fairly traditional, in his mind showing that it took a while for the Nazi iron grip to solidify in cinema:

"The change, however, was gradual and it was some years before Goebbels' all-embracing power was completely obvious in the German selections for the Venice Festival."[41] In that sense, film consolidation mirrored other cultural consolidations from 1933 to 1936. Kracauer also has a note of interest about Froelich assisting Sagan with *Maidens in Uniform*, so Froelich was definitively indicative of major shifts in cultural orientation.[42]

In fact, this may be a perfect representation of the attitudinal shift that took place in Germany between 1931 and 1933 and the resulting sifted sands that finally solidified by the mid-1930s: the man who helped the subversive Sagan went on to work for Hitler. Wollenburg is not terribly clear on his opinion of the timing of solidification, but does state that firm changes against experimentation in German film were clear by 1935–6, a similar time frame as when photo exhibitions were solidifying their Führer cult, explored in Chapter 5.[43] One of the reasons for including the Appendix at the end of this book as an aggregate of selected films is justified by Wollenburg's apt statement: "We can trace quite clearly the tightening up of the control of the German Ministry of Propaganda on entertainment in the country, merely by considering the films which were entered each year at Venice."[44] In other words, lists themselves can illuminate in the nature of the selections and how they changed.

Kracauer's first mention of Ucicky's oeuvre comes on the heels of Froelich's Napoleonic drama from 1931. Ucicky's *York*, of the same year, embraces a theme of military rebellion, which Kracauer interprets as a symbol of anti-democratic sentiment. Ucicky also made one of the Frederick the Great dramas that were popular in the early 1930s.[45] But perhaps most telling of all as to how he fit into the German hegemonic program, Ucicky directed the film *Dawn*, about self-sacrifice on a German submarine during the First World War, which the Reich chose to release one day after Hitler had been appointed chancellor. All the new cabinet attended the Berlin opening night, and there are photographs of Hitler, Vice-Chancellor Franz von Papen (on Hitler's left), and President Hindenburg seated with their programs, Hitler looking almost giddy (Figure 4.4).[46]

Similarly to Froelich and Ucicky, the two documentarians chosen to represent Germany in 1934 became important contributors to the Nazi apparatus. Sven Noldan was an innovator in the use of animated maps and would go on to make the Nazi war films *Baptism of Fire* and *Victory in the West*.[47] Basse, according to Kracauer, was an "indifferent" filmmaker, making moistly pointless statements about surface effects, which led him to neutrality when it came to making films under the Nazis. Basse's film entry in Venice in 1934 (*Deutschland von Gestern und Heute*) was considered by Kracauer an overly neutral analysis of German

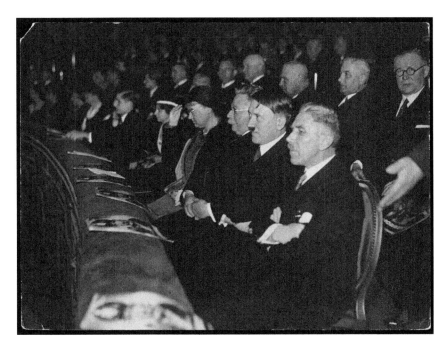

Figure 4.4 Adolf Hitler at a premiere, 1933. Courtesy Getty Research Institute, Los Angeles (920024). © Südd Verlag.

cultural life which, according to documentary filmmaker and critic Paul Rotha, "refused to penetrate beneath the skin."[48] As with *Heimat*, it encouraged people to look the other way as if everything was (a) the same and (b) normal.

Differentiation of hegemonic intent was likewise clearer in the Italian slate as time went on, including escapist features, such as the costume drama *Teresa Confalonieri* (called Loyalty of Love in English) directed by Guido Brignone as their prizewinner in 1934. Other feature films included the cross-cultural *Il canale degli Angeli*, *La signora di tutti* (directed by Max Ophüls) about an actress, *Seconda B*, and *Stadio*. Then there were the more bombastic documentaries. Striking in the documentary section of 1934 is that every one of the five entries was a government product from LUCE—they showed only one in 1932.[49] These documentaries don't list a director, just the Institute as producer, that is, bureaucracy as auteur. The 1934 slate included *Mare di Roma*, *Fiori*, *Sinfonie di Roma*, *Trebbiatura di grano all'Agro Pontino*, and *Varietà*.

As mentioned earlier, The Istituto Luce had been founded in 1924, with the blessing of Il Duce himself, by De Feo, also the founding director of the Venice Film Festival. LUCE was tasked with spreading filmic propaganda throughout the state, and specialized in newsreels, although there was also a photographic

department, with photographers who remained anonymous.[50] A 1926 decree required the exhibition of LUCE productions in all Italian movie theaters, so the Italian audiences were already well primed in what to expect as default documentary cinema.[51] LUCE staff found innovative ways to get these messages to the people, including sending out trucks with projectors called *cinemobili* into the countryside that lacked theaters. As noted earlier, many small towns did have theaters, so the cinemobili were penetrating extreme rural areas. This resulted in most demographic groups having access to content.[52]

Many of LUCE's films are available online, enabling close formal analyses of the content. *Mare di Roma* (or *Mare del Lido di Roma*, 1934) documented romps by the sea to get out of the hot city, but in its own way idealizes life under Mussolini, with happy faces, splashing about. So the film provides innocuous pleasure, with a healthy dose of pro-state propaganda, in a tightly interwoven package.

Trebbiatura, in contrast, is more formally satisfying as a filmic experience. The film hovers closely to an Italian version of *Heimat*, with Mussolini greeting adoring rural crowds in his lightly militaristic garb, as they, decked out in large straw hats with happy faces, raise their arms in fealty. There are some arrestingly New Vision–style shots of faces raised up to him on an oblique angle. Il Duce then goes out into the fields of Ferrara to thresh wheat himself, in theatrical fashion, alongside the peasants (Figure 4.5), with his threshing glasses on. Afterward they all stare approvingly into burlaps sacks full of wheat, and he drives off in his intimidating black car. The official Cinecittà Luce website which has uploaded hundreds of videos to YouTube under its logo has also given this film a slightly different title and date: *Benito Mussolini: la trebbiatura del grano nell'Agro Pontino* (1935), but films often debuted in the calendar year after the late summer/early fall festival.[53] This cross-section of films gives a varied sense of

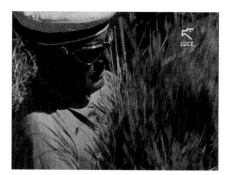

Figure 4.5 *La Trebbiatura del grano nell'Agro Pontino*, 1935. © Istituto Cinecitta Luce.

how messages of Il Duce's supposed one-ness with workers were normalized by the films emphasizing certain types of clichéd virile images, while concurrently serving "other" audiences more lavish, aristocratic costume dramas.

1935: *Triumph of the Will*

The 1935 Festival marked the beginning of the festival as an annual event. It was pivotal for coinciding with the finalization of a statute for the IFC, led by De Feo. De Feo agreed to work closely with Goebbels's leading film official, Arnold Raether, on an educational institute under the IFC umbrella. As Benjamin Martin has explored in depth, this Italian "capitulation" thus allowed the Germans to celebrate a reintegration into the international film scene from which the Germans had been ostracized, a development the German press labeled as "a colossal-prestige success," due to the manner in which it ended an international trend toward boycotting German films and replaced that trend with normalization.[54]

This perceived boost in prestige allowed for a heightened basking in the premiere of *Triumph of the Will* (Figure 4.6). The film met with some grumbling

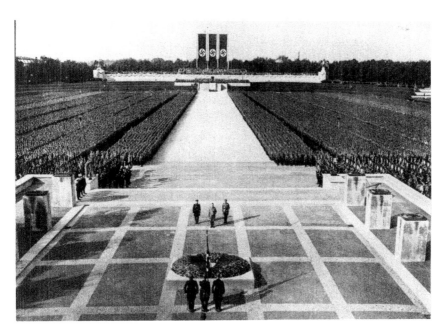

Figure 4.6 *Triumph of the Will* (director Leni Riefenstahl), 1935. Courtesy Stiftung Deutsche Kimenathek.

by the Italian press, but *Il Gazzetino* admitted its enthusiastic applause by the audience.[55] The critic Wollenberg in *Twenty Years* continued his blunt assessment of the years after the Reich takeover as not nearly living up to the slate in 1932. He was particularly distressed about Rienfenstahl's *Triumph of the Will* being featured as a Reich showpiece in 1935.[56] Much has been written about the director's attempts to self-analyze her own propagandistic tour de force set at the Nazi Nuremburg rally (1933) as simply a piece of formalist "art";[57] but any Intro to Film 101 would easily penetrate glaring examples of angle manipulation to make Hitler appear aggrandized, particularly the shots pushing in from behind his motorcade as he arrives at the rally.[58] Perhaps more egregiously, this camera position allowed for numerous overly dignified profile shots—that is, "Roman coin" style profile shots.

To crystallize the hegemonic goals of the film, one only need extract a few moments from the two-hour-plus film: Riefenstahl commences with the clouds parting for Hitler's plane and rolling mountains in the distance ("emphasis on cloud conglomerations indicates the ultimate fusion of the mountain- and the Hitler-cult").[59] As *Heimat* =*Volk*, Riefenstahl provided the people with a point of interest. After a behind-Hitler-motorcade rolling shot she includes many deliberate, extreme close-up shots of happy blonde boys laughing away: life could not be better; there are also interspersed close-up views of Nuremberg's ancient architecture, speaking—as did the clouds—to the timelessness of the Reich. Endless camera movements formed the backbone of her cinematic power. She was able to accomplish this level of complex camera work in part due to the thirty cameras at her disposal.[60] Indeed, in one of the most compelling passages of his immediately-postwar book, Kracauer describes how the entire rally itself was designed as a movie set for Riefenstahl, that is, real life as film construction which would then play back to film audiences as real life: the ultimate echo chamber.[61] This is not to say that audience participation was coerced without consent—but it was highly engineered. Again, the lack of opportunity for audiences to break out of this cycle of willing submission and redirect toward critical distance was exacerbated by being incorporated into Fascist mass rituals whereby "social and economic contradictions were seemingly eliminated."[62]

The 1935 German/Italian Slate: Cultural Hegemony at Work

Other German feature films included that year were *Hermine und die sieben Aufrechten* (Frank Wysbar), *Peer Gynt* (Frank Wenhausen), *Ich für Dich,*

Du für Mich (Carl Froelich), *Der alte und der junge König* (Hans Steinoff), *Oberwachmeister Schwenke* (Carl Froelich), *Regine* (Erich Waschneck— Wollenburg is complimentary about this one, particularly its lead performances), and the fascinating *Der verlorene Sohn* (*The Prodigal Son*, Luis Trenker). The only things of note in Kracauer about these directors are about earlier output. Wendhausen made a film in 1927 called *Out of the Mist* that he described as snowy woods and spring scenery, about the return from suspicious, "far away" cities of a young man to his native mountain village. Reviews of the film note that "every enduring motive" in the film "springs from the life of the soil while foreign emotions remain unfulfilled."[63] It is continuing the didactics of "looking away" from certain challenging political realities—such as the urban/rural divide—and instead toward the soil. Analysis of Waschneck's *Eight Girls in a Boat* from 1932 creates quite a liberal picture of this director, even confronting issues of abortion and rebellious girl runaways. But this analysis is Kracauer at his reductive worst: despite the plot sounding antiauthoritarian, the author reduces the girls banding together to be a harbinger of Hitler Youth. He simply refuses to believe that any alt-authoritative cinema could have existed in immediate pre-Hitler Germany.

Trenker made pictures at the juncture of mountain films and national films. He played mountain men in some of them himself. His film at the 1935 Venice festival translates as the Lost, or *The Prodigal Son*. This film warrants closer analysis for its extraordinary use of *Heimat*—such a seductive hegemonic tool— including the manner in which the director re-contextualized *Heimat* later in his career as he attempted to distance himself from this potent Nazi cultural tactic.

The plot of the film advances a rejection and vilifying of the German protagonist's experiences in New York, including mixing with other races. He then returns to the purity of the mountainous homeland for ancient Christmas rituals.[64] In 1978 Trenker tried to define *Heimat* as a "spiritual reaction against Nazi materialism and blood-and-soil drivel,"[65] which is of course ridiculous. As Rentschler points out in his essay analysis of this film, "There No Place Like Home": "The homeland at once provides meaning and forecloses thought." I would switch the order of those. *Heimat* forecloses thought and then fill the mind with its own meaning. It is the essence of enabling the "look away": "Nazi fantasy production endeavored—with mixed success—to occupy and control all territory in a concerted effort to eradicate alterity. In *The Prodigal Son*, there is no space that does not relate to the protagonist, no shot that is not narratively contained or psychologically bound"[66]—again, nowhere to run, nowhere to hide, in the coercive drive to take advantage of the willingness to look away.

As for documentaries, the 1935 slate from Germany included six films but only two with a named director: Lotte Reiniger's *Das Geraubte Herz* and another Oskar Fischinger, *Symphonie in Blau*. The others were the UFA-produced *Der Ameisenstaat*, *Der Koenig des Waldes* (*The King of the Forest*), and *Schmetterlinngsleben*; and *Leben unter dem Els* (*Life under the Ice*) produced by Bavaria-Filmkultur. The true climax of pure "propagandism" in feature films, whereby burying messages was no longer considered necessary, was bound to come with the outbreak of war.

The Italians continued to engage in clever differentiation for the festival audiences: themes for those desiring escapism and themes for those desiring nationalism, sometimes in the same evening. The prizewinner in 1935 was *Casta Diva*, a sumptuous costume drama about the mistress of the opera composer Bellini, Maddelena Fumaroli; the themes are essentially escapist: ambition and love gone awry. The director was Carmine Gallone, famed for his spectacles such as *Scipione l'Afrique*, that tied Fascism to Romanism.[67] The Italian press loved it, with the Fascist daily *Il Popolo d'Italia* celebrating it as encompassing "Italianissimo."[68] German émigrés kicked out by the Nazis were essential to producing the film, namely Arnold Pressburger and Gregor Rabinovitch and their new company Allenza Cinematografica Italiana. The Italians downplayed this as much as possible.[69] The short LUCE documentary film shown before this froth on its opening night furthered the regime's hegemonic goals in a much more literal sense. *Abyssinia* charted the "incivility" of the country—now known as Ethiopia—as Mussolini prepared to invade it. In the month after this prominent opening party, public opinion rallied behind Il Duce's buildup of arms. The invasion was subsequently launched in October.

The Italian documentaries were slightly more varied in authorship this year. Two, *Maratona Bianca* and *Il Museo dell-amore*, had named directors. The others were institutional: two by LUCE (*Alle Madri d'Italia* and *Lo Stato corporativo*) and one, *Riscatto*, by the Italiano Cinematografica Educativa e Didattica. Both *Alle Madri* and *Riscatto* make clear how propagandistic the documentary Italian films were by this point in the life of the festival, counter to much of the (later) official analysis that it was only during the war years that propaganda took over.

Alle Madri d'Italia translates as "Mothers of Italy." There is an early inter-title celebrating the "mothers of tomorrow" and an image of a mother holding her baby in front of a poster of Mussolini, immediately intertwining Fascism, propaganda, and the reproductive survival of the state. This is a forty-minute silent film about how to produce and take care of babies. It is undoubtedly dry material, but also strangely fascinating to compare with our contemporary

modes of how-to advice, particularly in expectant mother books. The film opens with a kind of gauzy Pictorialism—a preferred way to commence these Fascists shorts—first showing a close-up of flowers, then a hazy image of mother and child.[70] After presenting a range of women in factories and others leading more agricultural lives, the film moves onto an idealized young woman, in a landscape worthy of *Heimat* photography, doing her exercises from an oblique angle and brushing her hair outdoors. Subsequently an inter-title pops up: *a donna prossima a diventare madre* (a woman next becomes a mother). A litany of advice follows: don't carry heavy things, don't ride bicycles, eat healthy, don't drink, etc. After the baby comes, there are how-tos on giving baths, breastfeeding, bottle sterilizing, dentists, and how to handle diseases. Large images of eyes begin to populate the inter-titles as they warn against fires and falling out of cribs. Not surprisingly it concludes with happy tots, but the final shot is jarring and breaks the narrative: a statue of three workers in mid-hoist, almost a precursor of photographer Joe Rosenthal's famous Iwo Jima pose. The takeaway is presumably that future workers are thus being provided for the state.

Riscatto is even more difficult to watch with a straight face, despite its shorter running time of fifteen minutes. Again, Pictorialism sets the stage, with primeval forests and never-ending seascapes. Then workers' arms begin to be seen, shoveling mud and then planting crops. There are intermittent scenes of trading, talking, and getting haircuts with a large picture of Mussolini in the background. Those shots are followed by cement trucks and men building, also using oblique angles, the most prominent lingering modernist conceit. The whistle blows, a random series of shots of breastfed babies comes in, and then they go to church and play bocce balls. The soundtrack is cacophonous and cloying, and there is only one inter-title at the beginning: "redeem the earth and earth's men." All this proselytizing seems homemade for Italian-specific consumption, advocating for very specific and comforting societal roles, with a goal of de-emphasizing any questioning of those roles.

Venice Film Festival Reception

Petrucci's compendium of 2000 films in the Venice festival further documented its reception. For Flavia Paulon's essay "A Brief History of the Venice Film Festival," in the book about the history of the festival, she remarked that for the first festival in 1932 all the Italian papers sent envoys.[71] She makes no note of foreign press present there, but does mention that the exhibition gained attention

abroad. For example, the French "waxed lyrical in their enthusiasm."[72] She then lists many papers with articles in 1932 (*Le Monde, Le Temps, Le Cinematographie Française* among them) implying—without specificity—that all had universal praise.[73] She also claims that papers in the United States were amazed at the lack of censorship, but she also did not footnote this.

Paulon is somewhat more specific in quoting Italian reviews, but they are mostly skewed toward effusive platitudes. *Il Giornale d'Italia* (Rome, July 13, 1932) focuses on the Greek muses and how cinema fits in with the high arts. The critics appeared to still have a long leash in the early years. Eugenio Giovannetti, who published a survey in *Pegaso* (September 1932), felt unshackled enough in his film criticism to praise the American slate as the best.

Paulon opines that documentaries became the most esteemed entries in the early years of the festival, likely signaling a large audience for some of the more propaganda-oriented films. Audiences were apparently extremely enthusiastic about Flaherty's film *Man of Aran* winning best foreign film in 1934, which does give this festival a distinction in relation to early definitions of documentary: Flaherty was essentially the inventor of it in the early 1920s, and, as discussed earlier, John Grierson is given the credit for first using the term "documentary" to describe one of the Flaherty's films, *Monoa* (1926). *Man of Aran* was a similarly up-close look at the everyday struggles of the inhabitants of a land of distinction, in this case fisherman trying to survive in a tiny island off the coast of Ireland, working-class material which dovetailed nicely with anti-elitism. The 1932 program even appealed to youth audiences. There were reportedly many Italian youths in attendance as well, "some . . . attended the screening of every single film . . . full of enthusiasm," signaling an excitement with moving-image propaganda in the younger generations, a key barometer of sustainable hegemonic success.[74]

The 1936 Slate: The Year of the Accord

The next chapter will turn back to photography exhibitions, as 1936 was pivotal in that arena, but any hegemonic conclusions about the Venice Film Festival must address where it was headed that year. The 1936 German-Italo screenings took place as the mass media and military relationship also deepened in concert between the two nations. If one cherry-picks just one or two films from each slate, it is indicative of the more substantive intertwining.

In documentaries, half of the German slate of eight films was procured by the state: either the Kultur Film Institute, or the Reichspropaganda, or the

Reichfilmkammer. UFA also produced one documentary that year by Walter Ruttmann (*Metall des Himmels*).[75] For Italy, the documentary offerings were even more dominated by the state than in Germany, with LUCE producing all but one of them. A prominent entry in the German feature film category was Froelich's *Traumulus* (*The Dreamer*), starring the veteran star and Nazi propagandist (he campaigned for the Nazis in the 1938 Reichstag elections) Emil Jannings. Just as in the classic *Blue Angel*, he played a teacher too simple for his times, especially in contrast to his militaristic and Darwinian surroundings.

In the Italian feature film slate, a standout there was *Cavalleria*, set among cavalry officers. Landry describes it as "conversion through melodrama."[76] The main character ends up dying in the First World War. His heroism is tied to love of a female character, but he is also shown as obedient and self-sacrificing. Landry describes his dramatic death on the battlefield in provocative terms as a form of spectacle: "The transformation of life into melodrama and spectacle offers itself as a means of legitimizing death and aggression."[77] It creates an analogy to large-scale rallies—spectacles as battlefields—as a method for preparing the participants for death in battle. The methodology of spectacle is now shifting from encouraging people to "look away" from troubling developments in the regime, toward more personal and bodily sacrifice. Militaristic themes dominated the slate that year in Italy—even more so that in Germany, with other titles such as *Lo squadrone bianco* and *Tredici uomini e un cannone* (*The White Squadron* and *Thirteen Men and a Cannon*).

The White Squadron contained colonial themes in keeping with the then-current Italian obsession with the Mussolini-instigated Ethiopian invasion in 1935–6. Ben-Ghiat has recently explored how the "empire films" like *The White Squadron* were considered a domestic necessity to battle Mussolini's international image problem after the invasion.[78] The desperation of the Italians to impress the Germans with their military prowess as the decade progressed will become acutely apparent through the exhibitions that dominate the next chapter. At the Film Festival, Goebbels had become impatient with too much internationalism, particularly due to the success of French films by Julien Duvivier, Jean Renoir, and others. He threatened to withdraw Germany from the festival, and by 1938, the selection jury was abolished.[79] 1938 was also the final year that Americans allowed their films to be shown in Italy until after the war, as extreme capitulation by the Italians was made clear.[80] In 1940 the film festival epitomized Nazism when Veit Harlan's infamous film *Jud Suess* was shown at the Festival.[81] Material in the vein of *Jud Suess* is so cartoonish, with its cunning and scheming Jewish treasurer corrupting the "good" German Duke—it actually contains less potency—without the combination of seemingly harmless + the hegemonic.

Notes

1 "The 'fundamental irony' of 'international art in a period of increasing nationalism'": Lawrence Alloway, *The Venice Biennale, 1895-1968: From Salon to Goldfish Bowl* (Greenwich: New York Graphic Society, 1968), 93.

2 Gramsci, *Prison Notebooks*, 246.

3 "Work of Art," in Benjamin, *Selected Writings*, 116. This is the second version of the essay in May 1936, a revision of the first version from fall 1935.

4 Buchloh, "Faktura," 39. My italics.

5 "Work of Art," in Benjamin, *Selected Writings*, 120–1.

6 See Martin in particular on the 1937 film accord, where he points to the "patriotic" historical film *Condottieri*, filmed in German and Italian versions at studios in Berlin and Rome. Martin, *Nazi-Fascist New Order*, 97.

7 Stone, *Patron State*, 130. And, subsequently: "Spectators were the pivotal spoke in the wheel of Fascist state patronage ... together with the desire to mobilize the population within controlled conditions." Stone, *Patron State*, 99.

8 Stone, *Patron State*, 130.

9 Simonetta Lux, ed., *Avanguardia, traduzione, ideologia: itinerario attraverso un ventennio di dibattito sulla pittura e plastica murale* (Rome: Bagatta Libri, 1990), 4.

10 Further statistical analysis is laid out in Stone, *Patron State*, 121–3.

11 Flavia Paulon, in Antonio Petrucci, *Twenty Years of Cinema in Venice* (Rome: Edizioni Dell Ateneo, 1952), 12.

12 According to Stenger's unpublished manuscript, the Funkhalle am Ausstellungsgelandes am Kaiserdamm where *Kipho* was shown burned down one year after the exhibition. Erich Stenger, *Lebenserinnerungen eines Sammlers* (Recollections of a collector) (unpublished manuscript), Collections, Agfa Fotohistorama, Cologne, 306.

13 "Creative activities are useful only if they produce new, so far unknown relations." László Moholy-Nagy, "Production/Reproduction," *De Stijl*, no. 7 (1922): 97–101, in Krisztina Passuth, *Moholy-Nagy*, trans. Kenneth McRobbie and Ilona Jánosi (New York: *Thames and Hudson,* 1985), 289.

14 Ute Eskildsen, "Innovative Photography in Germany between the Wars," in Van Deren Coke (ed.),*Avant-Garde Photography in Germany 1919-1939* (San Francisco: Museum of Modern Art, 1980), 35.

15 Bodo von Dewitz, "Erich Stenger und seine Sammlung zur Kulturgeschichte der Photographie" (Erich Stenger and his collection of historical photography), *Kölner Museums-Bulletin*, no. 1 (1997): 18. His historical collection focused on material up until the early 1870s.

16 "Ein reiches Material aus der Geschichte der Kinematographie sollte durch geschichtliche-photographische Beiträge abgerundet werden. Man hatte mich

hierzu gebeten und ich füllte einige Vitrinen und Glaskästen mit ausgesucht schönen Bildern. Es sprach sich bald herum, dass ich Sehenswertes zeigen konnte, und so habe ich seit der *Kipho* fazs ununterbrochen bis zum Beginn des zweiten Weltkriegs jährlich ausgestellt, in manchem Jahre sogar mehrmals." Stenger, *Lebenserinnerungen*, 306. A more specific idea of the juxtapositions he arranged for these exhibitions can be found in a letter from Moholy-Nagy to Stenger in December 1930 regarding material the latter had lent to *Fifo*, including a daguerreotype ("the man with the silk scarf"), a calotype, a Hill, an Auguste Salzman ("landscape with building"), and a Cameron. László Moholy-Nagy, Berlin, to Erich Stenger, Charlottenburg, December 22, 1930, Collections, Agfa Fotohistorama, Cologne.

17 The screening area is reproduced in Tymkiw, *Nazi Exhibition Design*.

18 Cited in Petrucci, *Twenty Years of Cinema in Venice*. Among various publications, Cauda wrote a short book in 1932 entitled *Italian Film* with a preface by P. M. Bardi (Nuova Europa), as well as another entitled *Cinematography for the People* in 1931.

19 Stone, *Patron State*, 131.

20 Gian Piero Brunetta documents how rapidly tens of thousands of Italian theaters proliferated, not just in urban centers but in small towns and theaters. *The History of Italian Cinema* (Princeton: Princeton University Press, 2003), 20.

21 Ruth Ben-Ghiat, *Fascist Modernities: Italy, 1922-1945* (Berkeley: University of California Press, 2001), 74.

22 Ben-Ghiat, *Fascist Modernities*, 74, quoting Mussolini from Giuseppe Rossi, "La Propaganda Agriaria Cinematografica Svolta dall'Opera Nazionale Combattenti," *La Conquista Della Terra* (February 1930).

23 Ben-Ghiat, *Fascist Modernities*, 2001.

24 Martin, *Nazi-Fascist New Order*, 49.

25 Pierluigi Erbaggio, "Istituto Nazionale Luce: A National Company with an International Reach," in Giorgio Bertellini (ed.), *Italian Silent Cinema: A Reader* (London: John Libbey, 2013), 221–31.

26 Ben-Ghiat discusses the producer Alessandro Blasetti realizing the shortcomings of the LUCE messaging machine as early as 1927. Ben-Ghiat, *Fascist Modernities*, 75.

27 H. H. Wollenburg, in Petrucci, *Twenty Years of Venice*, 37. Wollenburg published *Fifty Years of German Film* in 1948 (London: Falcon Books) in which he charted the determination of the Nazis to take over the film industry for use in propaganda, including the founding of the Reich Chamber of Films before all other chambers. See Pamela M. Potter, *Art of Suppression: Confronting the Nazi Past in Histories of the Visual and Performing Arts* (Berkeley: University of California Press, 2016), 82–3.

28 Art historians such as Maud Lavin are extremely straightforward about this as Sagan's sexual orientation, although she did marry later in life.

29 Wollenberg, in Petrucci, *Twenty Years of Venice*, 38.

30 Mordaunt Hall, "Girls in Uniform," *New York Times* (September 21, 1932).

31 Landy, *Fascist Film*, 230.

32 Landy, *Fascist Film*, 245. Ben-Ghiat observes about this film that the Italian press at the 1932 Biennale embraced it as "profoundly" Italian, despite it seeming to "undercut fascist resocialization." Ben-Ghiat, *Fascist Modernities*, 84.

33 Landy, *Fascist Film*, 245.

34 Paulon, in Petrucci, *Twenty Years of Venice*, 15.

35 Ekk studied with the revolutionary Soviet theater director Vsevolod Meyerhold, and Soviet writer—and major theorist of the left—Osip Brik was a screenwriter on the film, so the film had a very strong Communist pedigree.

36 Paulon, in Petrucci, *Twenty Years of Venice*, 14.

37 Kracauer, *From Caligari to Hitler*, 259.

38 I believe Kracauer to be too dismissive of this possible reading, in his rush to proclaim this as representative of the German people embracing the irrational.

39 The most famous city symphony film being 1927's *Berlin: The Symphony of a Great City*, Ruttman's classic of quick cut "kaleidoscopic" scenes, flashing a street gutter here, some close cropped pedestrian legs there, etc.

40 Kracauer, From *Caligari to Hitler*, 24.

41 Wollenburg in Petrucci, *Twenty Years of Venice*, 40.

42 Kracauer, *From Caligari to Hitler*, 226.

43 Wollenburg writes that the exodus out of Berlin briefly goosed the Austrians to make more lauded films in 1935–6. Wollenburg, in Petrucci, *Twenty Years of Venice*, 40.

44 Wollenburg, in Petrucci, *Twenty Years of Venice*, 41.

45 Kracauer, *From Caligari to Hitler*, 267.

46 Kracauer, *From Caligari to Hitler*, 269.

47 Kracauer devotes an unusual number of pages to this film, including appendix analysis.

48 Kracauer, *From Caligari to Hitler*, 188, quoting Paul Rotha, *Documentary Film* (London, 1936), 131.

49 *Manovre navali*, see Appendix.

50 See Caruso, *Italian Humanist Photography from Fascism to the Cold War*, 18.

51 Erbaggio, "Istituto Nazionale Luce," 221.

52 Martin, *Nazi-Fascist New Order*, 52.

53 The Varieta could be any number of documents about variety shows that the "Institute" produced.

54 Martin, *Nazi-Fascist New Order*, 68.

55 Martin, *Nazi-Fascist New Order*, 69.

56 "But as we mentioned, the Third Reich left its visiting card in the able hands of Leni Riefenstahl, with her Triumph des Willens. Wollenburg, in Petrucci, *Twenty Years of Venice*, 40.

57 Goebbels's diaries debunk Riefenstahl's claims of being forced. See Longerich, *Goebbels: A Biography*, 808, n110.

58 Fiss points out that because the camera was hidden in the back of the car in the motorcade, the crowd was more unselfconsciously adoring. Fiss, *Grand Illusion*, 167. Riefenstahl used a highly diversified list of dollies: roller skates, fire truck ladders, and elevators among them. Fiss, *Grand Illusion*, 172.

59 Kracauer, *From Caligari to Hitler*, figures 59 and 60.

60 Kracauer, *From Caligari to Hitler*, 301.

61 I specify the time frame because many consider his *Caligari to Hitler* to be passé in methodology, but it is still invaluable as a catalogue of German interwar films, as and for his analytical skills—including the way he pinpoints that this film unlike other "monster" spectacles pretends to be an expression of people's real and spontaneous feelings.

62 Pohlmann, "Political Weapon," 287.

63 C. A. Lejeune, *Cinema* (London, 1931), 284, quoted by Kracauer, *From Caligari to Hitler*, 155. Kracauer then mentions blood-and-soil literature of the Nazis, although he does not get specific.

64 Goebbels was reportedly excited about the way that this film achieved the foreclosure with more "polish" than the more didactic Nazi films. Eric Rentschler, "There's No Places like Home: Luis Trenker's The Prodigal Son," *New German Critique*, no. 60 (Autumn 1993): 42.

65 Rentschler, "There's No Place Like Home," 33.

66 Rentschler, "There's No Place Like Home," 53.

67 Landry, *Fascism in Film*, 19.

68 Martin, *The Nazi-Fascist New Order*, 71.

69 Martin, *The Nazi-Fascist New Order*, 71.

70 Although Caruso has explored interesting ways in which Pictorialism was considered an anti-Fascist—albeit conservative—style in Fascist Italy, very different from how it was levied in Nazi Germany. See Caruso, *Italian Humanist Photography from Fascism to the Cold War*, 24.

71 Paulon, in Petrucci, *Twenty Years of Venice*, 12.

72 Paulon, in Petrucci, *Twenty Years of Venice*, 13.

73 Paulon, in Petrucci, *Twenty Years of Venice*, 13. In addition to critical reception, audience reception was likewise positive: "some young Italians attended the screening of every single film . . . full of enthusiasm," 17.

74 Paulon, in Petrucci, *Twenty Years of Venice*, 17.

75 Although there is a tendency to associate Ruttman with the "avant-gardism" of the city symphony Berlin, he became an enthusiastic propagandist, assisting Riefenstahl on Olympiad. He was fatally wounded in 1941 producing a film on the Germany army. As David Thomson notes, his pure formalism was always "ripe" for totalitarian appropriation. David Thomson, *A New Biographical Dictionary of Film* (New York: Alfred A. Knopf, 2002), 768.

76 Landry, *Fascism in Film*, 146.

77 Landry, *Fascism in Film*, 148.

78 Ruth Ben-Ghiat, "Moving Images: Realism and Propaganda," in Germano Celant (ed.), *Post Zang Tumb Tuum: Art Life Politics: Italia, 1918-43* (Milan: Prada Foundation, 2018), 385.

79 Martin, *The Nazi-Fascist Order*, 137–8.

80 Ben-Ghiat, "Moving Images," 385. Hence, the last year of Photofascism's Appendix is 1938.

81 Wollenberg, in Petrucci, *Twenty Years of Venice*, 41. See also David Culbert, "The Impact of Anti-Semitic Film Propaganda on German Audiences: Jud Suess and The Wandering Jew (1940)," in Etlin (ed.), *Arts, Culture*, 139–57.

Both/And

German and Italian Photography Exhibitions in 1936–7

"A Period of Assertion"

Goebbels's most recent biographer Peter Longerich—and the first to make use of Goebbels's full range of diaries (30,000 pages)—speaks of the autumn of 1936 through the spring of 1938 as a period of assertion, describing the environment in Germany as one in "the absolute grip of National Socialism on the central areas of cultural policy."[1] So, from the perspectives of the Nazis at least, hegemony had to a large extent been achieved; the German public had either bought in to National Socialism, or were looking the other way, or had left the country.[2]

Right at the start of this period was the launch of the Four Year Plan, and a massive propaganda effort, directed especially toward a domestic audience, to demonstrate how much the lives of the German people had improved under Hitler and would improve further. The march toward economic and political hegemony through the Four Year Plan also coincided with the culmination of Goebbels's centralization of all circulated visual culture. In addition to cultural policy, 1936 was a key year of consolidation for the Nazi power structure. Unemployment was falling, so the Nazi "experiment" was more easily portrayed to the outside world as functional, and was less and less vulnerable to interrogation.

Introduction to *Deutschland* (1936) and *Give Me Four Years' Time* (1937)

To underscore the key role of photography in the hegemonic vision of the Nazis, photo historian Ulrich Pohlmann stated in his essay "Not Autonomous Art But

a Political Weapon" that the "elaborately staged photography exhibitions and industrial fairs between 1933 and 1937 were major milestones on the path of National Socialist attempts to achieve hegemony."[3] It is not surprising that the Nazis would consider well-received industrial fairs to be key to gaining respect in the global economic sphere; however, the emphasis on photography exhibitions as well as exhibitions that fused the idioms of industrial fair and photography exhibitions were just as important to their goals. The ultimate expression of the two intertwined was *Gebt mir vier Jahre Zeit* (*Give Me Four Years' Time*), "the most complex exhibition ever planned by the Nazi regime in which . . . large-format photo panoramas and photomontages were put to use for propaganda purposes for the last time."[4]

The Nazis announced the new economic plan in September 1936. And their cultural reorganization had at this point entered its final phase through the purging of "degenerate art" from museums, of likewise "degenerate" professors from academic faculties, and of the commissioning of large-scale Fascist buildings in the neoclassical style.[5] Photographs on display in exhibitions such as *Deutschland*—on view during the 1936 Summer Olympics—fully absorb this peak hegemonic atmosphere through their modes of display (see Figure 5.1). The dramatic harnessing of artistic mediums is reminiscent of Adorno's statement about works of art, which is also applicable to exhibition display if one considers it as a medium in its own right: "History is constitutive of works of art. Authentic ones give themselves over completely to the material substance of their historical period . . . they represent the historiography of their times."[6] The methods of display were dependent on what was technologically available to serve National Socialist purposes. More sophisticated techniques of photo enlargement came onto market concurrent with the rise of the Nazis. In addition, as Lugon as observed in his analysis of the history of photography's scale, there developed between 1930 and 1937 "limitless reams of large-scale photographic paper." The available exhibition material suited the ideology perfectly, and, in essence, wrote the history of the times.[7]

There were noticeable differences between the creation of mass ornaments in *Die Kamera*'s Hall of Honor and the wholesale embrace of Hitler above all else in *Deutschland*'s Hall of Honor, representing a distinct progression from 1933 to 1936. The sham of a mass movement of "the people"—which was so effective as an enabling hegemonic tool both at the MRF in Rome and at the *Die Kamera* in Berlin—seems to completely give way to the absolute cult of the Führer, essentially a movement from all to one. However, once within the *Deutschland* exhibition, one is once again exposed to the Volk. The "Coming

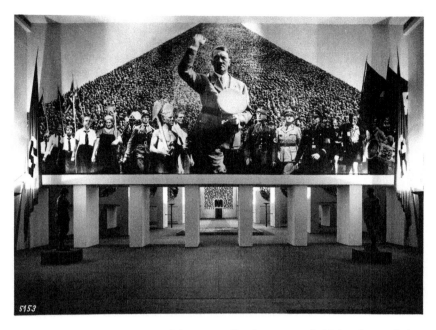

Figure 5.1 The *Deutschland* exhibition: Hall of Honor with Hitler front of photo montage, 1936. Courtesy Dittrick Medical History Center, Case Western Reserve University.

Nation" display featured youth organizations, as well as a rally photo blowup on the right that appears taken straight from *Triumph of the Will* (Figure 5.2). So the Führer cult is more programmed than at *Die Kamera*, but a dialectic with the Volk remains.

Interestingly, Wischek, the director of the Berlin Office for Exhibitions, Trade Shows, and Tourism, did not approve of the aesthetics of the 1936 *Deutschland* show at all. As Tymkiw has elucidated so effectively, Wischek used an article in the influential journal *Messe und Ausstellung* to implicitly critique *Deutschland* and instead raise up the MRF. As Tymkiw cites from the article:

> The 1932 Mostra della Rivoluzione Fascista marked the beginning of a new moment in the development of European exhibitions, one that used all the most modern dramatic media to provide a comprehensive and rousing picture of the emergence and effect of a new political system, Fascist Italy, and in so doing, totally transformed the exhibition as an instrument of political conquest and education. . . . In their methods . . . it takes a combative approach in which it portrays life, the Volk, the state in its accomplishments and it most recent goals. Through the forcefulness of its means of representation, the new approach stirs, convinces people, sweeps them away.[8]

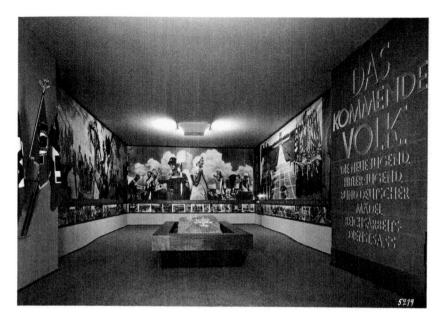

Figure 5.2 The *Deutschland* exhibition: "the coming nation" display on youth organizations, 1936. Courtesy Dittrick Medical History Center, Case Western Reserve University.

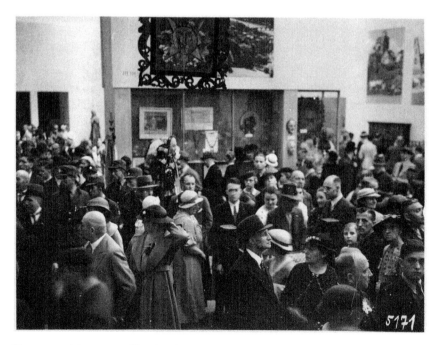

Figure 5.3 The *Deutschland* exhibition: crowd viewing exhibit, 1936. Courtesy Dittrick Medical History Center, Case Western Reserve University.

Whatever Wischek thought regarding the ideal way for exhibitions to achieve "conquest," evidence exists that Deutschland's version of the scopic Führer and all-encompassing Volk scenes were seen regularly by packed crowds (Figure 5.3).

Organization of *Give Me Four Years' Time*

During the progression of 1936 into 1937 in Germany "there was a palpable change in its visual propaganda."[9] 1936 also witnessed the signing of the key pact between Germany and Italy, the Rome-Berlin Pact, which initially seemed like a mutually beneficial pact for two increasingly ostracized nations, but which eventually underscored Italy's increasingly subordinate role in the relationship as the 1930s progressed.[10] Thus, in many ways, the massive German spectacles of 1937 display culture were a direct result of the consolidation of power the year before: put in chronological order of opening they included *Give Me Four Years' Time* (early May), Paris World's Fair (late May), and *Degenerate Art* (July).

The three 1937 exhibitions mentioned above create an interesting German troika, but the Paris World Fair and Degenerate Art were not primarily photographic and have been analyzed very extensively elsewhere—Paris most helpfully in Fiss, and the Degenerate Art reconstructions by the Neue Galerie (2014) and LACMA (1991)—so the focus here is on *Give Me Four Years' Time*. Although *Give Me Four Years' Time* could be considered more of an industrial fair than a photo exhibition due to its three-dimensional modeling of accomplishments such as the Autobahn and industrial machinery, photography was interspersed throughout all sections of the show. The photographic press actively reviewed the exhibition, including *Der Photograph* and *Photo-Fachhändler*. *Der Photograph*'s review delves into the foreword of the exhibition catalogue, and used it to contextualize *Give Me Four Years' Time* as a presentation of "wide-ranging . . . statistical and documentary (tatsächlichen) exhibits."[11] The foreword also states: "the exhibition is the most eloquent document for . . . great natural praise." And: "with this exhibition the German nation hands honors to the leader and his work."[12]

The design principle of statistics + photos + architecture again underscores the takeaways from formerly avant-garde exhibitions like the BWU, but with the addition of the final "keys" in the reshaping of public space in the 1930s which Schnapp described in his "Projections" essay: first, public spaces increased the prevalence of statistical data and visualizations as a means of mass persuasion; numbers count "as never before" and are translated visually as charts, graphs, and

tables—and this is an apt description of BWU. But secondly, he theorized that those spaces intensified the cult of singularity as masses look for connections; architecture is "summoned" to provide the needed stage set (e.g., the *Mostra* and *Die Kamera*). And thirdly, the spaces translated the interplay between hero and masses: this became a hallmark of Hitler and Mussolini-orchestrated display environments as the 1930s progressed, such as *Give Me Four Years' Time*.[13]

Large-scale photography also formed a key aspect of a "demagogic design repertoire whose realistic and monumentalizing impact was intended to influence especially those segments of the population that believed they could elude the grasp of National Socialist propaganda by adopting an apolitical posture."[14] Pohlmann means this analysis as a response to German art historian Wolfgang Kemp's suggestion that photography had been replaced as a design tool by this time by retrograde mosaic and fresco.[15] Pohlmann rebuts this very persuasively, arguing that while that may have been true about paintings at international prestige affairs like the Paris World Fair, domestically—and this is important for *Photofascism*'s focus on national audiences—photography was still looked upon as a way to influence the local public, especially those who might still be non-believers. In this way propaganda could be used as the Nazis "persistently traced each independent opinion and dragged it out from the remotest hiding place,"[16] to convince, and, if need be, coerce.

This is not to supersede the hegemonic argument of willing coercion: a majority of the population had left themselves open enough to Nazism to buy in. As Paxton has explored, recent scholarship undergirds the level of consensus that existed among the German public.[17] But even the holdouts would have had a difficult time finding space to breathe. Public photography constitutes a kind of "street awareness" that cannot be easily escaped: it seeps in, just by walking down the street in the form of posters, kiosks, banners, and covers of illustrated magazines, including advertisements for exhibitions.[18] Repetitious imagery on the streets negates unawareness, even if one wants to not know or not see. Thus, the street presence of propaganda is another method for using the subconscious to stomp out any residual nonconformity—or attempting to—complementing the impact of the more highly choreographed public spaces.

The methodology of "no escape" certainly permeated the installation of *Give Me Four Years' Time*. As in *Die Kamera*, there was the (reception) hall that all had to pass through. It contained nine massive "picture books of history" (Figure 5.4), photo-documentation of Nazi points in history accompanied by, in the hyper-masculinized words of a contemporary reviewer, "powerful strains of symphonic music and virile literary quotations."[19] The pages turned via hidden

rotary mechanisms, each revealing six images. A national emblem with cloth slats coming down in the form of sun rays, complete with lighting design, seemed to contrived to create a kind of ecstatic effect in the viewer, an apotheosis for each individual, being raised to the Nazi heavens through their experience of visual mythology. These images were beyond monumental: they were each thirty feet high and twenty feet wide, swallowing up any semblance of human scale—the kind of immense image made possible only through then-current technology. Figure 5.4 shows a packed audience which demonstrates scale, but Michael Tymkiw has recently published stunning close-up images documenting the individual photographs in the turning "picture book" vis-à-vis human scale, including a shot of the front end of a locomotive, seeming to chug dangerously toward the path of the dwarfed female spectator.[20]

An additional contribution of Tymkiw's research is to introduce the sixteen-minute documentary, also titled *Gebt mir vier Jahre Zeit*! It was screened in Hall 1a, in a space called the Tonkino ("sound film"), which closely resembles the open-plan theater space used in BWU (see Figure 4.2). Film grabs from the documentary became source material for the picture books, including Hitler "working" to break ground on constructions sites.

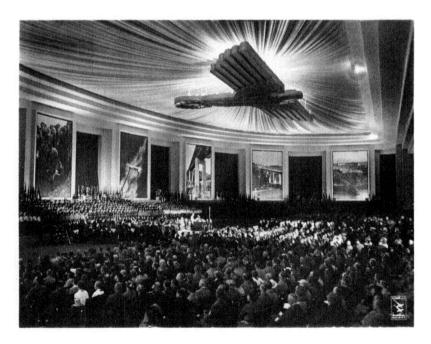

Figure 5.4 *Give Me Four Years' Time* Opening ceremonies, 1937. Courtesy Dittrick Medical History Center, Case Western Reserve University.

His acting abilities in these set-ups proved lesser than Mussolini during his wheat-threshing performances. Tymkiw doesn't overly discuss the film in formal terms due to a stated desire to focus his scope, but a few points of analysis reveal a surprising continued reliance on certain New Vision principles, even during this late phase of Nazi aesthetics, and even as the hegemonic project continued unabated.

Just about one minute into the film, the viewers witness Hitler digging ditches, but in a seemingly more urban environment than Mussolini in the rural setting of the earlier discussed film *Trebbiatura*. These images are followed by workers engaged in brick laying and some fascinating close-ups of machinery that are as close as one gets to the New Vision in this film. Subsequent views of the Autobahn—a big subject within the larger exhibition—are interspersed with Hitler speeches touting economic progress. Some of these speeches have an earthier feel than the usual scream speeches one associates with Hitler's pontificating; his voice seems calmer, and in some parts a bit throaty. To be sure, scream speeches are still utilized in shots of large-scale rallies, but other shots included footage in more intimate settings with smaller crowds. City building alternates with classic rural imagery: lines of men walk through Bavarian-looking homes carrying shovels and singing songs, with happy score music backing them up. Eventually the workers morph into images of tanks lining up. The cuts are extremely awkward, and clearly not on purpose, with close-ups of the Nazi eagle insignia plopped in randomly and ineffectively. That said, Tymkiw's overall argument that modernism and Nazi aesthetics cannot always be so easily bifurcated as in the past is borne out by those machine close-ups, which contain the most sophisticated dissolves in the film.[21]

The most aggressive possibilities vis-à-vis photographic blowups were pursued doggedly in the rest of this exhibition as well. There were two different halls, with different focuses: one was a national political section with a special section on professional photography, press photographers, and amateurs; the other was for industry, crafts, and an exhibition for photography, printing, and reproduction. The Hoffmann portrait of Hitler in Hall 2 where he was surrounded by a montage of farmers, workers, and belching smokestacks was enlarged to a size of forty meters high (Figure 5.5). That translates to 131 feet; for comparison, it is the height of certain bridges over water, the Christ Redeemer statue hovering over Rio de Janeiro, or just shy of the Statue of Liberty and the visitors in the photograph underscore this monumentality. To revisit Karen Fiss's point, the Nazis were clearly desirous of a "scopic inscription of a unifying

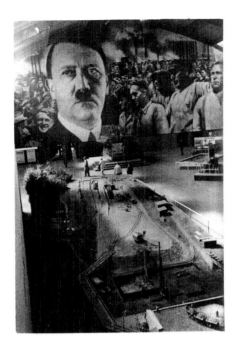

Figure 5.5 *Give Me Four Years' Time* Mining model beneath Hitler mural; people viewing, 1937. Courtesy Dittrick Medical History Center, Case Western Reserve University.

and totalizing will."[22] Here are related thoughts from the contemporaneous *Der Photograph* critic:

> And thus, corresponding to the main themes of the exhibition, each of the folding partitions features a vibrant and *reality-filled* depiction of achievements in the areas of land reclamation, food production, the revival of the construction industry, etc. In the last and perhaps most beautiful image, boys from the Deutsches Jungvok, girls from the Bund Deutscher Madel, a workman, a man-at-arms, and an SA man are shown marching in a unite front as if into the future, surrounded by examples of the National Socialist reconstruction.[23]

There is a remarkable similarity here to Bayer's oft-reproduced montage from the brochure produced for the *Deutschland* exhibition, with the farmer, worker, and soldier emblazoned over yet another oceanic mass, to imply empowerment. But in *Give Me Four Years' Time*, there is subservience between those images of "the people" and then the Führer and only the Führer, standing alone, in a different perspectival space.

Tymkiw undertook in his research to complicate this view of these montages in *Give Me Four Years' Time* as representative of that "totalizing will." One way

he does this is through an argument against the spectators being immobilized, and he describes instances in which they were forced to move their heads to see different perspectives.[24] In this author's opinion, that level of movement is not radical enough to rebut the more robust control the viewer had at, for example BWU, to literally create their own display experiences. Tymkiw's more convincing argument against immobilization involves the conveyor belts where visitors could grab products, as well as fantasize themselves as submarine soldiers. It is still not quite at the level of creating a variety of displays—of having the power to re-curate—and the product consumption was more akin to buying than learning, but the analysis of visitors acting in their own movie in the submarine display is riveting. In the end, the strongest argument against a purely photofascist read of the show is that at *Give Me Four Years' Time*, a self-consciousness regarding the construction of the murals—exposed scaffolding in particular—is present in a way not expected during peak Nazi Fascist display. It was still "unifying," but not smoothed out. So the show's design is somewhat anomalous in the German hegemonic program, but the intent is not. The intent at BWU was to empower the viewer with self-learned information. The intent at *Give Me Four Years' Time* was to pump up the populace for acceptance of the program, and eventually war.

On a final note regarding continuity: although even more aggressively focused on the Führer cult than *Deutschland,* and less on individual photographers than *Die Kamera,* there was also some continuity in *Give Me Four Years' Time.* Many artists returned from *Die Kamera* to appear in *Give Me Four Years' Time.* Erfurth's portfolio of Reich leaders, apparently undertaken on the advice of Grainer, was installed in Berlin as part of *Give Me Four Years' Time.*[25] A contemporaneous review from the time also notes Lendvai-Dircksen's "seven marvelous portraits of Nordic boys and girls" in the Society of German Photographers, continuing her legacy of feeding an Aryanized version of "reality" to mass numbers of spectators.[26]

Critical Reception of *Give Me Four Years' Time*

According to secondary sources, nearly one and a half million people reportedly attended *Give Me Four Years' Time* in 1937, which would comprise half of the population of the entire city of Berlin in the present day.[27] In addition, as with the Italian MRF, the populace at large was encouraged to submit items to the exhibition. In this case, rather than personal artifacts, there was a photography

competition with the theme "Four Years of Reconstruction" that resulted in sixty thousand submissions. Photographic submissions from the public would meet the criteria of the hegemonic attempts to meet halfway "those they seek to dominate." So, as with MRF, there existed the narcotic of the participatory: that we, the masses, are part of this movement, and invested in it, and empowered by it, and are even generating it.

Of course, they were nothing of the sort. Despite the continued and vilely brilliant use of bottom-up metaphors such as "blood" and "soil"—also favored by the Italian Fascists as seen earlier in the turbine photomontage—the very existence of Nazi-Fascism depended on power being in reality a one-way street, all top-down. The shell is created by the state. The people then fill it with their dreams. Although it is unfortunate that one must rely on biased publications from the time, what can be gleaned from contemporaneous reviews is that the reviewers present themselves as authentically in thrall. At the least they were given enough fodder from the shows to fake it expertly. Here is a firsthand account of the aforementioned display of the "picture books" of history:

> From the wide side of the courtyard coming between Halls 1 and 2, a huge semicircle. . . . Radiant light floods breaking on a seven-step staircase at the foot of the 120 meters wide sweeping arc wall. It is nine times divided: nine pedestals almost 9 meters high and 6 meters wide pictures raise up to the ceiling, the images (books) of elapsed four years. Each of these book images consists of 6 individual tablets, technically under artistic unique photo documents. They are illuminated by powerful spotlights of the base at the foot and how turned over by an invisible hand by a hidden mechanism. Gears up to 6 quintals in weight move there.[28] In precisely measured timing the headlights light up the giant panels begin silently turning under the powerful sounds of symphonic music and *manly/virile* poetic words. A solemn, unforgettable impression. And also in the history of representation of technology and photography, a remarkable event, because here was the first time and having flown to the attempt made to a moving, language and accompanied a photo show with music. It has created a completely new style of representation art that combines the sober intensity of photos with the emotional effect of music and poetry. Almost like you say, a worldly photo liturgy.[29]

What is described is a spectacle ridiculously over the top, and yet, the audience has spent years expecting the enormity of it through a combination of their own desires, and the aforementioned "false totality" and the "scopic inscription of a unifying and totalizing will." Hence apparently leading to a more reverent attitude—if the reviewer is to be even somewhat believed—complemented by

the fact that the viewer of the so-called picture books of history had to mount stairs to reach each of them, as if worshipping at a succession of altars—altars of faux-history. This construction of an altar-like ambiance ties in with the reviewer's statement of photo-liturgy, and also creates more clear connections with the MRF's Altar of Martyrs. Despite the fact that Goebbels had methodically dismantled any possibility the church had of influencing cultural policy—he wrote in his diary in 1937 about the church: "we want to liquidate it"[30]—he clearly understood the church as a hegemonic building block and how he could use the shell of religious structures to inject a sense of awe and self-sacrifice. The Altar of Martyrs also intertwined the multisensory and the spiritual, albeit not the photographic: flashing light effects swirling around a central altar with the words "Present" repeated over and over.

Parallels with 1936–7 Italian Exhibition Culture

In the wake of the MRF, audacious exhibition design continued to thrive in Italy through 1937. Indeed, the direct influence of the MRF—its "dynamic deployment of large-scale photomontages, muscular use of letter forms, and immersive approach to installation"—trickled down through key participants like Sironi.[31] It is also important to take into consideration—as will be analyzed below—in what ways the second iteration of the MRF of 1937 was woefully lacking in comparison with the first. It allows an opportunity to emphasize the importance of design innovation in selling Fascist ideals more convincingly.

Jeffrey Schnapp explores in his essay "The Spectacle Factory" the "great" generation of architect-designers surrounding Mario Sironi as he undertook a large part of the organization of the Fifth Milan Triennial (1933).[32] They included Giuseppe Pagano and many others, who designed a variety of landmark exhibitions in the years between the two Triennials. Those exhibitions made particularly grandiose use of montage, photographic enlargements, and three-dimensional human cutouts, such as *Esposizione dell'Aeronautica* Italian (1934) and *Mostra Nazaionale dello Sport* (1935). But displays within the later 1936 Triennial were likewise photographically arresting.

A 1936 case in point in was a room dedicated to new housing ideas and plans (Figure 5.6). In this display, the architects Bianchetti and Pasquali utilized the most effective of Bayer's pre-BWU techniques, including large photo blowups—containing New Vision viewpoints—on industrial-looking suspensions, to create a floating sensation on the right-hand side, as well as the tilted views on the left.

Concurrently, as the viewer was headed straight toward the enlargement on the far wall, on the left, the architecture of the Palazzo dell'Arte was incorporated beautifully with Bayer-like tilted images alternating with stabilizing pillars. The subject matter regarding the pragmatic organization of the modern space, as seen in the layout on the bottom left of (Figure 5.6), likewise brings one back to the utilitarian ambitions of the BWU. On the same trajectory of the hyper-pragmatic was the exhibition in the *Salone dell'Auto* in Milan, 1937, hocking Shell products. But they used a show-stopping enlargement, with a dynamic interspersing of figures, cards, and flying flags (Figure 5.7, lower left). However, as with MRF and *Give Me Four Years' Time*, the radical potential of great design is undercut by the basic premise of the show: to stimulate the desire for products, which will help fund the hegemonic regime. This sets it apart from the BWU's program to educate the public about labor unions. Labor unions are not products.

Several other parallels proving the hegemonic usefulness of exhibitions can be drawn between the 1937 version of MRF and *Give Me Four Years' Time*, more so than between the former and *Die Kamera*. The suffocating presence of hyper-masculinity that characterized both Fascist regimes was omnipresent.

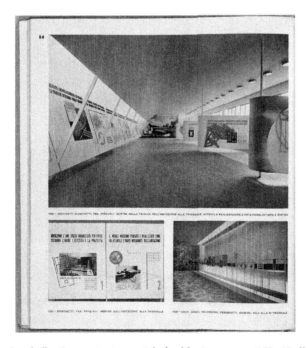

Figure 5.6 *Casabella-Costruzioni*, special double issue, no. 159–60 (March–April 1941): 54. Courtesy Avery Architectural & Fine Arts Library, Columbia University, New York.

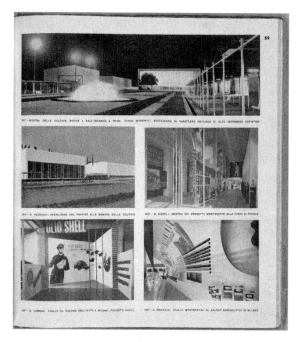

Figure 5.7 *Casabella-Costruzioni*, special double issue, no. 159–60 (March–April 1941): 59. Courtesy Avery Architectural & Fine Arts Library, Columbia University, New York.

The *Der Photo* reviewer above of *Give Me Four Years' Time* makes a point of interpreting the recited poetry being projected with the picture books of history as being decidedly "virile." The paranoia around proving virility in German militaristic society has been thoroughly articulated and illustrated by the German sociologist Klaus Theweleit.[33] It was likewise a concept coursing through most of Mussolini's visual culture, including his infamous shirtless public appearances, a theatrical posture that continues to be used today by proliferating authoritarians.[34]

Another parallel with MRF which actually differentiates *Give Me Four Years' Time* from *Die Kamera* is a de-emphasis on individual photographers, avoiding the appearance of elitist dependence on artistic merit which has much potential in meeting a mass audience where they live, so to speak. The reviews barely mention them, with a few exceptions like Lendvai-Dircksen; instead, there are analyses such as this, later in the 1937 *Der Photograph* review:

It is not the purpose of this exhibition to highlight the achievements of individuals . . . rather the order of professional photographers, as represented by its best practitioners, has placed itself in the service of the lofty political idea,

that photography, for once, is not an occupation, not autonomous art . . . but political weapon, this, it seems to us, is what is essential and significant about this exhibition.[35]

This may seem a selective critique, given my applauding of this exact anonymity in Chapter 1's BWU exhibition. But the differences in intent are profound: BWU embraced anonymous photography, raising large-scale images of various workers—both in montage and in individualized portraits—above the work of individual artists. At *Give Me Four Years' Time*, we consistently have the Führer and only the Führer raised up for celebration over others. So the Nazis were able to co-opt the anti-elitist appeal of anonymous photography while still negating any substantial message of true collectivity. Unlike BWU, *Give Me Four Years' Time* is consistently dotted with the dictator.

Pohlmann summarizes the key role that exhibitions plus photography played in carrying off the Nazi façade/charade:

> Under National Socialism, exhibitions became the ideal stage for presenting constructed realities. With their suggestive concentration, they sketched an emphatic portrait of political conditions in the National Socialist state. Although National Socialist visual propaganda always invoked the authenticity and documentary character of photography, its images of political life and the daily lives of the people were anything but "objective" reproductions of facts and events; on the contrary, they were documents of their one-sided reconstruction.[36]

However, they weren't likely seen as such at the time; it is more with hindsight that they are understood as those one-sided documents rather than a give-and-take with the populace. As Tymkiw posits, the audience *senses* engaged spectatorship, but retroactively it clearly contained only the appearance of a two-way street.

The design for this exhibition was as far as the Nazis could push. As Pohlmann demonstrates, after *Give Me Four Years' Time*, and between 1937 and 1945, there was no other photographic event that was comparable to *Give Me Four Years' Time*, and the trade office that sponsored it closed in 1942. Thus is reached the end of the German part of the story. However, the Italian part of the tale continues.

Afterlife of the *Mostra*, 1937

The original *Mostra* in 1932 was considered such a public relations coup that it was reformulated twice after its closure in 1934. In 1937 it was re-installed at the Galleria di Arte Moderna e Contemporanea in Valle Giulia to celebrate

the bi-millennium of the birth of Augustus Caesar, with additional rooms that trumpeted the recent conquest of Ethiopia and the successes of Franco in the Spanish Civil War, as well as what things "would" look like in a post-Fascist victory Empire (Figure 5.8), using large-scale redrawn maps.[37]

Indeed the autumn of 1936 was as successful for the Italian Fascists as for the Germans. It brought Mussolini's high point of popularity due to the Ethiopian invasion, as well as the Rome-Berlin Pact, and the later MRF exhibition's contents reflected these new world realities. Despite these developments, most of the same artifacts from 1932 were shown. This is evident from comparative installation shots but also from the astonishing fact that nearly every artifact displayed in 1937 was documented.[38] The mural of Fascists abroad, for example, described in detail in Chapter 2 is clearly displayed in both iterations (Figure 5.9). However, the architectural elements in 1937 were so dramatically inferior that scholars have the opportunity to assess just how essential the exhibition design was to creating visually coercive moments in 1932. Photography alone in these images does not contain the "sheer force of presence" of the earlier iteration; it needed to be fitted into a compelling design. One can see this acutely by revisiting Salas A, G, and O.

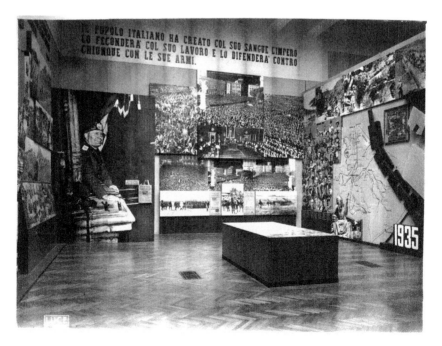

Figure 5.8 Sala 25 ("Impero") of the *Exhibition of the Fascist Revolution*, 1937. © ACS, MRF, fasciolo 2 (*Mostra* 1937), Album 8, neg. # 129 (Aut. 1593/2019).

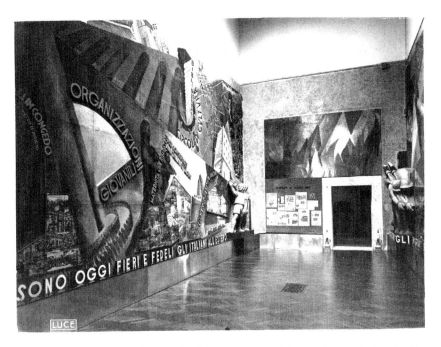

Figure 5.9 Sala 1 ("Fasci all'estero") of the *Exhibition of the Fascist Revolution*, 1937. ©
ACS, MRF, fasciolo 2 (1937), Album 7, neg. # 12. (Aut. 1593/2019).

The descriptive denotations of the 1937 show were no longer A-P, but rather
they have numerals. Therefore, what was Sala "A" (1914) became now Sala no
4, "Intervento." One of the installation shots (Figure 5.10) demonstrates the
inability to replicate the design flourishes of the 1932 iteration. One primary
reason that the space—if you place it side by side—is less compelling is that
the lesser presence of dense photographic material inarguably compromises
the imagistic power. At this point the "documentary material" that was to be
"implanted architectonically" as stated in the original catalogue was reliant solely
on pieces of paper—mounted in the same perpendicular vitrine yes, but without
the backdrop of grandiose, overlapping draft call-outs, and aggressive statuary. It
is also lacking in dynamic typography, with a much drier presentation of didactic
texts above the vitrines. With Sala G (Figure 5.11), the later iteration has parquet
floors, staid white walls, messy flags hung up, and none of the stronger design
assertion of the original seen in Chapter 2; such as the dark contrasts behind the
minions following the leader, and the dynamic anthropomorphic figure filled
with photo-references to Il Duce.

And, finally, vis-à-vis Sala O, the great room of Terragni: in 1937, it's as if
the entire room was placed in a great shrinking machine (Figure 5.12). There is

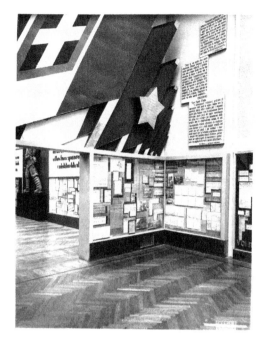

Figure 5.10 Sala 4 ("Intervento") of the *Exhibition of the Fascist Revolution*, 1937. © ACS, MRF, fasciolo 2 (1937), Album 7, neg. #24. (Aut. 1593/2019).

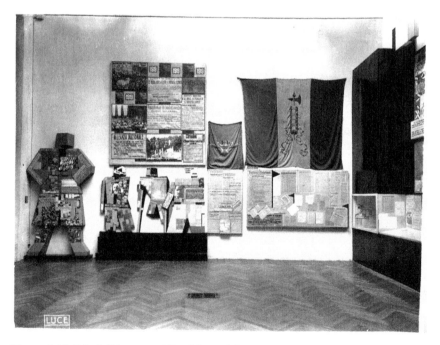

Figure 5.11 Sala 9 ("Anno 1919") of the *Exhibition of the Fascist Revolution*, 1937. © ACS, MRF, fasciolo 2 (1937), Album 7, neg. #47. (Aut. 1593/2019).

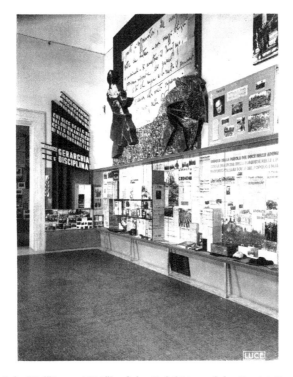

Figure 5.12 Sala 17 ("Anno 1922") of the *Exhibition of the Fascist Revolution*, 1937. © ACS, MRF, fasciolo 2 (1937), Album 7, neg. #92. (Aut. 1593/2019).

none of the monumentality, none of the ability to wrap the visitor up physically into the spaces, and therefore enrapture them. Indeed, some of the areas, such as the turbines, or the "iron man," which appeared so effective in the 1932 version, take on the look of a grade school science fair in comparison with the theatrical phantasmagoria of the earlier iteration (see Chapter 2), partly because the limitations of scale work to make everything appear 2D rather than 3D. The later Sala P also reminds one of the needs for stark contrasts in the coloration of spaces, as the lack thereof detracts mightily from the original's striking effects. This more lackluster version of the exhibition would be installed yet again in 1942. It is as if the Fascists felt they had to drag out old, tired hits again and again, as will be seen in the next chapter: bad design but with the addition of virulent anti-Semitism. What is clear is that, tragically, the superior design elements coincided with the period when extreme persuasion was needed. The best talent unleashed the conditions that were most ripe for consent in 1932. The public went along, and hegemony grew into domination by the time the regime began curdling.[39]

"Let's Hope He's Not Deceiving Himself"

Later in the year 1937, Mussolini went to Munich to begin his state visit. He moved on to Berlin where the Nazis stage-managed large-scale rallies on the streets and in the Olympic stadium. Goebbels announced attendance of three million in total, between the street crowds and the stadium itself. The public was strongly encouraged by the daily newspapers to be there. Once there, they were not allowed to leave unless granted special permission, despite often-unbearable conditions, such as oppressive heat and claustrophobic surroundings.[40] Although Goebbels continued his long-standing fawning over the charisma of Il Duce, an ominous statement appeared in the propaganda minister's diary entry about him on September 29, 1937: "But let's hope he's not deceiving himself."[41]

It seems that Il Duce was indeed deceiving himself. The Italians had convinced themselves that the relationship was one of equals. And in their minds, when it came to cultural initiatives, the Italians would inarguably take the lead due to their historically dominant role in the realm of artistic production.[42] But the following year of 1938 would provide a series of reality checks on the relationship. Despite the Italian-German Cultural Accord of that year, the Italians would become more subordinate to the German machine, and feel more self-conscious about the idea that they had to get tougher. And thus the mutual conversation within the photo and exhibition cultures of the two nations naturally concludes at this juncture. However, the denouement of the relationship necessitates a short final chapter. As revealed in Chapter 6, Italy's increasingly desperate position in relation to their German partners urgently needs to be explored further: both for its pathetic machismo and vile racism and for its uncomfortable parallels to certain contemporary political discourses both in Europe and the United States.

Notes

1 Longerich, *Goebbels: A Biography*, 328.

2 This stage of Fascism in Gramsci is more recognizable as "domination" than hegemony, but as Walter L. Adamson has explored, Fascism builds up hegemony to match domination. Adamson, "Gramsci's Interpretation of Fascism," *Journal of the History of Ideas* 41, no. 4 (October–December 1980): 629.

3 Pohlmann, "Political Weapon," 279.

4 Pohlmann, "El Lissitzky's Exhibition Designs," 63. He also mentions on same page the modern techniques of enlargement being available since 1933 but doesn't cite it.

5 Pohlmann, "Political Weapon," 292.

6 This version of the quote is from Jan Avkigos, "Point Zero: German Art in the 1950s," *Arts Magazine* (March 1990): 52, but is not sourced. There is another translation of this quote in Theodor W. Adorno, *Aesthetic Theory*, eds. Greta Adorno and Rolf Tiedemann (Minneapolis: University of Minnesota, 1997), 182, but it is a bit awkward in formulation: "The historical moment is constitutive of artworks: authentic works are those that surrender themselves to the historical substance of their age without reservation and without the presumption of being superior to it. They are the self-unconscious [*sic*] historiography of their epoch."

7 Lugon, "Photography and Scale," 392. Pohlmann observes in "El Lissitzky's Exhibition Designs," 37–8 that until Lissitzky and *Pressa* in 1928, large-scale photo-agitation beyond poster size did not take place.

8 Tymkiw, *Nazi Exhibition Design*, 156.

9 Pohlmann, "Political Weapon," 292.

10 Ben-Ghiat's lucid discussion of Italian insecurities in the wake of the Berlin Pact will be discussed further in the conclusion, as those insecurities were on full display by 1938. Prior to that, however, "mutual influence, rather than unilateral imitation, characterized the relationship of the Italian and German dictatorships in the early thirties." Ben-Ghiat, "The Dynamics of an Uneasy Relationship," 263.

11 "Gebt mir vier Jahre Zeit!," *Der Photograph*, no. 36 (May 7, 1937): 141.

12 *Der Photograph* (1937), 141.

13 Schnapp, "Projections," 42.

14 Pohlmann, "Political Weapon," 294.

15 Pohlmann, "Political Weapon," 293.

16 Kracauer, *From Caligari to Hitler*, 298.

17 Paxton, *Anatomy of Fascism*, 135.

18 See my analysis of the power of photography in street culture in the essay "Bad Girls: The New Woman in Weimar Film Stills." Elizabeth Otto and Vanessa Rocco, eds., *The New Woman International: Representations in Photography and Film from the 1870s through the 1960s* (Ann Arbor: University of Michigan Press, 2011), 213–230.

19 *Der Photograph* (1937), 141.

20 Tymkiw, *Nazi Exhibition Design*, 136. He adds a footnote later about the mechanisms of some storybooks not being completely in sync.

21 See Tymkiw, "Introduction," in *Nazi Exhibition Design*, 1–17. This refutation of a stark line between modernism and Fascism in the 1930s has growing support in the field, including in the earlier-mentioned essay about Sander versus Lendvai-Dirksen by Lessa Rittelmann.

22 Fiss, *Grand Illusion*, 80.

23 *Der Photograph* (1937), 142.

24 Tymkiw, *Nazi Exhibition Design*, 147.

25 Kräussl, "GDL," in Bodo von Dewitz (ed.), *Hugo Erfurth: Photograph Zwischen Tradition und Moderne* (Cologne: Wienand Verlag, 1992), 73, quoting Grainer, GDL Rundbrief (July 1, 1937), 3. "Im Jahr 1937 folgte er der Aufforderung des Vorsitzenden Franz Grainer, der von Erfurth die folgenden Bildleistungen erwartete: '5 Erfurth Porträtleistungen von führenden Männern, die sich im Dritten Reich hervorgetan haben.'"

26 *Photographie für Alle*, no. 33 (1937): 189.

27 Pohlmann, "Political Weapon," 296.

28 For comparison, that equals 1,200 pounds.

29 *Der Photograph* (1937), 141, my italics.

30 Longerich, *Goebbels: A Biography*, 331.

31 Jeffrey Schnapp, "The Spectacle Factory," in Celant (ed.), *Post Zang Tumb*, 261.

32 The V Milan Triennial also included a *Pavilion of the Press*, with an exhibition of international photographers including Lendvai-Dircksen, see Caruso, *Italian Humanist Photography from Fascism to the Cold War*, 28.

33 Klaus Theweleit, *Male Fantasies, Volume 1: Women, Floods, Bodies, History* (Minneapolis: University of Minnesota Press, 1987).

34 The over-masculinized rhetoric of the Nazis is well-documented, but I would point out the vile tactics of influencers like the publisher Julius Streicher, who used pornography specifically to recruit young men. Many thanks to my student Michael Collins for sharing his research on Streicher.

35 *Der Photo* (1937), 150.

36 Pohlmann, "Political Weapon," 297.

37 Ghirardo also explores the emphasis on a much more "straight" documentary style in this incarnation: less avant-gardism, more historical and "factual" indoctrination. Ghirardo, "Architects, Exhibitions, and the Politics of Culture in Fascist Italy," 70.

38 The Archivio Centrale dello Stato in Rome has every 1937 *Mostra* object documented on CD-roms.

39 I should reiterate here that innovative exhibition design did not end in Italy in 1937. Ironically, at the very Palazzo delle Esposizioni where the 1932 MRF was installed, the state held an exhibition in 1937 entitled *Mostra Augustea della Romanita*. This exhibition, celebrating the birthday of Augustus, contained far more interesting use of photographic enlargements, scaffolded architectural structures, and three-dimensional objects than the re-install of the MRF. See installation shots in Marla Stone, "Exhibitions and the Cult of Display in Fascist Italy," in Celant (ed.), *Post Zang Tumb*, 190.

40 Longerich, *Goebbels: A Biography*, 366.

41 Longerich, *Goebbels: A Biography*, 366.

42 Italian cultural presumptions in this regard, particularly in 1938, are explored in Ben-Ghiat, "The Dynamics of an Uneasy Relationship," 263–70.

Epilogue

From Hegemony to Terror: 1938–42 and Visual Culture in the Twenty-first Century

The year 1938, like 1936, was another turning dramatic point year in the relationship between the two regimes. The year came to a close with the signing of the Italian-German Cultural Accord in November; the propaganda part of the accord was actually in place before the dictators pledged solidarity, demonstrating the high prioritization of visual culture by both regimes.[1] This ostensibly increased mutual influence, as German exhibitions of Italian art increased, and German presence increased at the Venice Biennale and Venice Film Festival.[2] But 1938 permanently adjusted the momentum of the relationship for many reasons, including the German annexation of Austria, which dramatized the perception of Nazis as a power on the march, and made Italy a neighbor.

On the Italian side, there was an embarrassingly failed effort in the Battle of Guadalajara, on the northeast Madrid front in the Spanish Civil War. The Republic routed Mussolini's troops, with help from anti-Fascist Italian Internationals. This was a key loss that would stalemate Madrid. Not coincidentally, this was the point at which Italy began promoting its own prejudicial racial legislation, a common response of regimes to political humiliation. This new push led Italy to pass laws that reeked of desperation, redefining Italians as "Mediterranean Aryans," and for Mussolini to declare that the Italians needed to be less *simpatici* and more "odious"—in other words, more like the Germans.[3] Further parroting the Nazis, he ordered the imposition of the goose step for the military forces.

Hitler made a state visit to Rome in May 1938, where the "new politics of spectacle" continued to be on full display, including Mussolini putting LUCE into overdrive producing newsreels and photographs of Hitler's visit.[4] And there was a commemorative volume published that included an essay by journalist Giovanni Ansaldo proclaiming Mussolini's ability to advise Hitler on the craft of "collective

persuasion";[5] in other words, it was still Il Duce's assumption that he himself was the master of visual hegemony, the snake charmer who could best persuade the public into collusion. But that same month the crisis of Nazi aggression in Czechoslovakia was percolating, and the Czechs were mobilizing. By September the appeasement of Hitler by the British and the French had taken place, Czechoslovakia was about to disappear from the map—with the gift of Albania to Mussolini, like a little pat on the head—and the Second World War would be declared within a year. The German connection to cultural hegemony was robust, but as the 1940s dawned, hegemony would shift more to domination and terror. Indeed scholarship in the last generation has illuminated the fact that "ordinary" Germans were not subjected to consistent coercive violence by the Nazis until the 1940s.[6]

The Italians, 1940–1

A 1940 book by the bilateral cultural commissioner Balbino Giuliano, *Latinita e Germanesimo* (officially published in 1941) still tried to assert the superiority of the Italians over the Germans in the areas that he considered most important, namely winning over hearts and minds. He was convinced that the route to this was cultural rather than militaristic hegemony: "in fact, today we realize that cultural expansion can become an ever more powerful means of preparing the way for political expansion."[7] These cultural attachés at the time were, in effect, convinced that such ambitious undertakings as the large-scale exhibitions under discussion here would lay the foundation for further Fascist expansion. The Germans were of a similar mindset; it can be summarized under the umbrella of cultural hegemony, or the idea that culture is just as important as politics, economics, or the military, in creating the conditions for hegemonic consent among the people.[8] But the Italians were becoming more desperate to assert an equivalence wherever they could. Large-scale exhibitions continued unabated, especially exhibitions with colonial themes such as the *Exhibition of Italian Overseas Territories*, opening in Naples in May 1940. It was intended to be the first of a series of Triennials, which of course never repeated. The exhibition catalog has numerous examples of fairly simplistic photomontages, including Musssolini's image slapped on top of a reproduction of the African continent, and others of local populations working the land, or close-up images documenting piles of agricultural products.[9] As recently noted by Marla Stone, exhibition culture was such a key part of the Fascist program, and shows kept churning out until the very end.[10]

Perhaps the Italian self-delusion in certain non-rabid Fascist circles of a kinder, gentler version of conquest through culture is what allowed publications such as the extraordinary double issue of *Casabella-Costruzioni*, devoted to exhibition spaces in 1941, to still publish. An article by its editor—the often subversive Giuseppe Pagano—accompanying reams of exhibition installation shots, arranged in grid-like formations, expressed a deep-rooted sense that exhibitions could be culturally enlightening in a manner beyond any other medium. To revisit a quote in the Introduction to this study 'Exhibitions are the most efficacious vehicles for the knowledge, the diffusion, and the theorization of the concepts that dominate the modern sensibility.'[11] The illustrated exhibitions in Pagano's issue begin where the journey of this book began: the first illustration is Gropius's Bauhaus building, and one of the first interior shots included is Moholy's Room 1 in *Fifo* (see Figure 0.3). One of the deepest analyses is the BWU, with several shots from the Building Workers Unions. Also included were the *Deutscher Werkbund* exhibition (Figure 6.1), and, not surprisingly, the MRF, all embedded within sixty-five pages of interior and exterior shots of exhibitions all over Europe, an extraordinary investment in cross-cultural dialogues beyond

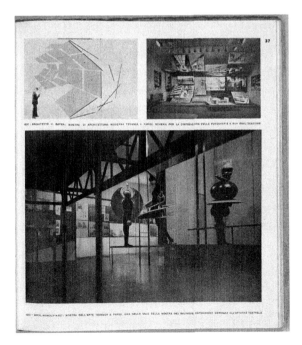

Figure 6.1 *Casabella-Costruzioni*, special double issue, no. 159–60 (March–April 1941): 37. Courtesy Avery Architectural & Fine Arts Library, Columbia University, New York.

the Axis this deep into the war. It included not just Italo-Germanic shows—although there was a heavy emphasis on those—but also exhibition spaces from many nations from 1925 to 1940, including installations in Scotland, Brussels, and the Bauhaus installation at the Museum of Modern Art (MoMA) in New York in 1938.[12]

The publication was anomalous for this late date in the regime. And Pagano himself was anomalous. A rationalist architect and former devotee to the perceived modernism of Fascism, he found the regime's increasingly backward-seeming aesthetics and stances revolting.[13] He defected in 1943 to fight for the anti-Fascist resistance and died in a concentration camp in Mauthausen in 1945. Despite the anomalies, it is a useful reminder of the perceived power of exhibitions at the time, if someone of the stature of Pagano chose to use them as his most sustained act of visual rebellion.

German Influences on the *Mostra della Rivoluzione Fascista*, 1942

A grand reformulation of the *Mostra della Rivoluzione Fascista* in 1942 was intended for installation at the *Esposizione Universale di Roma*, but circumstances of war dictated a more sober reinstallation in the same Valle Giulia. Here one is able to see how the show changed even over time (from 1932 to 1937 to 1942), and became more anti-Semitic as Mussolini tried to show that he was as "tough" as Hitler, especially after 1938. Mussolini's more racialized rhetoric, as well as legislation, did not sit well with all Fascist intelligentsia. The aforementioned journalist Giovanni Ansaldo, for example, expressed his concern that racialized politics led to "paranoia and misguided policymaking."[14] It seems that some Italian cultural figures thought they could both tame and dominate the Germans in the cultural realm, given their perceived historical superiority in that arena. But in reality, the new generation of military-bred Germans were becoming, in the aforementioned alarmed warning words of the German-born Italian cultural employee—and therefore a direct observer—Giame Pintor, "obedient and tranquil killing machines," beyond ideology, and outreach of any humanizing effects of culture. Apparently the Nazis had eventually succeeded in the goals of no dreams/no memory, at least when it came to some infantrymen. This is a specific example of how hegemony morphs into domination and terror, including brainwashing.

The third MRF iteration in 1942 changed to keep apace with this new Teutonic world order, including new large-scale murals. The darkened top

half contained a menorah, a caricature of a male in bourgeois top hat, and a spider caught in a web, all spot lit cinematically. A group of coins spill out to the left of the spider web. The quote raking across the lower half of this mural (Figure 6.2) is: *l'ebraismo mondiale e' stato durante sedici anni nostra politica un nemico irreconciliabile del Fascismo* (The world Jewry has been during sixteen years of our policy an irreconcilable enemy of Fascism). Like the spider web in Sala O pontificating against the Communists, this metaphor implied that the enemies will catch "us" in their web if not careful. The wall vitrine installed below the mural contained charts and graphs, one of which looks related to eugenics. These were reproduced alongside documentary photographic blowups of European Jews in a single-file line, and another reproduction of a menorah. Anti-Semitic spectacles easily slid into the template already developed for pro-Fascist spectacles. As Schnapp laid out the Action (!) equation (op cit): statistical data + cults of singularity (heroism proven by those very intimidating statistics) = hero as larger than life in public spaces. Here the state is hero.

This exchange of ideas in the realm of exhibition culture had continued throughout the 1930s despite Germany's rising dominance. Goebbels's

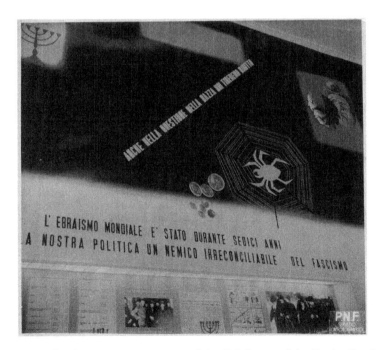

Figure 6.2 Sala Ebraismo e massoneria of the *Exhibition of the Fascist Revolution*, 1942. © ACS, MRF, fasciolo 15 (*Mostra* 1942), Album 113, neg. # 551 (Aut. 1593/ 2019).

viewing of the original MRF and affirmative statements about it echoed in Wischek's 1936 *Messe* article. That same year, as Tymkiw has explored, the design team of the Munich exhibition *Der ewige Jude* (The Eternal Jew, 1937–8) had, a year earlier, borrowed material from the MRF for their exhibition *Der Bolschewismus* (Bolshevism, 1936). *Der ewige Jude* utilized many of the same jutting photographic designs as the MRF, and took particular inspiration from Sala E.[15]

Through their newly retrofitted propagandistic displays such as the 1942 version of the MRF, the Italians had fulfilled Mussolini's late wishes and indeed become more "odious," although recent scholarship shows that the 1938 racial laws were unpopular with the Italian public, and the later iterations of the *Mostra* may have fallen off in attendance due to this lack of support, as much as the increasingly subpar design.[16] The anxiety seen in such displays is in many ways a transference of desperation from the Italian regime into modes of display. And the anxiety of the Italian Fascists in the year 1942 was well founded. The following year would see Mussolini stripped of his authority by the same king that had acquiesced to such a startling degree in 1922. The backroom deal had come full circle by July 1943 when Il Duce was arrested by order of the king. In April 1945 he was executed by Italian Communists, and strung up like a pig for the slaughter in Milan.

Visual Culture in the Twenty-first Century

Grievance can be talked into people

—Nicholas O'Shaughnessy, 2018

In essence, all the large-scale rallies of the 1930s Fascists also became "images" to be experienced physically with others; they were so highly choreographed precisely in order to be consumed as images in films and in photographic outlets like magazines, posters, and pamphlets, but most effectively in large-scale exhibitions, and with little of the on-the-ground messiness. Mussolini and Hitler were both accomplished in this area, although Hitler's propaganda machine was better at creating the more disciplined, perfectly sculpted, geometric, aerial views for films. As discussed in Chapter 2, Il Duce set his rallies with oceanic crowds pulsating around ancient Roman ruins. That then translated perfectly to images he made use of in his mass-market magazines, and photo blowups for exhibitionary spectacles.

In many ways the contemporary world is facing its own version of this echo chamber of crowds-to-images/images-to-crowds. The current president, Donald Trump, used rallies as the backbone of his campaign, having forgone the usual foundations of saturation advertisements and ground game infrastructure. The rallies are in many ways created specifically for broadcast effectiveness, similar to Riefenstahl and Nuremberg. They are vehicles of adoration to whip people up into a frenzy, with the greatest applause lines coming from racist and nativist rhetoric, as well as the politics of grievance, that is, "you're not getting what you deserve":

As Nicholas O'Shaughnessy has observed: "Grievance does not have to actually exist objectively—it can be talked into people."[17] One of the perplexing things to many economic writers, and indeed to Obama, about 2016 being a change election was that the economy overall was doing quite well. In fact, it has since been demonstrated, in contrast to initial conventional wisdom, that the majority of Trump voters were doing fairly well economically, at least post-recession.[18] But they got "talked into" grievance. Indeed, Paxton argues that resentment politics was one of the key benchmarks of 1930s Fascism, used very effectively by both Mussolini and Hitler, and it creates one of the more convincing parallels with Trumpism.[19] In particular, the current sense of being put upon had its most odious and Nazi-reminiscent expression in the fatal 2017 Charlottesville demonstration, replete with torches and grievance statements such as "Jews will not replace us." However, the parallels are many. Keeping in mind that Paxton wrote his comprehensive study of the topic of German and Italian Fascism in 2004, long before Trump versus Clinton, his bullet point analysis of the Fascist playbook feels eerily familiar (the following list is partial):

- a sense of overwhelming crisis beyond the reach of any traditional solutions
- the primacy of the group . . . and the subordination of the individual to it
- the belief that one's group is a victim
- dread of the group's decline under the corrosive effects of individualistic liberalism, class conflict, and alien influences
- the need for closer integration of a purer community, *by consent if possible*, or by exclusionary violence if necessary
- the need for authority by a natural chief (always male)
- the superiority of the leader's instincts over . . . reason
- the right of the chosen people to dominate others without restraint from any kind of . . . law.[20]

Earlier in the book, Paxton points to Fascism as replacing actual policy with rituals.[21] This list feels very much like Donald Trump's greatest hits, at least as expressed in his rallies.

Trump also uses familiar Fascist tactics in riling up a crowd, as described by firsthand journalistic accounts: make them wait for hours, deprive them of water, and force them to stand up, with a "building sensation of togetherness"; then when he appears, everyone is so strung out that they let out all their pent-up frustration and energy, to the point of "orgasmic" screaming and moaning.[22] However, it often seems that Trump creates those rally images for the impact they will have on television and social media platforms. So, yes, he gets the hysteria on site, but can multiply the effect by a factor of thousands, if not millions, that is, the fact that "I am loved." In fact, he has complained bitterly that the media does not "show" the size or enthusiasm of his rallies enough.[23]

Layered on top of that echo chamber is his facility with Twitter, which has made him uncannily adept at creating succinct slogans. And although this word-based medium may seem at loggerheads with the visual-based thesis of this book, slogans have become ever-more powerful visual tools in the twenty-first century. How many people are seeing channels like Fox News, CNN, and MSNBC with the volume turned off, whereby all that is consumable is the banner plastered across the bottom? Not the tiny scroller, but the chyron carrying however the particular channel thinks they should winnow down the current statement-of-the-moment—and by recent media reports, Trump is preoccupied by the chyrons more than the other moving screen parts. Anecdotally it seems safe to say that more people are getting their news at the moment from those chyrons—at countless gyms, car dealerships, sports bars—than from newspapers or actual evening news broadcasts, if falling television ratings are any indication. Trump understands how to choose the words that will repeatedly end up on that banner (Crooked Hillary, Little Marco, Lyin' Ted). This is as visual as words can get—in the neighborhood of a pictograph, words-as-image. It is a full subject for a different book, but words-as-image were an additional tactic at certain exhibitions discussed, such as Deutschland (Figure 6.3). As in the 1930s, the political regime embodies a visual regime in order to win consent from those it subjugates, particularly through repetition.[24]

One must take seriously the recent observations of the *New York Times* by Professor Moshuk Temkin that historians should not be pundits, and scholars must resist easy historical analogies.[25] And yet, visual tools that created the conditions of willing coercion were used to shattering effect in the 1930s. If a new generation of visuals is being likewise harnessed, it is incumbent upon all

to understand the antecedents. And, consequentially, policy makers with real-world experiences under totalitarian regimes such as Madeleine Albright are genuinely—and not in a facile way—concerned about the return of Fascism in the twenty-first century.[26]

There is no story in twentieth-century history more important to understand than Hitler's rise to power and the collapse of civilization in Nazi Germany—
—Richard J. Evans, *The Coming of the Third Reich* (2004) book jacket

If the esteemed historian Richard Evans is correct in this assessment, it means that all twentieth-century historians must *continually* understand that story, and look at it with fresh perspective and with new methodologies. Propaganda has certainly played its part in the historical analysis of Hitler's rise, but the core combination of photography and display, not as much.

Kracauer offers in *Caligari to Hitler* what might seem an alternative theory to the *Photofascism* project as to the importance of propaganda: "Instead of proving immune to Nazi indoctrination, the bulk of the Germans adjusted themselves to totalitarian rule with a readiness that could not be merely the outcome of propaganda and terror." He's propping up his interest in a psychological

Figure 6.3 The *Deutschland* exhibition: display on political strife overcome by Nazis, 1936. Courtesy Dittrick Medical History Center, Case Western Reserve University.

methodology now heavily critiqued—that although the German people refused to vote for Hitler, something inherently in them allowed for acquiescence—but he's not denying that propaganda was part of the triad of causes he presents here. He goes on to say: "Whereas Italian Fascism was a sort of theatrical display, Hitlerism assumed aspects of a religion."[27] Scholars often try to make this distinction: which cultures treated propaganda as a religion, which didn't.[28] The fact is both regimes used the religious proclivities and other interests of large swaths of the populace—including politics of resentment, a desired sense of belonging, and diversification of emphasis depending on audience—to propagate their corrupt and vile ideals.

To take two non-illustrated examples from the chapters, the Altar of Martyrs of the Italians venerated fallen Fascists—especially those fallen to Communists—as saints. The Hall of Honor at *Die Kamera* did exactly the same. Both constructions effectively used religion, resentment of Communism, and faith in the military to coalesce the consent to dictatorship. Contemporary societies would be well advised to notice Trump's current integrations of religion and political propaganda, as he preaches to his followers what Jeff Sharlet calls "prosperity gospel, the American religion of winning."[29] Religion, images, and politics have been proven as a most intoxicating and lethal combination. In the interwar period, exhibition spaces were well suited for this type of communing: large, physically encompassing spaces; spaces in which experiences could be controlled through mass-media imagery; spaces with communal possibilities. Now that the communal is no longer spatial in the twenty-first century, but digital, Trump has tapped into new, frighteningly effective, display techniques—on screens.

But in the interwar period, the communal was still spatial, if starting to fragment a bit through increasing filmic experiences. This is why it is so crucial that exhibitions are finally being asserted as a medium unto itself: but one that is open, interdisciplinary and dynamic, as opposed to a closed view of, say, the medium of painting as one gets in Greenbergian formalism. As Kevin Lotery and Claire Grace have said in presenting their special issue of *October* in 2014 "Artists Design Exhibitions": "Rather than elaborating a medium per se, artists who turned to exhibition design sought tactical, site-specific . . . interventions in the pressing questions of their present, and they did so by positioning their work within the terms, materials, and technologies then active."[30] In other words, exhibitions are a new take on the concept of medium. This latest scholarship on the medium of exhibitions is in many ways in keeping with Adorno's definition of an artwork: that it does nothing less than represent the historiography of its times.[31]

In the majority-consenting populaces of these two regimes, there was clearly dissent. But most dissenting ideas during the Fascist regimes of the 1930s were dragged out of the corners to be squelched publicly, and spectacular display-based propaganda filled the resulting gaps. That suffocation created easy conditions for entire populaces, most dramatically the German people, but also the Italians, to consent or look the other way. Evidence has come to light of the presence of concentration camps, not just out in the countryside, but smaller ones, dotting many of the German municipalities: they were everywhere. The willingness to look away was deep, substantive, and collective, like a new social contract, and it assisted in establishing what Gramsci characterized as the hegemonic. It has become a well-established cliché to talk about never forgetting about what the Nazis, as well as the Italian Fascists, did, but in order to do so, contemporary societies must not be willing to allow dissent to be dragged out of the corners and squelched, lest the avalanche of contemporary images—including digital, deep fakes, and chyron-words-as-images—which have not been critically digested, will fill those voids and interstices.

As Gramsci assists in understanding propaganda's past, another great twentieth-century philosopher understood the power of propaganda in terms of his own present and the future. Bertrand Russell wrote in a 1936 periodical, in a continually prescient statement on war in our time: "Propaganda is, first, an effect, and later, the cause of the divisions that exist in the modern world."[32] This cyclical division continues, albeit on increasingly dispersed platforms.

Notes

1 Ben-Ghiat, "The Dynamics of an Uneasy Relationship," 263.

2 Ben-Ghiat notes this, but also sees my appendices for increased German slate in 1938. Ben-Ghiat, "The Dynamics of an Uneasy Relationship," 263.

3 This is despite arguments by intellectuals like Ansaldo that Italians did well to distinguish themselves from the radical Anti-Semitism of the Nazis. Ben-Ghiat, "The Dynamics of an Uneasy Relationship," 262.

4 Ben-Ghiat, "The Dynamics of an Uneasy Relationship," 264.

5 Ben-Ghiat, "The Dynamics of an Uneasy Relationship," 268 citing Giovanni Ansaldo, "Romanità e Germanesimo," in *Italia e Germania,* maggio XVI, 79–82.

6 See Paxton, *Anatomy of Fascism,* 135.

7 Balbino Giuliano, *Latinità e Germanesimo* (Bologna: N. Zanichelli, 1941), 3, 152 quoted by Ben-Ghiat, "The Dynamics of an Uneasy Relationship," 272.

8 Benjamin Martin includes a telling anecdote about Goering, "self-styled patron of the arts," as obsessed with a clash of civilizations. He stated that he considered "cultural questions as important as political and economic." Martin, *Nazi-Fascist New Order*, 76.

9 See Paola Redemagni's essay "The 1st Triennial Exhibition of Italian Overseas Territories," as well as accompanying images in Celant, *Post Zang Tumb*, 484–7.

10 Stone, "The Cult of Display in Fascist Italy," in Celant, *Post Zang Tumb*, 186–91.

11 "Uno dei più efficace vercoli per la conoscenza, la diffusione e la saggiatura delle idée che presidono al gusto moderno é rappresentato dale esposizioni." Giuseppe Pagano, "Parliamo un pò di esposizioni," in *Casabella-Costruzioni*, special double issue, nos. 159–160 (March–April 1941): n.p.

12 In the wake of incredible exhibitionary spectacles in the interwar period, in the form of exhibitions, MoMA was likewise testing the boundaries of experimentation. A never-mounted exhibition called *For Us the Living* attempted to push into areas of design that the Nazis and Fascists had not conquered: such as moving mannequins, mirrors, and full immersive experiences such as the Avenue of Fascism. Soon after this exhibition failed to be mounted, Herbert Bayer would be designing *Road to Victory*, officially importing many of the techniques he had first perfected for the Bauhaus, and then the Nazis. Many thanks to my Pratt student Bobby Walsh for sharing his archival research with me.

13 See Caruso on his Fascist military training in 1937 that demonstrated his commitment to the regime at that point, 65.

14 Ansaldo, "Romanità e Germanesimo," 1938 in Ben-Ghiat, "The Dynamics of an Uneasy Relationship," 268.

15 Tymkiw, *Nazi Exhibition Design*, 181.

16 Borden W. Painter, Jr., *Mussolini's Rome: Rebuilding the Eternal City* (New York: Palgrave Macmillan, 2005), 78–9.

17 O'Shaughnessy, *Marketing the Third Reich*, 279.

18 Cite that Political Wire story about Trump voters and the difference between money and identity panic.

19 Such parallels must be explored further in a book less about historical Fascism than this one, and approached with caution, as discussed in a recent *New York Times* "Op-Ed" by Moshuk Temkin (June 26, 2017).

20 Paxton, *Anatomy of Fascism*, 219–20. Italics are mine.

21 Paxton, *Anatomy of Fascism,* 16.

22 Sharlet, "American Preacher," 142.

23 Jonathan Lemire, "Trump Brags About Crowd Size," *AP Newswire* (August 17, 2016).

24 There is fresh, post-2016 research pointing to how people begin to believe information that is repeated, no matter how high their initial skepticism. The Yale

researchers call this the "illusory truth effect." "Using actual fake news headlines
. . . even a single exposure increases subsequent perceptions of accuracy." Gordon
Pennycook, Tyrone Cannon, and David G. Rand, "Prior Exposure Increases
Perceived Accuracy of Fake News," *Journal of Experimental Psychology* (May
3, 2018), Abstract. To complement the disturbing aspects of that research, Jim
VanderHei wrote a political piece for *Axios* about Trump's dedication to "repetition"
as his main tool of persuasion. "Trump's Mind Control Superpowers," *Axios* (June 4,
2018).

25 Moshuk Temkin, *New York Times* (June 26, 2017).

26 See Madeleine Albright, whose family experiences both Nazi and Soviet repression,
with Bill Woodward, *Fascism: A Warning* (New York: Harper/Harper Collins,
2018). One of the more chilling statements in the *New York Times Book Review*
of this book is a quote from Hitler: "I will tell you what has carried me to the
position I have reached. Our political problems appeared complicated. The German
people could make nothing of them. . . . I, on the other hand . . . reduced them
to the simplest terms. The masses realized this and followed me." Sheri Berman,
"Exhibitions and Can It Happen Here?" *New York Times Book Review* (May 20,
2018), 10.

27 Kracauer, *From Caligari to Hitler*, 204.

28 Cronin, *Heimat,* argues against Germans' over-utilizing religion, where Pohlmann,
"El Lissitzky's Exhibition Design," argues that the Italians did influence them to do
so.

29 Sharlet, "American Preacher," 42. Anti-intellectualism also appears to make up a
core part of Trump's appeal—he's often speaking against "elites"—which Pohlmann
has explored as integral to Nazi appeal.

30 Kevin Lotery and Claire Grace, eds., "Artists Design Exhibitions" *October*, no. 150
(Fall 2014), web abstract.

31 Theodor Adorno, "Reconciliation under Duress," in Roger Taylor (ed.), *Aesthetics
and Politics* (London: NLK, 1977), 166. According to Adorno, in order to achieve
authenticity, works of art must reach a certain state of objectivity, or what might be
better called "object-ness": "They objectify themselves by immersing themselves
totally, monadologically, in the laws of their own forms, laws which are aesthetically
rooted in their own social content," he says on page 166. Phrased another way
in the same essay on 153, objectivity in works of art is "achieved by procedures
and techniques which dissolves subject matter and reorganizes it in a way which
does create (historical) perspective." When considered in terms of an exhibition,
"technique" is applicable not only to the works of art but also to the design of the
exhibition itself, the mounting, the graphics, how the works are juxtaposed. The
BWU, the MRF, *Die Kamera*, the Venice Biennale Film Festival, *Deutschland*, *Give
Me Four Years' Time*; the material aspects that became available to them at that
particular historical moment—such as the widespread use of photomontaging and

the monumentality of photo blowups—were essential to the effectiveness of each specific exhibition. They were tools of coercion: intended to be as such; built with those intentions embedded in them, and received as such. In sum, exhibitions offer a completely new permutation on Adorno-esque definitions of artworks, which needs to be further explored, as this field of exhibition studies continues to break open.

32 Bertrand Russell, "On Propaganda," *Estudios* (September 1936).

Appendix

Listings of German, Italian, and American Films from Venice Film Festivals, 1932–8

Symbols are as follows:

A=Author
B=Screenplay
C=Scenario
D=Director
E=Photographed By
F=Music
G=Design
H=Cast
I=Costumes
L=Choreography
M=Assistant Director
N=Supervision
O=Editing
P=Production
Q=Special Effects
R=Dialogues
S=Animation
T=Poem
V=Commentary

All information, including language choices, symbols, spelling, and formatting, is taken directly from Antonio Petrucci, *Twenty Years of Cinema in Venice* (Rome: Edizioni Dell Ateneo, 1952), 475–97. There are therefore various misspellings and inconsistencies that are not being corrected. I am extricating out from those lists only the German, Italian, and American films.

1932: Feature Films

Germany

Mädchen in Uniform—P: Deutsche Film-Gemeinshaft G.m.b.H—N: Carl Froelich—D: Leontine Sagan—B: Christa Winsloe e F. D. Adam dalla commedia di Christa Winsloe (from Christa Winsloe's play)—F: Hansom Milde—Meissner—E: Reimar Kuntze, Franz Weihmayr—G: Fritz Maurischat e Frederich Winckler-Tannenberg—H.: Hertha Thiele, Ellen Schwannecke, Dorothea Wieck, Emilie Unda, Hedwig Schlichter.

Zwei Menschen—P: Cicero Ton Film—C: A Schirokauer da un romanzo di Richard Voss (from a novel by Richard Voss)—D: Erich Waschneck—E: M. Greenbaum, Richard Angst, G. Vitrotti—F: M Pflugmacher, K. May—H: Charlotte Susa, Gustav Froelich.

Der Kongress tanzt—P: Universum Film Aktiengesellschaft—Erich Pommer—D: Erik Charell—C: Norbert Falk e Robert Liebmann—F: Werner R. Heymann—E: Carol Hoffmann—G: Robert Herith e Walker Roehrig—H: Lilian Harvey, Willy Fritsch, Conrad Veidt, Lil Dagover, Eugen Rex, Otto Wallburg, Carl-Heinz Schroth, Alfred Abel, Adele Sandrock, Margarete Kupfer, Julius Falkenstein, Max Gülstorff, Paul Hoerbiger.

Das blaue Licht—P: Leni Riefenstahl—C: Béla Balázs—E: Hans Schneeberger—G: Leopold Blonder—H: Leni Riefenstahl, Mathia Wiemann, Max Holsboer, Beni Führer, Franz Madacea.

Das Lied einer Nacht—P: Cine Allianz Tonfilm—C: Irma von Cube—D: Anatole Litvak—F: Mischa Spoliansky, W. Schmidt-Gentner—E: F. A. Wagner, Robert Baberske—H: Jan Kiepura, Magda Schneider.

Italy

Gli uomini, che mascalzoni!—P: Cines Stefano Pittaluga—D: Mario Camerini—A: Aldo De Benedetti—B: Mario Soldati—E: Massimo Terzano—G: Gastone Medin—H: Lia Franca, Vittorio De Sica, Cesare Zoppetti, Isa Pola, Tino Erler, Pia Locchi.

Due cuori felici—P: S.A. Stefano Pittaluga—D: Baldassarre Negroni—H: Ruggero Ruggeri, Rina Franchetti, Vittorio De Sica, Mimì Aylmer, Umberto Melnati.

United States

Dr. Jekyll and Mr. Hyde—P: Paramount Pictures—D: Rouben Mamoulian—A: dal romanzo di Robert Louis Stevenson (d'après le roman de Robert Louis Stevenson) from Robert Louis Stevenson's novel—B: Samuel Hoffenstein e Percy Heath—E: Karl Struss—G: Hans Dreier—I: Travis Banton—O: William Shae—H: Fredric March, Miriam Hopkins, Rose Hobart, Halliwell Hobbis, Edgar Horton, Arnold Lucy, Tempe Pigott, Col McDonnell.

Yellow Ticket—P: Fox Film Corporation—D: Raoul Walsh—H: Elissa Landi, Lionel Barrymore.

Frankenstein—P: Universal Pictures Corporation—D: James Whale—A: Mary Shelley—B: Garrett Fort, Francis Faragoh—E: Arthur Edeson—H: Boris Karloff, Colin Clive, Mae Clark.

The Devil to Pay—P: United Artists Corporation—D: George Fitzmaurice—A: da una commedia di Frederick Lonsdale—H: Ronald Colman, Loretta Young.

The Champ—P: Metro-Goldwyn Mayer—D: King Vidor—A: Frances Marion—B: Leonard Praskins—E: Gordon Avil—G: Cedric Gibbons—H: Wallace Beery, Jackie Cooper.

The Man I Killed—P: Paramount Pictures—D: Ernst Lubitsch—A: Maurice Rostand—B: Ernest Vajda, Samuel Raphaelson, Reginald Berkeley—E: Victor Milner—H: Lionel Barrymore, Nancy Carroll, Philip Holmes, Louise Carter, Zasu Pitts.

The Crowd Roars—P: First National—Warner Bros—D: Howard Hawks—H: James Cagney, Joan Blondel, Ann Dvorak, Eric Linden, Guy Kibbee, Frank McHug, Bill Arnold.

Strange Interlude—P: Metro-Goldwyn-Mayer—D: Robert Z. Leonard—A: dal dramma di E. O'Neill (d'après le drame de E. O'Neill—from E. O'Neill play)—B: Bess Meredith e C. Gardner Sullivan—H: Norma Shearer, Clark Gable.

Forbidden—P: Columbia Pictures Corporation—D: Frank Capra—A: Frank Capra—B: Jo Swerling—E: Joseph Walker—H: Barbara Stanwyck, Adolphe Menjou, Ralph Bellamy, Dorothy Peterson, Charlotte V. Henry.

Bring Them Back Alive—P: R.K.O Radio Picture—D: C. E. Elliot.

Grand Hotel—P: Metro-Goldwyn-Mayer—D: Edmund Goulding—A: Vicki Baum—B: William A. Drake—E: William Daniels—G: Cedric Gibbons—H: Greta Garbo, John Barrymore, Wallace Beery, John Crawford, Lionel Barrymore, Lewis Stone.

The Sin of Madelon Claudet—P: Metro-Goldwyn-Mayer—D: Edgar Selwyn—A: dalla commedia « The Lullaby » di Edward Knoblock's play—B: Charles Macarthur—H: Helen Hayes, Lewis Stone, Neil Hamilton, Cliff Edwards, Jean Hersholt, Marie Prevost.

1932 Documentaries

Italy

Assisi—P: Stefano Pittaluga-Cines—D: Alessandro Biasetti—E: Ubaldo Arata.

Manovre navali—Luce.

Fori imperiali—D: Aldo Vergano—P: Cines

I Pini di Roma—P: Persic Fono Roma—F: Ottorino Respighi—D: Mario Costa.

1934 Feature Films

Germany

Flüchtlinge—P: U.F.A.—D: Gustav Ucicky—E: Fritz Arno Wagner—C: Gerhard Menzel—F: Herbert Windt—H: Käthe von Nagy, Hans Albers, Eugen Klopfer.

Reifende Jugend—P: Carol Froelich Filmproduktion—D: Carl Froelich—A: R.A. Stemmle, Walter Supper dalla commedia (after Max Dreyer's play "Reifeprüfung")—E: Reimar Kuntze—F: W. Gronostay—H: Mertha Theile, Heinrich George, Peter Voss, Albert Lieven, Marie Luise Claudius.

Italy

Il canale degli Angeli—P: Venezia Film—A: P.M. Pasinetti—D: Francesco Pasinetti—M: Rinaldo Dal Fabbro—H: Anna Ariani, Nina Simonetti, Maurizio D'Ancora, Rinaldo Rinaldi, Ugo Gracci, Pino Locchi—F: Gino Gorini e Nino Sanzogno.

Teresa Confalonieri—P: Capitani Film—D: Guido Brignone—A: dalla commedia "Il Conte Aquila" di Rino Alessi (from Rino Alessi's plan)—E: Anchise Brizzi—H: Marta Abba, Nerio Bernardi, Elsa de Giorgi, Filippo Scelzo, Luigi Cimara, Tina Lattanzi, Luigi Carini.

La signora di tutti—P: Novella Film—D: Max Ophüls—A: dal romanzo di Salvator Gotta (from Salvator Gotta's novel of the same name)—F: Daniele Amfitheatrof—H: Isa Miranda, Memo Benassi, Tatiana Pavlova, Nelly Corradi, Lamberto Picasso, Franco Coop, Mario Ferrari.

Seconda B—P: S.A. Icar—C: Umberto Barbaro, Goffredo Alessandrini—E: Carlo Montuori—H: Sergio Tofano, Maria Denis, Dina Perbellini, Cesare Zoppetti—F: Virgilio Ranzato.

Stadio—P: Ardita Film—A: Romolo Marcellini—D: Carlo Campogalliani, Giorgio Ferroni—H: Mario Arcione, Luigi Beccali, E. Amante, Emma Guerra, Enzo Rampelli, A. Marconi, G. Del Vecchio, Giorgio Censi.

United States

The Invisible Man—P: Universal Pictures—D: James Whale—A: dal romanzo di H. G. Wells (d'après le roman de H. G. Wells—from H. G Well's novel)—B: R. C. Sherriff—E: Charles Fulton—H: Claude Rains, William Harrigan, Una O'Connor, Gloria Stuart—Q: Arthur Edeson.

Viva Villa—P: Metro-Goldwyn-Mayer—D: Jack Conway—A: Edgcumb Pinchon, O. B. Strade—B: Ben Hecht—E: James Wong Howe e Charles G Clarke—G: Harry Oliver—F: Herbert Stothart—H: Wallace Beery, Fay Wray, Katherine de Mille, Stuart Irwin.

It Happened One Night—P: Columbia Pictures—A: Samuel Hopkins Adams—B: Robert Riskin—D: Frank Capra—E: Joseph Walker—G: Stephen Goosson—F: Louis Silvers—H: Clark Gable, Claudette Colbert, Walter Connolly.

The World Moves On—P: Fox Film Corporation—D: John Ford—A: Reginald Berkeley—B: Reginald Berkeley—E: George Schneidermann—H: Madeleine Carroll, Franchot Tone, Rayl Roulin, Reginald Denny, Lumsden Hare, Dudley Diggs, Frank Melton, Brenda Fowler, Frank Morgan.

Death Takes a Holiday—P: Paramount Pictures—A: dalla commedia « La morte in vacanza » di Alberto Casella (d'après la pièce « La mort en vacance » d'Alberto

Casella—from Alberto Casella's play « Death Takes a Holiday »)—B: Maxwell Anderson, Gladis Lechman—D: Mitchell Leisen—H: Fredric March Evelin Venable, Guy Standing.

Little Women—P: R.K.O. Pictures, George Cukor—A: dal romanzo di Louisa May Alcott (d'après le roman de Louisa May Alcott—from Louisa May Alcott's novel)—B: Sarah Y. Mason e Victor Heerman—H: Katherine Hepburn, Joan Bennett, Jean Parker, Francis Dee—I: Walter Plunkett—F: Max Steiner.

White Heat—P: Seven Seas Corp.—A: James Bodrero—D: Lois Weber—E: Alvin Wyckoff, Franck Titus—H: Virginia Cherrill, Mona Maris, Hardie Albrecht, David Nardal.

Lot in Sodom—P: New World Pictures—D, A: John Sibley Watson e Melville Webber—E: Webber e Watson—G: Watson e Webber—H: Frederick Haak, Hildegarde Watson, Dorotea Hans, Lewis Whittooeck jr (*last name is Whittooeck, but only Lewis Whitlock jr is credited in this film)—F: Louis Sieger.

Wonder Bar—P: First National—Warner Bros Inc. New York—A: da una commedia (d'après una comédie—from a play)—B: Earl Baldwin Ricardo Cortez, Dolores del Rio, Kay Francis.

Twentieth Century—P: Columbia Pictures—C: Ben Hecht, Charles McArthur—D: Howard Hawks—E: Joseph August—H: John Barrymore, Carole Lombard.

By Candlelight—P: James Whale—A: da una commedia de Sigfried Geyer (d'après une pièce de Sigfried Geyer—from a play by Sigfried Geyer)—H: Elissa Landi, Paul Lukas.

Going Hollywood—P: Metro-Goldwyn-Mayer—F: N. H. Brown, Arthur Freed—D: Raoul Walsh—H: Marion Davies, Stuart Erwin, Bing Crosby, Fifi d'Orsay, Ned Spark, Pat Patsy Kelly, Bobby Watson.

Broken Dreams—P: Metro-Goldwyn-Mayer—D: Roberto Vignola—A: Olga Printzlau—H: Buster Phelps, Randolph Scott, Joseph Canthorn.

Queen Christina—Metro-Goldwyn-Mayer—D: Rouben Mamoulian—A: Salka Viertel e Margaret P. Levino—B: S. N. Behrman—E: Joseph Daniels—H: John Gilbert, Greta Garbo, Lewis Stone, Cora Sue Collins, Jan Keith, Elisabeth Joung, C. Aubrey Smith.

1934 Documentaries

Germany

Studio n. 7 (colored rhythmical drawings)—P: Oskar Fischinger—D: Oskar Fischinger.

Studio n. 8 (colored rhythmical drawings)—P: Oskar Fischinger, Berlino—D: Oskar Fischinger.

Studio n. 9—P: Oskar Fischinger, Berlino—D: Oskar Fischinger.

Carmen—(Silhouette Film)—based on parodies of Bizet's Carmen—D: Lotte Reiniger.

Was is die Welt—P: Atelier Nolden, Berlino—D: Svend Nolan.

Deutschland Zwischen Gestern und Heute—P: Basse-Film—F: Wolfgang Zeller—D: Wilfried Basse—E: Wilfried Basse.

Italy

Mare di Roma—P: Istituto Nazionale Luce.

Fiori—P: Istituto Nazionale Luce.

Sinfonie di Roma—P: Istituto Nazionale Luce—D: Piero Francisci.

Trebbiatura di grano all'Agro Pontino—P: Istituto Nazionale Luce.

Varietà—P: Istituto Nazionale Luce—D: Ristori.

United States

Italy—P: Metro-Goldwyn-Mayer—D: Fitzpatrick.

Lion Tamer—P: R. K. O. Pictures, New York—D: Irvin Stalling.

Sea Monsters—P: Television Production Lid—D: Roland Price—E: John Craig.

Oltre il Bengala—P: Showmen's Pictures—D: Harry Schenck.

Poor Cinderella—P: Paramount Pictures—D: Dave Fleischer.

Three Knaves and a Queen—P: R. K. O. Radio Pictures—A: Ely Culbertson—D: Sam White.

The Grasshopper and the Ants—P: United Artists—D: Walt Disney.

Three Little Pigs—P: Walt Disney, Hollywood—D: Walt Disney.

The China Shop—P: United Artists Corp—D: Walt Disney.

Funny Little Bunnies—P: United Artists—D: Walt Disney.

1935 Feature Films

Germany

Hermine und die sieben Aufrechten—P: Terra Film A.G., Berlino—D: Frank Wysbar—H: Heinrich George, Karin Hardt, Paul Henckels, Albert Lieven, Kurt Stepanek.

Peer Gynt—P: Bavaria Film A. G., D: Dr. Fritz Wendhausen—A: dal drama onomino di Henrik Ibsen (from Henrik Ibsen's play of the same name)—H: Hans Albers, Marie Luise Claudius, Ellen Frank, Olga Tschechowa.

Ich für Dich, Du für Mich—P: Carl Froelich Filmgesellschaft—D: Carl Froelich—H: Marlaa Wanck, Ruth Eweler, Inge Kick, Heinz Rippert, Carl Dannemann.

Der alte und der junge König—P: Deka Film—D: Hans Steinhoff—C: Thea von Harbou, Rolf Lauckner—E: Karl Puth—F: Wolfgang Zeller—G: Fritz Maurischat, Karl Weber—H: Emil Jannings, Werner Hinz, Claus Clausen, Marieluise Claudius, Walter Janessen, Friedrich Kayssler, Georg Alexander, Rudolf Klein-Rogge, Theodor Loos.

Triumph des Willens—P: Leni Riefenstahl—D: Leni Riefenstahl.

Oberwachtmeister Schwenke—P: Europa Film—D: Carl Froelich—H: Gustav Frohlich, Marianne Hoppe, Karl Dannemann.

Regine—P: Fanal-Film—D: Erich Waschneck—H: Luise Ullrich, Adolf Wohlbrück, Olga Tschechowa.

Der Verlorenen Sohn—P: Rotha Film—C, D: Luis Trenker—H: Luis Trenker, Maria Andergast, Marian Marsh, Paul Henckels.

Italy

Casta Diva—P: Alleanza Cinematografica Italiana—D: Carmine Gallone—H: Marta Eggerth, Sandro Palmieri, Bruna Dragoni, Lamberto Picasso, Giulio Donadio, Gualtiero Tumiati.

Passaporto rosso—P: Tirrenia Film—D: Guido Brignone—A: Gian Gaspare Napolitano—H: Isa Miranda, Filippo Scelzo, Giulio Donadio, Ugo Ceseri, Giuseppe Fares, Mario Ferrari, Tina Lattanzi, Olga Pescatori, Mario Pisu.

Le scarpe al sole—P: Industrie Cinematografiche Italiane—D: Marco Elter—A: dal romanzo di Paolo Monelli (from Paolo Monelli's novel)—F: Antonio Veretti—H: Camillo Pilotto, Cesco Baseggio, Isa Pola, Carlo Ludovici, Giorgio Covi, Carlo Duse, Nelly Corradi, Dina Perbellini.

Darò un milione—P: Novella Film—D: Mario Camerini—A: da "Buoni per un giorno" di Cesare Zavattini e Giaci Mondaini (from "Good for a Day" by the same)—B: Cesare Zavattini, Ivo Perilli, Mario Camerini, Ercole Patti—E: Otello Martelli, Carlo Montuori—F: Gian Luca Tocchi—G: Ugo Blasi—H: Vittorio De Sica, Assia Noris, Luigi Almirante, Mario Gallina, Franco Coop, Emma Bolognesi, Cesare Zoppetti.

Amore—P: Industrie Cinematografiche Italiane—D: Carlo Ludovico Bragaglia—H: Edwige Feuillère, Gianfranco Giacchetti, Dina Perbellini, Anna Maria Dossena.

Freccia d'oro—P: Ala Film—D: C. D'Errico e P. Ballerini—H: Augusto, Marcacci, Maurizio d' Ancora, Emma Baron, Laura Nucci.

United States

Becky Sharp (technicolor)—P: R.K.O. Radio Productions, Inc.—D: Rouben Mamoulian—A: dal romanzo « Vanity Fair » di William Thackeray (d'après le roman « Vanity Fair » de William Thackeray « and » from William Thackeray's novel « Vanity Fair »)—C: Frances Faragoh—E: Rey Rennehan—G: Robert Edmund Jones—H: Miriam Hopkins, Frances Dee, Nigel Bruce, Alan Mowbray, Alison Skipworth.

Wedding Night—P: United Artists Corporation—D: King Video—A: da una commedia di Edwin H. Knopf (d'après une pièce de Edwin H. Knopf—from a play by Edwin H. Knopf)—B: Edith Fitzgerald—E: Gregg Toland—G: Richard Day—H: Anna Sten, Gary Cooper, Ralph Bellamy, Helen Winson, Sigfried Ruhman.

Broadway Bill—P: Columbia Pictures Corporation—D: Frank Capra—A: Marc Hellinger—B: Robert Riskin—E: Joseph Walker—H: Myrna Loy, Warner Baxter, Helen Dilson, Walter Connolly, Douglas Dumbrille.

No Greater Glory—P: United Artists Corporation—D: Frank Borzage—A: Ferenc Molnar—B: Jo Swerling—E: Joseph August—H: George Breakston, Frankie Darro, Ralph Morgan, Lois Wilson.

Black Fury—P: Warner Bros, Pictures Inc.—D: Archie Mayo—H: Paul Muni, Karen Morley, William Gargan, Barton MacLane, John Gualen.

Curly Tops—P: Fox Film Corporation—D: Irving Cumming—H: John Boles, Rochelle Hudson, Shirley Temple.

Folies Bergeres—P: Roy del Ruth—H: Maurice Chevalier, Merle Oberon.

The Crusades—P: Paramount Pictures—D: Cecil B. De Mille—C: Harold Lamb, Waldemar Young e Dudley Nichols—E: Victor Milner—F: Rudolph Kopp—H: Loretta Young, Henry Wilcoxon, Jan Keith, Katherine De Mille, C. Aubrey Smith.

The Devil is a Woman—P: Paramount Pictures—D: Josef von Sternberg—A: da « La Femme et le pantin » di Pierre Louys (d'arès « Le Femme et le pantin » de Pierre Louys—from « La Femme et le pantin » by Pierre Louys)—C: John Dos Passos—E: Josef von Sternberg—F: Ralph Rainger—H: Marlene Dietrich, Lionel Atwill, Cesar Romero, E. E. Horton, Alison Skipworth.

China Seas—P: Metro-Goldwyn-Mayer—D: Tay Garnett—H: Clark Gable, Jean Harlow, Wallace Beery.

The Informer—P: R.K.O Radio Pictures—D: JOhn Ford—A: Liam O'Flaherty—B: Dudley Nichols—E: Joseph H. August—G: Van Nest Polglase—F: Max Steiner—H: Victor McLaglen, Preston Foster, Margot Grahame, Heather Angel, Wallace Ford, Una O'Connor, J.M. Kerrigan.

Dante's Inferno—P: Fox Film Corporation—D: Harry Machman—C: Philip Klein, Robert M. Yost—E: Rudolph Mate—G: Willy Pogany—H: Spencer Tracy, Claire Trevor, Henry B. Walthall, Alan Dinehart, Scott Beckett, Robert Gleckler, Rita Cansino (Hayworth), Garry Leon, Morgan Wallace.

Anna Karenina—P: Metro-Goldwyn-Mayer—D: Clarence Brown—A: dal romanzo di Leone Tolstoi (d'après le roman de Léon Tolstoi—from the Leon Tolstoi's novel)—C: Clemence Dane, Salka Viertel, S.N. Behrman—E: William Daniels—G: Cedric Gibbons—F: Herbert Stothart—H: Greta Garbo, Fredrick March, Freddie Bartholomew, Maureen O'Sullivan, Basil Rathbone.

La Cucaracha—P: Pioneer Pictures—D: Lloyd Corrigan—E: Ray Rennahan—G: Robert Edmund Jones—H: Steffi Duna, Don Alvarado, Paul Porcasi.

David Copperfield—P: Metro-Goldwyn-Mayer—D: George Cukor—A: dal romanzo di Charles Dickens (d'après le roman homonyme de Charles Dickens—from the Charles Dickens's novel of the same name)—C: Hugh Walpole, Howard Estabrook—E: Oliver T. Marsh—G: Cedric Gibbons—F: Herbert Stothart—H: W.C. Fields, Lionel Barrymore, Maureen O'Sullivan, Madge Evans, Edna May Oliver, Lewis Stone, Frank Lawton, Freddie Bartholomew.

1935 Documentaries

Germany

Der Ameisen Staat—P: U.F.A.

Das Geraubte Herz—P: Lotte Reiniger—D: Lotte Reiniger.

Der König des Waldes—P: U.F.A.

Leben unter dem Elms—P: Bavaria—Filmkultur.

Symphonie in Blau—P: Oskar Fischinger—D: Oskar Fischinger.

Schmetterling Seben —P: U.F.A.

Italy

Alle Madri d'Italia—P: Istituto Nazionale Luce.

Maritiana Bianca—P: Mario Craveri—D: Allessandro Previtera.

Il Maschio dell'amore—P: Milano Film—D: Mario Bafico—H: Liano Perri, Gianni Alberici.

Riscatto—P: Soc Italiana Cinematografica Educativa e Didattica. Lo Stato corporativo. P: Istituto Luce.

United States

Corke Carnival—P: Walt Disney.

Band Concert—P: Walt Disney.

The Golden Touch—P: Walt Disney.

Mickey Mouse—P: Walt Disney.

The Robber Kitten—P: Walt Disney.

Water Babies—P: Walt Disney.

Barcarola—P: United Artists Corporation.

Fish From Hell—P: Marine Productions Ltd.

Mediterranean Song—P: Audion Pictures.

Tappa Kliou—P: Bennett Pictures Corporation—D: Henri de la Falaise.

When the Cat is Away—P: Metro-Goldwyn-Mayer

1936 Feature Films

Germany

Schlussakkord—P: U.F.A. —D:Detlef Sierck—H: Willy Birgel, Lil Dagover, Maria von Tasnady.

Ave Maria—P: Itala Film—D: Johannes Riemann—H: Beniamino Gigli, Käthe von Nagy.

Verräter—P: U.F.A. —D: Karl Ritter—H: Willy Birgel, Rudolf Fernau, Heinz Welzel, Lida Baarova, Paul Dahlke.

Der Bettelstudent—P: U.F.A.—D: Georg Jacoby—H: Carola Hohns, Marika Rokk, Ida Wust, Berthold Ebbecke, Fritze Kampers.

Traumulus—P: Carl Froehlich Film Produktion—D: Carol Froelich—H: Emil Jannings, Hannes Stelzer—F: Mie Meissner.

Der Kaiser von Kalifornien—P: Luis Trenker Filmgesellschaft—D: Luis Trenker—E: Albert Benitz—F: Giuseppe Becce—H: Luis Trenker, Viktoria von Ballasko, Werner Kung, Karil Zwingmann.

Italy

Ballerine—A.F.I. —D: Gustav Machatý—E: Vaclav Cih—F: Bizelli—H: Silvana Jachino, Laura Nucci, Olivia Fried, Maria Ray, Maria Denis, Marina Scialipin, Antonio Centa, Livio Pavanelli, Fausto Guerzoni.

Lo squadrone bianco—P: Roma Film—D: Augusto Genina—A; da un romanzo di Joseph Peyré (from a novel by Joseph Peyré)—E: Anchise Brizzi, Massimo Terzano—F: Antonio Veretti—H: Fosco Giachetti, Antonio Centa, Fulvia Lanzi, Guido Celano, Olinto Cristina, Cesare Polacco, Loris Gizzi, Francesca Dalpe, Olga Pescatori.

Cavalleria—P: Industrie Cinematografiche Italiane—D: Goffredo Alessandrini—A: Oreste Biancoli e Salvator Gotta—B: Goffredo Alessandrini, Aldo Vergano—E: Vaclav Vich—G: Gastone Medin—I: Gino Sensani—H: Elisa Cegani, Silvana Jachino, Clara Padoa, Amedeo Nazzari, Enrico Viarisio, Luigi Carini, Mario Ferrari, Adolfo Geri, Silvio Bagolini.

La Damigella di Bard—P: Industrie Cinematografiche Italiane—A: da una commedia di Salvator Gotta (from Gotta's play)—D: Mario Mattoli—E: Anchise Brizzi—F: F. Casavola—H: Emma Gramitica, Luigi Cimara, Cesare Battarine, Armando Migliair, Ameila Chellini, Olga Pescaroti, Graziella Pardi, Romolo Costa, Nino Brizzolari.

Tredici uomini e un cannone—P: Pisorno Film—D: Giovacchino Forzano—H: Fosco Giachetti, Filippo Scelzo, Ernesto Sabatini, Ugo Ceseri, Pietro Sharoff, Egisto Olivieri, Carlo Duse, Piero Pastore, Silvio Bagolini, Carlo Tamberlani, Giuseppe Addobbati.

United States

The King Steps Out—P: Columbia Pictures Corporation—D: Josef von Sternberg—A: dall'operetta « Cissy » di Herbert ed Ernst Marischka ricavata dalla commedia « Cissy » di Ernst Decsey e Gustav Hohn (d'après l'oppèrette « Cissy » de Herbert et Ernest Marischka, tirée de la comédie « Cissy » de Ernst Decsey et Gustav Hohn—from the operette « Cissy » be Herbert and Ernest Marischka, taken from the Eernst Decesy and Gustav Hohn's play of the same name)—C: Sidney Buchanan—E: Lucian Ballard—F: Fritz Kreisler e Howard Jackson—L: Albertina Rasch—I: Ernst Dryden—H: Grace Moore, Franchot Tone, Walter Connolly, Raymond Walburn, Victor Jory, Elizabeth Risdon, Nana Bryant, Frieda Inescort.

The Story of Louis Pasteur—P: Warner Bros—First National—D: William Dieterle—C: Sheridan Gibney, Pierra Collins—E: Tony Gaudio—G: Robert M Haas—F: Erich von Korngold—H: Paul Muni, Josephine Hutchinson, Anita Louise, Henry O'Neil, Fritz Lieber, Donald Woods.

Show Boat—P: Universal Pictures—D: James Whale—A: dall'operetta di Edna Ferfer e Oscar Hammerstein (d'après l'opérette de Edna Ferber e Oscar Hammerstein—from the operette by Edna Ferber and Oscar Hammerstein)—F: Jerome Kern—H: Irene Dunne, Allan Jones, Charles Winninger, Paul Robeson, Helen Morgan, Hele Wesley.

The Trail of the Lonesome Pine—P: Paramount Pictures Inc.—DL Henry Hathaway—H: Silvia Sidney, Fred MacMurray, Henry Fonda.

The White Angel—P: Warner Bros, Pictures Inc.—D: William Dieterle—H: Kay Francis, Jan Hunter, Donalds Woods.

San Francisco—P: Metro-Goldwyn-Mayer—D: W.S. Van Dyke—A: Robert Hopkins—B: Anita Loos—E: Oliver T. March—F: Gus Kahn—G: Cedric Gibbons—H: Clark Gable, Janet MacDonald, Spencer Tracy, Jack Holt, Jessie Ralph, Ted Healy, Shirley Ross, Margaret Irving, Harold Huber, Edgard Kennedy.

Mr. Deed Goes to Town—P: Columbia Pictures Corporation—D: Frank Capra—C: Robert Riskin da « Opera Hat » di Clarence Budington Kelland (Robert Riskin d'après « Opera Hat » de Clarence Budington Kelland—Robert Riskin from Clarence Budington Kelland's « Opera Hat »)—E: Joseph Walker—F: Haward Jackson—H: Gary Cooper, Jean Arthur, Raymond Walburn, Douglas Dumbrille, George Bancroft, H.B. Warner, Lionel Stander, Warren Hymer.

The Great Zigfeld—P: Metro-Goldwyn-Mayer—D: Robert Z. Leonard—A: dalla biografia di William Anthony McGuire (d'après la biographie de William Anthony McGuire—from William Anthony McGuire's biography)—E: Oliver T. Marsh, Ray Line, George Felsey, Karl Freund—F: Walter Donaldson, Harold Adamson e Irving Berlin—L: Seymour Felx—I: Adrian—G: Cedric Gibbons—H: Wililam Powell, Myrna Loy, Luise Rainer, Virginia Bruce, Reginald Owen, Frank Morgan, Fannie Brice, Ray Bolder, Ernest Cossart.

Mary of Scotland—P: R.K.O—D: John Ford —A: dal dramma d Anderson (d'après la pièce de Maxwell Anderson—from Maxwell Anderson's play)—B: Dudley Nichols—E: Joseph August—H: Katherine Hepburn (Mary Stuart), Fredric March (Bothwell), Florence Eldridge (Elizabeth), Douglas Walton, John Carradine, Monte Blue, Jan Fenwick, Robert Barratt, Jan Keith, Moroni Olsen, Ralph Forbes, Alan Mowbray, Donald Crisp.

1936 Documentaries

Germany

Fische unserer—P: Bavaria Film AG Monaco Bav.

Handwerk im Dorf—P: Kulture Film-Institut.

Jugend der Welt—P: Reichspropagandaleitung der NSDAP, Abt. Film D: Hans Weidemann.

Die Kamera fahrt mit—P: Tobis-Cinema A.G.

Ein Meer Versinkt—P: Bavaria Film A.G.

Metal des Himmels—P: UFA—D: Walter Ruttmann.

Olympiades de Berlin—P: Reichsfilmkammer

Das Paradies der Pferde—P: Reichspropagandaleitung der NSDAP, Abt. Film.

Italy

Il cammino degli eroi—P: Istituto Nazionale Luce.

Pompei—P: Istituto Nazionale Luce.

Preludio a Scipione—P: E.N.I.C.—D: Carmine Gallone.

Uno sguardo al fondo marino—P: Istituto Nazionale Luce.

United States

Who Killed Cook Robin—P: Walt Disney.

On Ice—P: Walt Disney.

Three Orphan Kittens—P: Walt Disney.

Attualita—P: Fox Movietone.

Dancing on the Moon—P: Paramount Pictures.

Immortal Swan—Rievocazione delle danze di Anna Pavlova—D: Nakhimoff.

The Kids in the Shoe—P: Paramount—D: Max Fleischer—S: Seymour Kneitel e Roland Grandall.

Metropolitan Nocturne—P: Resettlement Administration, Washington—D: Pare Lorentz—F: Virgil Thompson.

Time For Love—P: Paramount—D: Max Fleischer.

Stereoscopics—P: Metro-Goldwyn-Mayer.

1937 Feature Films

Germany

Patrioten—P: UFA—D: Karl Ritter—E: Gunther Anders—F: Theo Mackenden—H: Mathias Wiemann, Bruno Hobner, Lida Baarova, Hlde Korber.

Der Mann der Sherlock Holmes war—P: UFA—E: Fritz Arno Wagner—D: Karl Hartl—F: Hans Bommer—H: Hans Alber, Heinz Rühmann, Marieluise Claudius, Hansi Kenotck, Hilde Weissner.

Wenn wir alle Engel wären—P: Carl Froelich Filmproduktion G.m.b.H. —D: Carl Froelich—H: Heinz Rühmann, Leni Marenbach, Harald Paulsen, Lotte Rausch.

Zu neuen Ufern—P: UFA—D: Detlef Sierck—A: (from a story by Louis H> Lorenz)—B:Detlef Sierck, K: Heuser—E: F. Weihmayr—F: Ralph Benatzky—H: Zarah Leander, Willy Birgel, Viktor Staal.

Die Warschauer Zitadelle—P: ABC Film G.m.b.H.—D: Fritz Peter Buch—H: Agnes Straub, Lucie Höflich, Werner Hinz, Claire Winter, Paul Hartmann, Viktoria von Ballasko.

Der Herrscher—P: Tobis-Magna—D: Veit Harlan—F: Wolfgang Zeitey—H: Emil Jannings, Paul Wegner, Tannes Stelzner, Hilde Vorben, Maria Koppenhöfer.

Versprich mir Nichts—P: Tobis-Magna—D: Wolfgang Liebeneiner—H: Luise Ullrich, Victor de Kowa, Heinrich George.

Italy

Condottieri—P: ENIC—D: Luis Tranker—E: Carlo Montuori—H: Luis Tranker, oris Gizzi, Laura Nucci, Carlo Sveva, Ethel Maggi, Giulio Cirini, Sandro Dani, Mario Ferrari, Tito Gobbi, Augustro Marcacci, Nino Marchetti, Lando Nunzio, Ernesto Nannicini, Umberto Sacripante, Carlo Temberlani, Gino Viotti.

Sentinelle di bronzo—P: ENIC. D: Romolo Marcellini—A: Marcelo Orano—B: Gian Gaspare Napolitano—H: Fosco Giachetti, Doris Duranti.

Scipione L'Africano—P: E.N.I.C. D: Carmine Gallone—C: Camillo Mariani dell'Anguillara, S.A. Luciani, Carmine Gallone—E: Anchise Brizzi—G, I: Pietro Aschieri—F: Ildebrando Pizzetti—H: Guglielmo Barnabó, Memo Benassi, Francesca Bragiotti, Piero Carnabuci, Francesco Coop, Ciro Galvani, Forco Giachetti, Marcello Giorda, Carlo Lombardi, Isa Miranda, Annibale Ninchi, Clara Padoa, L. Picasso, Camillo Pilotto, Marcello Spada, Raimondo Van Riel, Gino Viotti.

Il signor Max—P: Astra Film—D: Mario Camerini—A: Amleto Palermi—B: Mario Camerini, Mario Soldati—E: Anchise Brizzi—G: Gastone Medin—I: Gino Sensani—F: Renzo Rossellini—H: Vittorio De Sica, Assia Noris, Ruby

d'Alma, Umberto Melnati, Mario Casaleggio, Lilia Dale, Caterina Collo, Virgilio Riento, Romolo Costa, Luciano Dorcaratto, Desiderio Nobile.

United States

Shall We Dance—P: R.K.O Radio Pictures, Inc.—D: Mark Sandrich—H: Fred Astaire, Ginger Rogers.

Winterset—P: R.K.O. Radio Pictures, Inc.—D: Alfred Santel—A: Maxwell Anderson—B: Anthony Veiller—E: Peverell Marley—G: Lansing C. Holden—F: Max Steiner—H: Burgess Meredith, Margo, Eduardo Cianelli.

Kid Galahad—P: Warner Bros Pictures, Inc.—D: Michael Curtiz—H: Edward G. Robinson, Bette Davis, Humphrey Bogart, Wayne Morris, Jane Bryan, Harry Carey, William Hoade, Soledad Jiminez.

Theodora Goes Wild—P: Columbia Pictures Corporation—D: R. Boleslawski—E: Joseph Walker—H: Irene Dunne, Melwyn Douglas, Thomas Mitchell, Thurston Hall.

Lloyds of London—P: 20th Century Fox Film Corporation—D: Henry King—E: Bert Glennon—H: Freddie Bartholomew, Madeleine Carroll, Tyrone Power.

Three Smart Girls—P: Universal Pictures Corporations—D: Henry Koster—H: Deanna Durbin, Barbara Reed, Nan Grey, Binnie Barnes.

This is My Affair—P: 20th Century Fox Film Corporation—D: William A. Seiter—H: Robert Taylor, Barbara Stanwick, Victor MacLaglen.

A Star is Born—P: David O'Selznick—D: William A. Wellmann—A: William A Wellmann, Robert Carson—B: Dorothy Parker—E: W. H. Greene—G: Lansing C. Holden—F: Max Steiner—H: Janet Gaynor, Fredrick March, Adolphe Menjou, May Robson, Lionel Stander.

Marked Women—P: Warner Bros, Pictures Inc.—D: Lloyd Bacon—H: Bette Davis, Humphrey Bogart, Isabell Jewell, Eduardo Ciannelli, Rosalind Marquis, Lola Lane, Jane Bryan, John Litel.

Seventh Heaven—P: 20th Century Fox Film Corporation—D: Henry King—A: da una commedia di Austin Strong (d'après une pièce de Austin Strong—from a play by Austin Strong)—H: Simone Simon, James Stewart.

Wings of the Morning—P: 20th Century Fox Film Corporation—D: Harold Schuster—H: Annabella, Henry Fonda, Leslie Banks.

1937 Documentary Films

Germany

Besuch in Frankfurt—P: U.F.A.

Bunte Fischwelt—P: U.F.A.

Deutschland—P: Atelier Noldan.

Hamburg und seine Nachbarstadt "Altona"—P: Tobis-Melofilm—D: Franz Schroder.

Klar Schiff zum Gefecht—P: Tobis-Kulturfilm.

Landschaft und Leben—P: Tobis-Melofilm.

Der Olympia—Film entsteht—P: Tobis Tonbild-Syndikat—D: Rudolf Schaad.

Mysterium des Lebens—P: UFA—D: Walter Ruttmann.

Röntgenstrahlen(m)—P: UFA—D: Martin Rikli.

Reineke Fuchs—P: U.F.A.

Unendlicher Weltenraum—P: U.F.A.

Tiergarten des Meers—P: U.F.A.

Sinnesleben der Pflanzen—P: U.F.A.—D: Ulrich K.T. Schulz.

Italy

Primavera fiorentina—P: Istituto Nazionale Luce.

Scuola fascista—P: Istituto Nazionale Luce.

Cronache dell'Impero—P: Istituto Luce.

United States

Popeye Meets Sinbad the Sailor—P: Paramount Pictures, Inc.—D: Max Fleischer.

Hawaiian Holiday—P: Walt Disney.

Music Land—P: Walt Disney.

Old Mill—P: Walt Disney.

Alpine Climbers—P: Walt Disney.

Country Cousin—P: Walt Disney.

Mickey's Polo Team—P: Walt Disney.

1938 Feature Films

Germany

Heimat—P: Carl Froelich Produktion GmbH—D: Carl Froelich—A: from Hermann Sudermann's play—B: Harald Braun—E: Franz Weihmayer—F: Theo Mackeben—H: Heinrich George, Zarah Leander, Ruth Hellberg, Lina Carstens, Georg Alexander, Franz Schafheitlin, Leo Slezak, Ruth Heilberg.

Urlaub auf Ehrenwort—P: U.F.A.—C: Kilian Koll, Walter Bloehn, Charles Klein—D: Karl Ritter—E: G. Anders—F: E.E. Buder—H: Ingeborg Theck, Fritz Kampers, Rolf Moebius, Berta Drews, Rene Deltgen, Heinz Walzel.

Der Mustergatte—P: Imagoton Film G.m.b.H.—C: Jacob Geiss, Hans Albin, Heinz Rühmann, Leny Marenbach, Hans Söhnker, Heli Finkenzeller, Werner Fuettere.

Olympia—P: Olympia Filmgesellschaft—D: Leni Riefenstahl—Part I: Popular Festival; Part II: Beauty Festival—E: Willy Zielke, Hans Ertl, Walter Frentz, Guzzi Lantschner, Kurt Neubert, Hans Scheib, ecc.

Fahrendes Volk—P: Tobis—C: Jacques Feyder—D: Jacques Feyder—E: Fritz Koch, Josef Illig—F: Wolfgang Zeller—H: Hanx Albers, Françoise Rosay, Camilla Hors, Herbert Hübner, Irene von Meyendorff, Hannes Stelzer.

Verwehte Spuren—P: Majestic Film GmbH—C: Thea von Harbou, Veit Harlan, Felix Lützkendorf—D: Veit Harlan—E: Bruno Mondi—F: Hans Otto Borgmann—H: Kristina Söderbaum, Fritz van Dongen, Charlotte Schulze, Friedrich Kessler, Paul Dahlke.

Yvette—P: Tobis Filmkunst G.m.b.H.—A: from a story by Guy de Maupassant—B: Bernard Hofmann—D: Wolfgang Liebeneiner—E: Franz Weihmayr—F: Milde-Meisner—H: Käthe Dorsch, Albert Johannes Riemann, Ruth Hellberg.

Italy

Luciano Serra, pilota—P: Aquila Film—D: Goffredo Alessandrini—E: Ubaldo Arata, Piero Pipili, Mario Del Frant—C: Roberto Rossellini, Goffredo Alessandrini F. Masoero, Ivo Perilli, Fulvio Palmieri, C.G. Viola—G: Gastone Medin—O: Giorgio C. Simonelli—F: G.C. Sonzogno—H: Amedeo Nazzari, Mario Ferrari, Germana Paolieri, Egisto Olivieri, Gino Mori, Roberto Villa, Felice Romano, Andrea Checchi.

Giuseppe Verdi—P: S. A. Grandi Film storici—D: Carmine Gallone—A: Lucio D'Ambra—H: Focso Giacchetti, Gaby Morlay, Maria Cebotari, Maria Jacobini, Bella Starace Sainati, Cesco Baseggio, Cosntatn Remy, Beiaminio Gigli, Camillo Pilotto, Germana Paolieri, Lamberto Picasso, Henry Roland.

Sotto la Croce del Sud—P: Mediterranean Film—D: Guido Brignone—A: Jacopo Comin—H: Doris Duranti, Antonio Centa, Giovanna Grasso.

Hanno rapito un uomo—P: Juventus Film—D: Gennaro Righelli—H: Vittoria de Sica, Caterina Borgato, Maria Denis, Evelina Paoli, Romolo Costa.

United States

Mother Carey's Chickens—P: R.K.O. Pictures Inc.—D: Rowland V. Lee—H: Fay Bainter, Ruby Keeler, Anne Shirley, James Ellison.

Vivacious Lady—P: R.K.O. Pictures Inc.—A: da un racconto di I. A. R. Wylie (d'après un conte de I. A. R. Wylie—from a story by I. A. R. Wylie)—D: George Stevens—H: Ginger Rogers, James Stewart, Charles Coburn.

Test Pilot—P: Metro-Goldwyn-Mayer—D: Victor Fleming—H: Clark Gable, Myrna Loy, Spencer Tracy, Lionel Barrymore.

Marie Antoinette—P: Metro-Goldwyn-Mayer—A: Stephen Zweig—D: W.S. van Dyke—H: Norma Shearer, Tyrone Power, John Barrymore, Gladys George, Joseph Schildkraut.

Snow White and the Seven Dwarfs—P: Walt Disney—C: Ted Sears, Richard Creedon, Dick Rickard, Otto Englander, Earl Hurd, Merril De Maris, Web Smith, Dorothy Ann Blank—S: Frank Thomas, Les Clark, Dick Lundy, Fred Spencer, Arthur Babbitt, Bill Roberts, Eric Larson, Marvin Woodward, Milton Kroll—F: Franck Churchill, Leigh Harline, Paul Smith—G: Samuel Armstrong, Mique Helson, Merle Cox, Claude Coats, Phil Dike, Ray Lockrem, Maurice Noble—I: Albert Hurter, Joe Grant.

Jezebel—P: Warner Bros Pictures Inc.—D: William Wyler—C: John Huston, A. Finkel, Clemens Ripley dalla commedia di Owen Davics (d'après la pièce de Owen Davics—from Owen Davic's play)—E: Ernst Haller—F: Leo Forbstein—H: Bette Davis, Margaret Lindsay, George Brent, Henry Fonda, Richard Cromwell, Donald Crisp, Fay Bainter, Spring Byington.

White Banners—P: Warner Bros Pictures Inc.—C: Lloyd C. Douglas—D: Edmund Goulding—H: Claude Rains, Fay Bainter, Jackie Cooper, Bonita Granville.

The Prisoner of Zenda—P: David O. Selznick—D: John Cromwell—A: dal romanzo di Antony Hope (d'après le roman de Anthony Hope—from Anthony Hope's novel)—H: Ronald Colman, Madeleine Carrol, Douglas Fairbanks Jr., Mary Astor, C. Aubrey Smith, David Niven, Raymond Massey.

The Adventures of Tom Sawyer—P: United Artists Corporations—A: dal romanzo di Mark Twain (d'après le roman de Mark Twain—from Mark Twain's novel)—D: Norman Taurog—H: Tommy Kelly, Ann Gillis, May Robson, Jackie Moran, Marcia Mae Jones.

Alexander's Ragtime Band—P: 20th Century Fox Film Corporation—D: Henry King—H: Tyrone Power, Alice Faye, Don Ameche.

Goldwyn Follies—P: Samuel Goldwyn—D: George marshall—H: Adolphe Menjou, Ritz Brothers, Andrea Leeds, Kenny Baker, Phil Baker.

The Rage of Paris—P: New Universal Pictures—D: Henry Koster—C: Felix Jackson, Bruce Manning—H: Danielle Darrieux, Douglas Fairbanks Jr., Micha Auer.

1938 Documentary Film

Germany

Der Bienenstaat—P: UFA—D: Dr. Ulrich Schultz.

Deutsche Rennwagen van der Front—P: Tobis-Cinema AG—D: F.A.R. Stoll.

Farbenpracht auf dem Meeresgrund—P: UFA—D: Ulrich Schultz—E: Walter Suchner—F: Albert Fischer.

Flieger—Funker—Kanoniere—P: URFA—D: Martin Rikli.

Gefiederte Strandgäste an der Ostsee—P: UA—D: Ulrich Schultz.

Heide—P: Tobis—D: Wolf Hart.

Kalt—Kälter—Am Kältesten—P: UFA—D: Martin Rikli.

Kamerajagd auf Seehunde—P: UFA—D: Ulrich Schultz.

Libellen—P: UFA—D: Ulrich Schultz.

Lotsen der Luft—P: UFA, Berlino—D: Hans F. Wilhelm.

Natur und Technik—P: Ufa-Kulturfilm—D: Dr. Schultz—E: Walter Suchner—F: Walter Winnig.

Riemenschneider, der Meister von Würzburg—P: Tobis-Dinema A.G.—D: Walter Hoge.

Schnelle Straseen—P: Tobis-Cinema A.G.—D: Sepp Allgaier.

Stammgäste der Nordsee—P: U.F.A.—D: Ulrich Schultz.

Steilküste—P: Tobis-Cinema A.G.—D: Hans Richter.

Tintenfische—P: U.F.A.—D: Ulrich Schultz.

Italy

Armonie pucciniane—P: Istituto Nazaionale Luce—D: G. Ferroni.

Fontane di Roma—P: Musical Films—D: Mario Costa.

Nella luce di Roma—P: Istituto Nazionale Luce.

Un mondo meraviglioso—P: Istituto Nazionale Luce —D: R. Omegna.

United States

Barraco's Night Out—P: Metro-Goldwyn-Mayer.

Little Buck Cheeser—P: Metro-Goldwyn-Mayer.

Night at the Movies—P: Metro-Goldwyn-Mayer.

Oriental Paradise—P: Metro-Goldwyn-Mayer.

The River—P: Farm Security Administration, Washington—D: Pare Lorentz—F: Virgil Thomson.

Romance of Radium—P: Metro-Goldwyn-Mayer.

Second Audioscopics—P: Metro-Goldwyn-Mayer.

Sinbad the Sailor Meets Ali Baba's 40 Thieves—P: Paramount Pictures, Inc.—D: Fleischer.

Sky Flight—P: Warner Bros, Pictures, Inc.

Farmyard Symphony—P: Walt Disney.

The Brave Little Tailor—P: Walt Disney.

Bibliography

Primary Sources

Alfieri, Dino, and Luigi Freddi. *Mostra della Rivoluzione Fascista: Guida Storica.* Bergamo: Italian Institute of Graphic Arts, 1933. Reprinted in Milan: Candido Nuovo, 1982 (both original and reprint used).

Attributed to "S." "Hundert Jahre Lichtbild." *Photographische Rundschau* 64 (1927): 202.

Bayer, Herbert. "Fundamentals of Exhibition Design." *PM (Production Manager)* 6, no. 2 ([1937] 1939–40): 17–25.

Bayer, Herbert, Walter Gropius, and Ise Gropius, eds. *Bauhaus 1919–1928.* New York: Museum of Modern Art, 1938.

Benjamin, Walter. "The Work of Art in the Age of Its Technological Reproducibility," in *Walter Benjamin: Selected Writings, Volume 3 (1935–38)*, eds. W. Jennings and Howard Eiland, 101–33. Cambridge, MA: Harvard University Press, [1936] 2002.

Biallas, Hans. "Die deutsche Arbeitsfront und Die Kamera." In *Die Kamera: Ausstellung für Fotografie, Druck und Reproduktion*, ed. Ingo Kaul, 13–14. Berlin: Ausstellunghallen am Funkturm, 1933.

Bucovich, Mario von. *Paris.* Berlin: Albertus, 1928.

Caffin, Charles H. "Some Impressions from the International Photographic Exposition, Dresden." *Camera Work*, no. 28 (October 1909): 33–8.

Claassen, Eugen. "*Deutsche Photographische Ausstellung.*" *Die Form* 12 (September 1926): 275–6.

Demachy, Robert. "Paris Photo-Club Salon." *The British Journal of Photography* 56 (June 4, 1909): 435.

Deutsche Photographische Ausstellung: Aussteller-Verzeichnis (DPA). Frankfurt a.m Main: Druckerei R. Th. Hauser & Co., 1926.

Dexel, Walter. "Neue Wege der Photographie." *Das Volk*, April 14, 1928.

Die Kamera. "Press Release." Collections, Agfa Fotohistorama, Cologne, November 1933.

Die Kamera: Ausstellung für Fotografie, Druck und Reproduktion, ed. Ingo Kaul. Berlin: Ausstellunghallen am Funkturm, 1933.

Dorner, Alexander. *The Way Beyond 'Art': Problems in Contemporary Art: The Work of Herbert Bayer.* New York: Wittenborn, Shultz, 1947.

Eck, W. "Berufsphotographie." *Das Atelier des Photographen* 33, no. 4 (1926): 101–4.

Eder, Joseph Maria. "Die Internationale Photographische Ausstellung in Dresden 1909." *Die Woche*, no. 18 (1909): 740.

"Ein altes lied." *Der Photograph*, no. 37 (1909): 146.

Emmerich, George. "*Iphad.*" *Photographische Kunst*, no. 5 (June 15, 1909): 62.

Emmermann. "*DPA*, Frankfurt am Main, 1926." *Das Atelier des Photographen* 33, no. 4 (1926): 85.

"ER," "Ausstellung 'Die Kamera' in Berlin." *Photo-Fachhändler*, no. 16 (1933): 488–9.

"Film und Foto." *Photographische Rundschau* 66 (March 1929): 104.

Fotografie der Gegenwart, Exhibition brochures for Berlin, Hanover, and Dresden venues, 1929. Collections, Museum Folkwang, Essen.

"Gebt mir vier Jahre Zeit!" *Der Photograph*, no. 36 (May 7, 1937): 141.

Goertz, Fritz. "Die Reproduktionsabteilung auf der Deutschen Photographischen Ausstellung." In *DPA Aussteller-Verzeichnis*, 48–50. Frankfurt a.m Main: Druckerei R. Th. Hauser & Co., 1926.

Graeff, Werner. Es *kommt der neue Fotograf*! Berlin: H. Reckendorf, 1929.

Grainer, Franz. "Die Deutsche Photographische Ausstellung Frankfurt a.M. 1926 und ihr Wert." In *DPA: Aussteller-Verzeichnis*, 17–20. Frankfurt a.m Main: Druckerei R. Th. Hauser & Co., 1926.

Grainer, Franz. "Das Neuzeitliche Damenbildnis." In *Das Deutsche Lichtbild Jahreschau*, XIV. Berlin: Robert and Bruno Schultz, 1927.

Gramsci, Antonio. *Selections from the Prison Notebooks*, eds. Quentin Hoare and Geoffrey Nowell Smith, 268. New York: International Publishers, 1971.

Haenel, Erich. "Die Internationale Photographische Ausstellung Dresden 1909." *Dekorative Kunst* 7 (August 1909): 474.

Hansen, Fritz. "Wanderungen durch *Iphad.*" *Der Photograph*, no. 37 (1909): 146.

Haviland, Paul B. "The Accomplishments of Photography and Contributions of the Medium to Art." *Camera Work*, no. 33 (January 1911): 67.

Herrmann, Fr. K. "Das Foto in der Bildberichterstattung." In *Die Kamera: Ausstellung für Fotografie, Druck und Reproduktion*, 31. Berlin: Ausstellunghallen am Funkturm, 1933.

Hoinkis, Ewald, Görlitz, to Museum Folkwang, Essen, June 7, 1929. Collections, Museum Folkwang, Essen.

Hoppé, E. O. "Preface." In *International Photographic Exhibition*. London: Whitechapel Art Gallery, 1929.

"The International Photographic Exhibition at Dresden." *The British Journal of Photography* (May 21 through July 2, 1909): 396–515.

Kassák, Lajos and Laszlo Moholy-Nagy. *Buch neuer Künstler*. Vienna: Elbemühl, 1922.

Kuehn, Heinrich, Innsbruck, to Erich Stenger, Charlottenburg, October 3, 1940. Stenger Archive, Agfa Fotohistorama, Cologne.

Kurzbein, Heiner. "Die Fotografie im nationalen Deutschland." In *Die Kamera: Ausstellung für Fotografie, Druck und Reproduktion*. Berlin: Ausstellunghallen am Funkturm, 1933.

Lendvai-Dircksen, Erna. "Zur Psychologie des Sehen." *Das Deutsche Lichtbild* (1931): n.p.

Lüking, Paul. "Foreword." In *Internationale Schau der Amateurfotografen*, 4. Frankfurt am Main: VDAV, 1936.

Matthies-Masuren, Friedrich. *Die Bildmässige Photographie*. Halle: W. Knapp, 1905.

Matthies-Masuren, Friedrich. "Kleine Mitteilungen." *Photographische Rundschau* 66 (March 1929): 101–2.

Moholy-Nagy, László. *Malerei, Photographie, Film*. Munich: Albert Langen Verlag, 1925.

Moholy-Nagy, László. "Beispiellos Photographie." In *Das Deutsche Lichtbild* Jahreschau 1927, X–XI. Berlin: Robert and Bruno Schultz, 1927.

Moholy-Nagy, László. "Neue Wege in der Photographie." *Photographische Rundschau* 65 (1928): 33–6.

Moholy-Nagy, László. *Von Material zu Architecktur*. Munich: A. Verlag, 1929.

Moholy-Nagy, László. Berlin, to Erich Stenger, Charlottenburg. December 22, 1930. Collections, Agfa Fotohistorama, Cologne.

Moholy-Nagy, László. *Vision in Motion*. Chicago: Paul Theobald, 1947.

"Neue Wege der Photographie," 1928, brochure. Collections, Museum Folkwang, Essen.

Niendorf, Helmut. "Die freien Gewerkschaften auf der Bauausstellung." *Soziale Bauwirtschaft* (June 8, 1931): 179–81.

Newhall, Beaumont. "Introduction." In *Photography 1839–1937*. Andover: Addison Gallery of American Art, 1937.

Offizieller Katalog der Internationalen Photographischen Ausstellung Dresden 1909. Dresden: Wilhelm Baensch, 1909.

Pagano, Giuseppe. "Parliamo un pò di esposizioni." *Casabella-Costruzioni*, special double issue, 159–60 (March–April 1941): n.p.

"*Photographie der Gegenwart*," *Essener Volkszeitung*, January 27, 1929, unpaginated.

"*Photographie der Gegenwart*," *Volksmacht*, Essen, January 28, 1929, unpaginated.

"*Photographie der Gegenwart*," *Hannover Kurier*, March 15, 1929, unpaginated.

"*Photographie der Gegenwart*," Hannoverischer Anzeiger, March 15, 1929, "Aus der Stadt" section.

Photographie für Alle, no. 33 (1937): 189.

"Photographische Ausstellung in Köln." *Photographische Rundschau* 64 (1927): 180. *Die Photographische Industrie*, no. 5 (January 30, 1929): frontispiece.

Renger-Patzsch, Albert. "Ziele." *Das Deutsche Lichtbild Jahreschau*, XVIII. Berlin: Robert and Bruno Schultz, 1927.

Renger-Patzsch, Albert. *Die Welt is schön*. Munich: K. Wolff, 1928.

Renger-Patzsch, Albert. "The Camera and Landscape Photography." In *Kunst der Nation* (November 1933). Translation by Daniel Magilow.

Rode, Otto. "Bauausstellung und Bauhüttenschau." *Soziale Bauwirtschaft* (June 8, 1931): 163–81.

Roh, Franz and Jan Tschichold. *Foto-Auge/Oeil et photo/Photo-Eye*. Stuttgart: Fritz Wedekind & Co., 1929.

Roh, Franz and Jan Tschichold. *L. Moholy-Nagy, 60 Fotos.* Berlin: Klinkhardt & Biermann, 1930.

Rossmann, Dr. Wilhelm. "Die Ausstellung 'Die Kamera' in Berlin 1933." *Das Atelier des Photographen* (1933): 131–4.

Russell, Bertrand. "On Propaganda." *Estudios* (September 1936).

Schönewald, Emil. "Ein Rundgang durch die Deutsche Photographische Ausstellung Frankfurt a.M. 1926." *Der Photograph*, no. 74 (1926): 293.

Schönewald, Emil. "Ein Rundgang durch die Deutsche Photographische Ausstellung Frankfurt a.M. 1926." *Der Photograph*, no. 75 (1926): 299.

Schumann, Dr. Paul. "The 'International Group' at the Dresden Exposition." *Camera Work*, no. 28 (October 1909): 45.

Seddig, Dr. "Wissenschaftliche Photographie." In *DPA Aussteller-Verzeichnis*, 38–40. Frankfurt a.m Main: Druckerei R. Th. Hauser & Co., 1926.

Steinorth, Karl. *Internationale Ausstellung des Deutschen Werkbundes Film und Foto.* Stuttgart: Deutsche Verlags-Anstalt GMBH, reprint 1979 (Des Deutschen Werkbund, 1929).

Stenger, Erich. "Das photographische Porträt um 1840." In *DPA Aussteller-Verzeichnis*, 45–7. Frankfurt a.m Main: Druckerei R. Th. Hauser & Co., 1926.

Stenger, Erich. "Historisches in *Film und Foto.*" *Stuttgarter Neues Tagblatt* (May 29, 1929): 2.

Stenger, Erich. *The History of Photography: Its Relation to Civilization and Practice.* Translated by Edward Epstean. Easton: Mack Printing Company, 1939.

Stenger, Erich. *Lebenserinnerungen eines Sammlers* (Unpublished Manuscript). Collections, Agfa Fotohistorama, Cologne.

"Unter uns." *Die Photographische Industrie*, no. 5 (January 30, 1929): 101.

Waldstein, Agnes. "*Photographie der Gegenwart*: Ausstellung im Folkwang-Museum." *Essener Volkszeitung*, January 27, 1929, unpaginated.

"Wanderausstellung 'Fotografie der Gegenwart,'" August 28, 1929, memo. Collections, Museum Folkwang, Essen.

Warstat, Dr. Willi. *Allgemeine ästhetik der photographischen kunst auf psychologischer grundlage.* Halle: Knapp, 1909.

Warstat, Dr. Willi. "Wo stehen wir?" *Der Photograph*, no. 72 (1926): 285.

Warstat, Dr. Willi. "Rückblick auf die Ausstellung der Gesellschaft Deutscher Lichtbildner bei der Pressa in Köln 1928." *Das Atelier des Photographen* 35 (1928): 126–8.

Weiss, Karl. *Iphad: In Wort und Bild.* Dresden: Wilhelm Baensch, 1909.

Weiss, Karl. "Die Photographische Industrie zur *DPA.*" In *DPA Aussteller-Verzeichnis*, 51–3. Frankfurt a.m Main: Druckerei R. Th. Hauser & Co., 1926.

"Werkbund-Ausstellung 'Film und Foto,' Stuttgart 1929." *Photographische Industrie* 27 (August 28, 1929): 910–11.

Wilhelm-Kästner, Kurt. "Grundsätzliches zur Ausstellung im Museum Folkwang, Essen." *Photographische Rundschau* 66 (March 1929): 93–6.

"Zu unseren Bildern." *Das Atelier des Photographen* 34 (May 1927): 60.

Other Sources

Adorno, Theodor. "Reconciliation under Duress." In *Aesthetics and Politics*, ed. Roger Taylor, 166. London: NLB, 1977.

Albright, Madeleine. *Fascism: A Warning*. New York: Harper Collins, 2018.

Alloway, Lawrence. *The Venice Biennale, 1895–1968: From Salon to Goldfish Bowl.* Greenwich: New York Graphic Society, 1968.

Altshuler, Bruce. *The Avant-Garde in Exhibition: New Art in the 20th Century*. New York: Harry N. Abrams, Inc., 1994.

Baltzer, Nanni. "Die Fotomontage im faschistischen Italien. Aspekte der Propaganda unter Mussolini." In *Studies in Theory and History of Photography*, vol. 3, 92–160. Berlin and Boston: De Gruytner, 2015.

Barr, Alfred Hamilton. *Cubism and Abstract Art*. New York: Museum of Modern Art, 1936 Reprint, New York: Museum of Modern Art, 1986.

Batchen, Geoffrey. *Burning With Desire: The Conception of Photography*. Cambridge, MA: MIT Press, 1997.

Bathrick, David and Andreas Huyssen, eds. *Modernity and the Text*. New York: Columbia University Press, 1989.

Baudelaire, Charles. *Art in Paris 1845–62: Salons and Other Exhibitions*. Translated by Jonathan Mayne. Oxford: Phaidon, 1981.

Bazin, André. *What Is Cinema*. Berkeley: University of California Press, 1967.

Ben-Ghiat, Ruth. *Fascist Modernities: Italy, 1922–1945*. Berkeley: University of California Press, 2001.

Ben-Ghiat, Ruth. "Italian Fascists and National Socialists: The Dynamics of an Uneasy Relationship." In *Arts, Culture, and Media under the Third Reich*, ed. Richard Etlin, 257–84. Chicago: University of Chicago Press, 2002.

Ben-Ghiat, Ruth. "Moving Images: Realism and Propaganda." In *Post Zang Tumb Tuum: Art Life Politics: Italia, 1918–43*, ed. Germano Celant. Milan: Prada Foundation, 2018.

Benjamin, Walter. *Illuminations*. Edited by Hannah Arendt. Translated by Harry Zohn. New York: Schocken Books, 1969.

Benjamin, Walter. *Walter Benjamin: Selected Writings, Volume 1 (1913-1926)*. Edited by Marcus Bullock and Michael W. Jennings, 444–88. Cambridge, MA: Harvard University Press, 1996.

Benjamin, Walter. *The Arcades Project*. Translated by Howard Eiland and Kevin McLaughlin. Cambridge, MA: Harvard University Press, 1999.

Benjamin, Walter. *Walter Benjamin: Selected Writings, Volume 2 (1927- 34)*. Edited by Michael W. Jennings, Howard Eiland, and Gary Smith, 207–22. Cambridge, MA: Harvard University Press, 1999.

Benzi, Fabio, ed. *Mario Sironi 1885–1961*. Milan: Electa, 1993.

Bertrand, Allison. "Beaumont Newhall's 'Photography 1838–1937': Making History." *History of Photography* (Summer 1997): 137.

Botar, Oliver. "Prolegomena to the Study of Biomorphic Modernism: Biocentricism iin Moholy-Nagy's New Vision and Kallai's *Bioromantik*." Ph.D. dissertation, University of Toronto, 1998.

Braun, Emily. *Mario Sironi and Italian Modernism: Art and Politics under Fascism.* Cambridge: Cambridge University Press, 2000.

Braun, Emily. "Shock and Awe: Futurist *Aeropittura* and the Theories of Giulio Douet." In *Italian Futurism, 1909–1944: Reconstructing the Universe*, ed. Vivien Greene, 269. New York: Solomon R. Guggenheim Museum, 2014.

Brüning, Ute. "Typophoto." In *Photography at the Bauhaus*, ed. Jeanine Fiedler, 204–19. Cambridge, MA: MIT Press, 1990.

Buchloh, Benjamin. "From Faktura to Factography." *October*, no. 30 (Fall 1984): 82–119.

Bunnell, Peter C., ed. *A Photographic Vision: Pictorial Photography, 1889–1923.* Salt Lake City: Peregrine Smith, Inc., 1980.

Caffin, Charles. *Photography as a Fine Art.* Reprint, New York: Morgan and Morgan, Inc., 1971.

Campbell, Joan. *The German Werkbund: The Politics of Reform in the Applied Arts.* Princeton: Princeton University Press, 1978.

Celant, Germano. *Post Zang Tumb Tuum: Art Life Politics: Italia, 1918–43.* Milan: Prada Foundation, 2018.

Chanzit, Gwen. *Finkel, Herbert Bayer and Modernist Design in America.* Ann Arbor and London: UMI Research Press, 1987.

Cohen, Arthur. *Herbert Bayer: The Complete Work.* Cambridge, MA: MIT Press, 1984.

Coke, Van Deren. *Avant-Garde Photography in Germany, 1919–1939.* New York: Panthcon, 1982.

Cooke, Lynne and Peter Wollen, eds. *Visual Display: Culture beyond Appearances.* New York: New Press, 1998.

Craig, Gordon. *Germany, 1866–1945.* New York: Oxford University Press, 1978.

Cronin, Elizabeth. *Heimat Photography in Austria: A Politicized Vision of Peasants and Skiers.* Vienna: Photoinstitut Bonartes, 2015.

Dewitz, Bodo von, ed. *Hugo Erfurth: Photograph Zwischen Tradition und Moderne.* Cologne: Wienand Verlag, 1992.

Dewitz, Bodo von. "Erich Stenger und seine *Geschichte der Fotografie*," typescript of lecture at the fourth Fotosymposium, Stadtmuseum München, October 26, 1996. Collections, Agfa Fotohistorama, Köln.

Dewitz, Bodo von. "Erich Stenger und seine Sammlung zur Kulturgeschichte der Photographie." *Kölner Museums-Bulletin*, no. 1 (1997): 18.

Dewitz, Bodo von and Karin Schuller Procopovici, eds. *David Octavius Hill and Robert Adamson.* Göttingen: Steidl, 2000.

Dewitz, Bodo von and Robert Lebeck, eds. *Kiosk: A History of Photojournalism.* Cologne: Museum Ludwig/Agfa Foto-Historama, 2001.

Dobrzynski, Judith H. "High Culture Goes Hands-on." *New York Times Sunday Review* (August 11, 2013): 1, 6–7.

Drutt, Matthew. "El Lissitzky in Germany, 1922–25." In *El Lissitzky: Jenseits der Abstraktion*, ed. Margarita Tupitsyn, 9–24. Munich: Schirmer/Mosel, 1999.

Eagleton, Terry. *Ideology: An Introduction.* London and New York: Verso, 1991.

Erbaggio, Pierluigi. "Istituto Nazionale Luce: A National Company with an International Reach." In *Italian Silent Cinema: A Reader*, ed. Giorgio Bertellini, 221–31. London: John Libbey, 2013.

Eskildsen, Ute. "Photography and the Neue Sachlichkeit movement." In *Germany: The New Photography, 1927–33*, ed. David Mellor, 100–12. London: Arts Council of Great Britain, 1978.

Eskildsen, Ute and Jan-Christopher Horak, eds. *Film und Foto der Zwanziger Jahre.* Stuttgart: Württembergischer Kunstverein, 1979.

Eskildsen, Ute and Jan-Christopher Horak. "Innovative Photography in Germany Between the Wars." In *Avant-Garde Photography in Germany 1919–1939.* San Francisco: Museum of Modern Art, 1980.

Eskildsen, Ute and Jan-Christopher Horak. "Die Abteilung Fotografie." In *Der westdeutsche Impuls 1900–1914: Kunst und Umweltgestaltung im Industriegebiet--Die Deutsche Werkbund-Ausstellung Cöln.* Cologne: Kölnischer Kunstverein, 1984.

Eskildsen, Ute and Jan-Christopher Horak. *Die Fotografische Sammlung im Museum Folkwang.* Essen: Museum Folkwang, 2003.

Evans, Richard J. *The Coming of the Third Reich.* New York: Penguin Press, 2004.

Evans, Richard J. *The Third Reich in Power.* New York: Penguin Press, 2005.

Falasca-Zamponi, Simonetta. *Fascist Spectacle: The Aesthetics of Power in Mussolini's Italy.* Berkeley: University of California Press, 1997.

Fiedler, Jeanine, ed. *Photography at the Bauhaus.* Cambridge, MA: MIT Press, 1990.

Fiss, Karen. *Grand Illusion: The Third Reich, the Paris Exposition, and the Cultural Seduction of France.* Chicago: University of Chicago Press, 2009.

Fiss, Karen and Robert H. Kargon, Morris Low, and Arthur P. Molella. *World's Fairs on the Eve of War: Science, Technology, and Modernity, 1937–1942.* Pittsburgh: University of Pittsburgh Press, 2015.

Flint, R. W., ed. and trans. *Let's Murder the Moonshine, Selected Writings, F.T. Marinetti.* Los Angeles: Sun & Moon Classics, 1991.

Fritzsche, Peter. *German into Nazis.* Cambridge, MA: Harvard University Press, 1998.

Frizot, Michel. *The New History of Photography.* Cologne: Könemann, 1998.

Fromm, Erich. *Escape from Freedom*, 280–1, New York: Rinehart, 1941.

Fulton, Marianne, ed. *Pictorialism into Modernism: the Clarence H. White School of Photography.* New York: Rizzoli, 1996.

Gasser, Martin. "Histories of Photography 1838–1939." *History of Photography* 16 (Spring 1992): 55.

Gellately, Robert. *Backing Hitler: Consent and Coercion in Nazi Germany.* Oxford: Oxford University Press, 2001.

Ghirardo, Diane. "Architects, Exhibitions, and the Politics of Culture in Fascist Italy." *Journal of Architectural Education* 42, no. 2, special issue (February 1992).

Ginex, Giovanna. "La Galleria Delle Arti Grafiche Alla IV Triennale Di Monza." In *Sironi: La Grande Decorazione*, ed. Andrea Sironi, 193–4. Milan: Electa, 2004.

Goeschel, Christian. "A Parallel History? Rethinking the Relationship between Italy and Germany, ca. 1860–1945." *The Journal of Modern History* 88 (September 2016): 610–32.

Golan, Romy. *Muralnomad: The Paradox of Wall Painting, Europe 1927–1957*. New Haven: Yale University Press, 2009.

Gough, Maria. "Constructivism Disoriented: El Lissitzky's Dresden and Hannover Demonstrationsraume." In *Situating El Lissitzky: Vitebsk, Berlin, Moscow*, eds. Nancy Perloff and Brian Reed, 77–125. Los Angeles: Getty Research Institute.

Graeve, Inka. "Internationale Ausstellung des Deutschen Werkbunds Film und Foto." In *Stationen der Moderne*. Berlin: Berlinische Galerie, 1988.

Greenberg, Reesa, ed. *Thinking About Exhibitions*. New York: Routledge, 1996.

Greene, Vivien, ed. *Italian Futurism, 1909–1944: Reconstructing the Universe*. New York: Solomon R. Guggenheim Museum, 2014.

Gunning, Tom. "What's the Point of an Index? Or Faking Photographs." In *Still/Moving: Between Cinema and Photography*, eds. Karen Beckman and Jean Ma, 23–40. Durham: Duke University Press, 2008.

Haus, Andreas. *Moholy-Nagy: Fotos und Fotogramme*. Munich: Schirmer/Mosel, 1978.

Herf, Jeffrey. *Reactionary Modernism: Technology, Culture, and Politics in Weimar and the Third Reich*. Cambridge: Cambridge University Press, 1986.

Hight, Eleanor. *Moholy-Nagy: Photography and Film in Weimar Germany*. Wellesley: Wellesley College Museum, 1985.

Hight, Eleanor. *Picturing Modernism*. Cambridge, MA: MIT Press, 1995.

Hight, Eleanor. "Introduction to Photo-Archives and New Histories of Photography." In *CAA Abstracts*. New York: College Art Association, 2003.

Hill, Paul and Thomas Cooper. *Dialogue with Photography*. New York: Farrar, Strauss & Giroux, 1992.

Internationale Ausstellung des Deutschen Werkbundes Film und Foto. Reprint, Stuttgart: Deutsche Verlags-Anstalt GmbH, 1979.

Kachur, Lewis. *Displaying the Marvelous*. Cambridge, MA: MIT Press, 2001.

Kadatz, Hans-Joachim. *Peter Behrens: Architekt, Maler, Graphiker und Formgestalter 1868-1940*. Leipzig: Seemann, 1977.

Kaes, Anton, Martin Jay, and Edward Dimendburg, eds. *The Weimar Republic Sourcebook*. Berkeley: University of California Press, 1994.

Karp, Ivan et al., eds. *Museum Frictions: Public Cultures/Global Transformations*. Durham: Duke University Press, 2006.

Kracauer, Sigfried. *From Caligari to Hitler: A Psychological History of the German Film*. Princeton: Princeton University Press, 1947.

Kracauer, Sigfried. *Mass Ornament*, trans. and ed. Thomas Y. Levin. Cambridge, MA: Harvard University Press, 1995.

La, Kristie. "'Enlightenment, Advertising, Education, etc.': Herbert Bayer and the Museum of Modern Art's *Road to Victory*," Conference paper presented at Exhibition as Medium, Harvard University, March 8–9, 2013.

Landy, Marcia. *Fascist Film: The Italian Commercial Cinema, 1931–1943*. Princeton: Princeton University Press, 1986.

Lavin, Maud. *Cut with the Kitchen Knife: The Weimar Photomontages of Hannah Höch*. New Haven: Yale University Press, 1993.

Lavin, Maud. *Clean New World: Culture, Politics, and Graphic Design*. Cambridge, MA: MIT Press, 2001.

Lissitzky, El. "Autobiography." In *El Lissitzky*, 8. Eindhoven: Municipal Van Abbemuseum, 1990.

Lissitzky-Küppers, Sophie. *El Lissitzky: Life, Letters, Texts*. Translated by Helen Aldwinckle and Mary Whittall. London: Thames and Hudson Ltd, 1968.

Lodder, Christina. "The Transition to Constructivism." In *The Great Utopia: Russian and Soviet Avant-Garde, 1915-1932*, 267–81. New York: Guggenheim Museum, 1992.

Lodder, Christina. "El Lissitzky and the Export of Constructivism." In *Situating El Lissitzky: Vitebsk, Berlin, Moscow*, eds. Nancy Perloff and Brian Reed, 27–46. Los Angeles: Getty Publications, 2003.

Long, Rose-Carol Washton, ed. *German Expressionism: Documents from the End of the Wilhelmine Empire to the Rise of National Socialism*. Berkeley: University of California Press, 1993.

Longerich, Peter. *Goebbels: A Biography*, 222. New York: Random House, 2015.

Lotery, Kevin and Claire Grace, eds. "Artists Design Exhibitions." October special issue, no. 150 (Fall 2014).

Lugon, Olivier. "La photographie mise en espace: Les expositions didactiques allenmades 1925 – 1945." *Études photographiques* (November 5, 1998): 97–118.

Lugon, Olivier. "Le marcheur: Piétons et photographes au sein des avant-gardes." *Études photographiques* (November 8, 2000): 69–91.

Lugon, Olivier. "The Progressions of Thought: Management of Circulation in Didactic Exhibitions (Des cheminements de pensée: la gestion de la circulation dans les expositions didactiques)." *Art Press* 21 (2000): 17–25.

Lugon, Olivier. *Le Style documentaire. D'August Sander à Walker Evans, 1920–1945*. Paris: Macula, 2001.

Lugon, Olivier. "Neues Sehen, Neue Geschichte: Laszlo Moholy-Nagy, Sigried Giedion und die Ausstellung *Film und Foto*." In *Sigfried Giedion und Bildnsenierungen der Moderne Die Fotografie*, eds. Werner Oechslin und Gregor Harbusch, 88–105. Zurich: gta Verlag, 2010.

Lugon, Olivier. "Photography and Scale: Projection, Exhibition, Collection." *Art History* 38 (2015): 386–403. doi: 10.1111/1467-8365.12155

Lusk, Irene Charlotte. László Moholy-Nagy: *Fotomontagen und Collagen, 1922–43*. Giessen: Anabas, 1980.

Lux, Simonetta, ed. *Avanguardia, traduzione, ideologia: itinerario attraverso un ventennio di dibattito sulla pittura e plastica murale.* Rome: Bagatta Libri, 1990.

Margolin, Victor. *Struggle for Utopia.* Chicago: University of Chicago Press, 1997.

Marien, Mary Warner. *Photography: A Cultural History*, 3rd ed. Saddle River: Pearson, 2011.

Martin, Benjamin. *The Nazi-Fascist New Order for European Culture.* Cambridge, MA: Harvard University Press, 2016.

Matthies-Masuren, Friedrich. "Secession." In *Offizieller Katalog der Internationalen Elite-Ausstellung Künstlerischer Photographien*, ix–xvi. Munich: Verlag des Vereines bildender Künstler, 1898. In *A Photographic Vision: Pictorial Photography, 1889–1923*, ed. Peter Bunnell, 91–3. Salt Lake City: Peregrine Smith, Inc., 1980.

McCauley, Anne. "Guest Editorial." *History of Photography* (Summer 1997): 86.

McCauley, Anne. "Writing Photography's History before Newhall." *History of Photography* (Summer 1997): 99, n20.

Mellor, David. "London-Berlin-London: A Cultural History. The Reception and Influence of the New German Photography in Britain 1927–33." In *Germany: The New Photography, 1927–33*, ed. David Mellor, 113–29. London: Arts Council of Great Britain, 1978.

Mendelson, Jordana. *Documenting Spain: Artists, Exhibition Culture, and the Modern Nation, 1929–1939.* University Park: Pennsylvania State University Press, 2005.

Moholy, Lucia. *Marginalien zu Moholy-Nagy: Moholy-Nagy, Marginal Notes.* Krefeld: Scherpe, 1972.

Moholy-Nagy, László. *Painting, Photography, Film.* Translated by Janet Seligman. Cambridge, MA: MIT Press, 1969.

Moholy-Nagy, László. "Sharp or Unsharp? A Reply to Hans Windisch." In *Photography in the Modern Era*, ed. Christopher Phillips, 132–9. New York: The Metropolitan Museum of Art/Aperture, 1989.

Nadeau, Luis. *Encyclopedia of Printing, Photogenic, and Photomechanical Processes.* New Brunswick: Atelier Luis Nadeau, 1997.

Naef, Weston. *The Collection of Alfred Stieglitz.* New York: Metropolitan Museum of Art/Viking Press, 1978.

Naef, Weston, ed. *In Focus: László Moholy-Nagy Photographs from the J. Paul Getty Museum.* Malibu: J. Paul Getty Museum, 1995.

Newhall, Beaumont, ed. *Photography: Essays and Images*, 5th ed. New York: The Museum of Modern Art, 1980.

Newhall, Beaumont. *The History of Photography*, 5th ed. New York: Museum of Modern Art, 1982.

Newhall, Beaumont. *Focus: Memoirs of a Life in Photography.* Boston: Bulfinch Press, 1993.

Nickel, Douglas R. "History of Photography: The State of Research." *Art Bulletin* (September 2001): 548–58.

O'Shaughnessy, Nicholas. *Marketing the Third Reich: Persuasion, Packaging, and Propaganda.* New York and London: Routledge, 2018.

Otto, Elizabeth and Vanessa Rocco, eds. *The New Woman International: Representations in Photography and Film from the 1870s to the 1960s*. Ann Arbor: University of Michigan Press, 2011.

Overy, Paul. "Visions of the Future and Immediate Past: The Werkbund Exhibition, Paris 1930." *Journal of Design History* 17, no. 4 (2004): 337–57.

Painter, Jr., Borden W. *Mussolini's Rome: Rebuilding the Eternal City*. New York: Palgrave Macmillan, 2005.

Paxton, Robert O. *The Anatomy of Fascism*. New York: Vintage Books, 2004.

Passuth, Krisztina. *Moholy-Nagy*. Translated by Kenneth McRobbie and Ilona Jánosi. New York: Thames and Hudson, 1985.

Pepper, Terence. *Camera Portraits by E. O. Hoppé*. London: National Portrait Gallery, 1978.

Perloff, Nancy. "The Puzzle of El Lissitzky's Artistic Identity." In *Situating El Lissitzky: Vitebsk, Berlin, Moscow*, eds. Nancy Perloff and Brian Reed, 1–26. Los Angeles: Getty Publications, 2003.

Petro, Patrice. *Joyless Streets*. Princeton: Princeton University Press, 1989.

Petrucci, Antonio. *Twenty Years of Cinema in Venice*. Rome: Edizioni Dell Ateneo, 1952.

Peukert, Detlev J. K. *The Weimar Republic*. Translated by Richard Deveson. New York: Farrar, Straus and Giroux, 1989.

Phillips, Christopher. "The Judgment Seat of Photography." *October* 22 (Fall 1982): 26–63.

Phillips, Christopher. *Photography in the Modern Era*. New York: The Metropolitan Museum of Art/Aperture: 1989.

Phillips, Christopher and Maria Morris Hambourg, eds. *The New Vision: Photography between the World Wars*. New York: Metropolitan Museum of Art, 1989.

Platt, Susan Noyes. *Art and Politics in the 1930s: Modernism, Marxism, Americanism*. New York: Midmarch Arts Press, 1999.

Pohlmann, Ulrich. *Kultur, technik and kommerz: die photokina-Bilderschauen 1950-1980*. Cologne: Historishes Archiv der Stadt, 1990.

Pohlmann, Ulrich. "Im Einklang mit den Großen der Zeit: Anmerkungen zur Rezeptiongeschichte des Erfurthschen Porträtwerkes in Ausstellungen und Publikationen." In *Hugo Erfurth: Photograph Zwischen Tradition und Moderne*, ed. Bodo von Dewitz, 119–38. Cologne: Wienand Verlag, 1992.

Pohlmann, Ulrich. *Frank Eugene: The Dream of Beauty*. Munich: Nazareli Press, 1995.

Pohlmann, Ulrich. "El Lissitzky's Exhibition Designs: The Influence of His Work in Germany, Italy, and the United States, 1923–1943." In *El Lissitzky: Jenseits der Abstraktion*, ed. Margarita Tupitsyn, 9–24. Munich: Schirmer/Mosel, 1999.

Pohlmann, Ulrich. "'Not Autonomous Art but a Political Weapon': Photography Exhibitions as a Means for Aestheticizing Politics and Economy in National Socialism." In *Public Photographic Spaces: Exhibitions of Propaganda from 'Pressa' to 'The Family of Man', 1928–55*, ed. Jorge Ribalta, 275–98. Barcelona: MACBA, 2008.

Pollock, Elizabeth. "The Biography of Heinrich Kuehn." In *Eine Ausstellung von hundert Photographien von Heinrich Kühn*. Munich: Stefan Lennert, 1981.

Prelinger, Elizabeth. *Kollwitz*. Washington: National Gallery of Art, 1992.

Print, Power, and Persuasion: Graphic Design in Germany, 1890–1945. Bard Graduate Center (May 24–August 26, 2001).

Puyo, E. J. Constant. "Synthetic Photography." *La Revue de Photographie* (April 15, 1904): 105–10. In *A Photographic Vision: Pictorial Photography, 1889–1923*, ed. Peter Bunnell, 167–70. Salt Lake City: Peregrine Smith, Inc., 1980.

Rentschler, Eric. "There's No Places like Home: Luis Trenker's The Prodigal Son." *New German Critique*, no. 60 (Autumn 1993): 33–56.

Ribalta, Jorge, ed. *Public Photographic Spaces: Exhibitions of Propaganda from 'Pressa' to 'The Family of Man', 1928–55*. Barcelona: MACBA, 2008.

Rittelmann, Leesa. "Facing Off: Photography, Physiognomy, and National Identity in the Modern German Photobook." *Radical History Review* 106 (2010): 137–61.

Rocco, Vanessa. "'Acting on the Visitor's Mind': Architectonic Photography at the Exhibition of the Fascist Revolution in Rome, 1932." In *Public Photographic Spaces: Exhibitions of Propaganda from Pressa to The Family of Man*, ed. Jorge Ribalta, 245–55. Barcelona: MACBA, 2008/09.

Rocco, Vanessa. "Pictorialism and Modernism at the Dresden Internationale Photographische Ausstellung." *The History of Photography* 33, no. 4 (November 2009): 383–402.

Rocco, Vanessa. "Exhibiting Exhibitions." In *Made in Italy: Rethinking a Century of Italian Design*, eds. Kjetil Fallin and Grace Lees Maffei, 179–93. New York and London: Bloomsbury, 2013.

Rocco, Vanessa. "Activist Photo Spaces: 'Situation Awareness' and The Exhibition of the Building Workers Union (Berlin, 1931)." *Journal of Curatorial Studies* 3, no. 1 (2014): 26–48.

Rosenblum, Naomi. *A World History of Photography*. New York: Abbeville Press, 1989.

Russo, Antonella. *Il Fascismo in mostra*. Rome: Editori Riuniti, 1999.

Sachsse, Rolf. *Lucia Moholy*. Düsseldorf: Edition Marzona, 1985.

Sachsse, Rolf. "Notes on Lucia Moholy." In *Photography at the Bauhaus*, ed. Jeanine Fiedler, 25–7. Cambridge, MA: MIT Press, 1990.

Salaris, Claudia. *La Quadriennale: storia della rassegna d'arte italiana dagli anni Trenta a oggi* (History of the exhibition of Italian art from the Thirties to today). Venice: Marsilio, 2004.

Saul, Julie. *Moholy-Nagy Fotoplastiks: The Bauhaus Years*. New York: Bronx Museum of the Arts, 1983.

Schnapp, Jeffrey T. "'Ogni mostra realizzata è una rivoluzione', ovvero le esposizioni sironiane e l'immaginario Fascista." In *Mario Sironi 1885–1961*. Milan: Electa, 1993.

Schnapp, Jeffrey T. and Matthew Tiews, eds. *Crowds*. Stanford: Stanford University Press, 2006.

Schnapp, Jeffrey T. "Projections (Some Notes on Public Space in the 1930s)." In *Encounters with the 30s*, ed. Jordana Mendelson, 31–8. Madrid: Museo Nacional Centro de Arte Reina Sofia, 2013.

Schnapp, Jeffrey T. "The Spectacle Factory." In *Post Zang Tumb Tuuum: Art Life Politics: Italia 1918-1943*, ed. Germano Celant, 258–65. Milan: Prada Foundation, 2018.

Shklovsky, Viktor. "Art as Technique." In *Russian Formalist Criticism, Four Essays*, eds. Lee T. Lemon and Marion J. Reis, 3–24. Lincoln: University of Nebraska Press, [1917] 1965.

Squiers, Anthony. *An Introduction to the Social and Political Philosophy of Bertolt Brecht: Revolution and Aesthetics*. Amsterdam: Brill/Rodopi, 2014.

Solomon-Godeau, Abigail. "The Armed Vision Disarmed: Radical Formalism from Weapon to Style." *Afterimage* 10 (January 1983): 9–14.

Solomon-Godeau, Abigail. "Winning the Game when the Rules have Changed: Art Photography and Postmodernism." *Screen* 25, no. 6 (1984). In *The Photography Reader*, ed. Liz Wells, 152–63. New York: Routledge, 2003.

Sontag, Susan. *On Photography*. New York: Doubleday, 1989.

Squiers, Carol. *Perfecting Mankind: Eugenics and Photography*. New York: International Center of Photography, 2001.

Staniszewski, Mary Anne. *Designing Modern Art and Culture: A History of Exhibition Installations at the Museum of Modern Art*. Ph.D. dissertation, CUNY Graduate Center, 1995.

Stansky, Peter. *On or About December 1910*. Cambridge, MA: Harvard University Press, 1997.

Stone, Marla. *Patron State: Culture and Politics in Fascist Italy*. Princeton: Princeton University Press, 1998.

Stone, Marla. "Exhibitions and the Cult of Display in Fascist Italy." In *Post Zang Tumb Tuum: Art Life Politics Italia: 1918–1943*, ed. Germano Celant, 186–91. Milan: Prada Foundation, 2018.

Theweleit, Klaus. *Male Fantasies, Volume 1: Women, Floods, Bodies, History*. Minneapolis: University of Minnesota Press, 1987.

Tucker, Anne. *The History of Japanese Photography*. Houston: The Museum of Fine Arts, 2003.

Tupitsyn, Margarita, ed. *El Lissitzky: Jenseits der Abstraktion*. Munich: Schirmer/Mosel, 1999.

Tupitsyn, Margarita. *Klutsis and Kulagina: Photography and Montage after Constructivism*. New York: International Center of Photography; Göttingen: Steidl, 2004.

Tymkiw, Michael. *Nazi Exhibition Design and Modernism*. Minneapolis: University of Minnesota Press, 2018.

Ward, Janet. *Weimar Surfaces*. Berkeley: University of California Press, 2002.

Weill, Alain. "*Fotografie der Gegenwart* brochure." In *Modernist Posters*. New York: Swann, 2001, lot 50.

Whitford, Frank. *Bauhaus*. London: Thames and Hudson, 1984.

Willett, John, ed. *Brecht on Theater: The Development of an Aesthetic*. New York: Hill and Wang, 1964.

Willett, John. *Art and Politics in the Weimar Period: The New Sobriety, 1917–33*. New York: Pantheon Books, 1978.

Windsor, Alan. *Peter Behrens: Architect and Designer*. New York: Whitney Library of Design, 1981.

Wolin, Richard. *Walter Benjamin: An Aesthetic of Redemption*. Berkeley: University of California Press, 1994.

Wollen, Peter. "Introduction." In *Visual Display: Culture beyond Appearances*, eds. Lynne Cooke and Peter Wollen, 10. New York: New Press, 1998.

Zervigón, Andrés Mario. "A 'Political Struwwelpeter'? John Heartfield's Early Film Animation and the Crisis of Photographic Representation." *New German Critique* 107, no. 36 (August 2009): 5–51.

Zervigón, Andrés Mario. "The Peripatetic Viewer at John Heartfield's Film und Foto Exhibition Room," Conference paper presented at *The Exhibition as Medium*, Harvard University, March 8–9, 2013.

Index

Note: Page numbers in italics denote figures.